W9-CMD-630

WHITE WOLF: LIVING WITH AN ARCTIC LEGEND

WHITE WOLF: LIVING WITH AN ARCTIC LEGEND

JIM BRANDENBURG

EDITED BY JAMES S. THORNTON

NORTHWORD PRESS, INC.

DEDICATION

To my parents, Edward and Olga, who gave me the gift of freedom and the confidence to roam.

Copyright © 1988 by Jim Brandenburg

All rights reserved. No part of this work may be reproduced or transmitted in any form or by any means — graphic, electronic or mechanical — without the prior written permission of the publisher.

NorthWord Press, Inc.
7520 Highway 51
Minocqua, WI 54548

For a free color catalog describing Northword's line of natural history books and gifts call 1-800/336-5666.

Editor-in-chief: Tom Klein

Jacket and book design: Madsen and Kuester, Inc., Minneapolis, MN

Calligraphy: Eric Madsen

Photography editor: Karen J. Altpeter

Printed in United States of America by Graphic Arts Center, Portland, Oregon.

Photographs on the following listed pages copyright © by the National Geographic Society: 14, 21, 24, 29, 60, 61, 63, 67, 77, 81, 99, 124, 125, 128, 133.

Library of Congress Number: 88-620957
ISBN 0-942802-95-0

CONTENTS

"IF ALL THE BEASTS WERE GONE, MEN WOULD

DIE FROM A GREAT LONELINESS OF SPIRIT, FOR

WHATEVER HAPPENS TO THE BEASTS ALSO

HAPPENS TO THE MAN. ALL THINGS ARE

CONNECTED. WHATEVER BEFALLS THE EARTH

BEFALLS THE SONS OF THE EARTH."

Chief Seattle of The Suwamish Tribe from a 1855 letter to
President Franklin Pierce.

ACKNOWLEDGMENT

I would like to thank the following individuals and organizations without whose effort and support this book could never have been realized:

My friend James S. Thornton, a gifted writer, who took the raw material of my experience and lent it eloquence and coherence.

Judy Brandenburg, whose indefatigable spirit always kept the details of this project on track.

Jim Vance, former publisher of the *Worthington Daily Globe*, who gave me my start and inspiration that is still with me today.

Dr. Art Aufderheide, who introduced me to the Arctic.

The *National Geographic*, for permission to publish work, some of which first appeared in their magazine, and especially Robert E. Gilka, former Director of Photography, who gave me what I consider the best job in the world; Editor Wilbur E. Garrett; Thomas R. Kennedy (Director of Photography); Kent J. Kobersteen (Assistant Director of Photography); William Graves (Expeditions); Gerard A. Valerio (Design).

For logistical assistance, Canada's Polar Continental Shelf Project; the Canadian Atmospheric Environment Service; and the gracious staff of the Eureka Weather Station.

L. David Mech, Ph.D., my Ellesmere companion and a true friend of wolves everywhere; my photographic assistant Stephen Durst and my son Anthony Brandenburg, who helped keep me organized back at camp; my daughter Heidi Brandenburg and my assistant Per Breiehagen, who helped keep things organized in Minnesota; Bezal and Terry Jesudason, outfitters extraordinare of Resolute Bay.

And finally the packmates of Ellesmere—Buster, Midback, Mom, Left Shoulder, Scruffy, Lone Ranger, Shaggy, Cloud, and their puppies—who revealed some of their secrets to me.

PROLOGUE

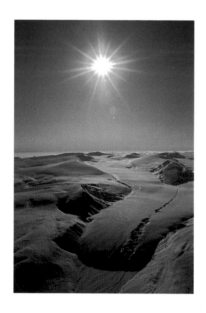

Glaciers glisten beneath a midnight sun on Canada's Ellesmere Island, 500 miles from the North Pole. (Opposite) The leader of the pack surveys his domain from an iceberg throne.

B undled up in my assorted Arctic gear, I must have looked like an abominable snowman. My feet were covered with caribou hide mukluks that reached almost to my knees. On my hands I wore wool-lined deerskin gloves inside giant mittens stitched by Inuit women from beaver skins. My head was crowned with a hat of red fox pelts, a gift from the Chinese when *National Geographic* sent me to do a story on Manchuria.

To imagine that this furry chimera crouching and lumbering across the ice might escape the notice of the wolves was ludicrous. With their extraordinary eyesight, hearing, sense of smell and native wariness, wolves may well be the most perceptive animals on earth. Even so, I could hardly keep myself from sneaking. My heart pounded with excitement: I *knew* I had a shot at a treasure, and my body bowed, almost religiously, to keep from jeopardizing my chances.

Part of this anxiety can be explained by the long history of my quest. For many reasons, wolves are my favorite animal, and for the past two decades I'd been looking for them in Canada, Alaska, northern Minnesota, China, the Soviet Union — all over the world. While I've had dozens of fleeting encounters with wolves, sometimes at extremely close range, I'd managed over 20 years to take only seven photographs of wild wolves. Not one of these pictures had the aesthetics of a great photograph.

One shot might show, for instance, a wolf glaring obscurely from a tangle of bushes. In another shot, the wolf might be hightailing away from my camera. You could get

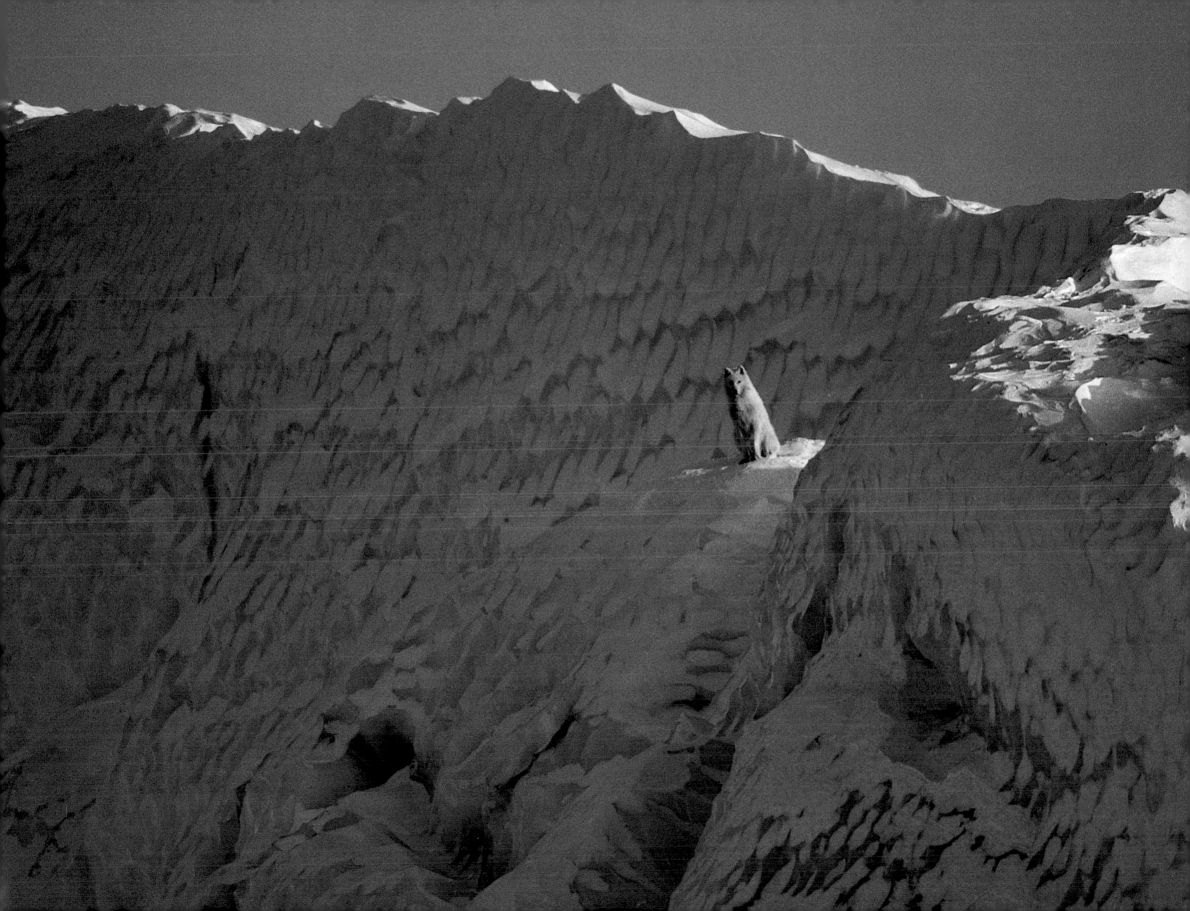

better wolf pictures at a zoo. By contrast, the high Arctic of Ellesmere Island is about as antithetical to a zoo environment as any place on earth. In late April, the habitat is especially surreal. The sun spins around the horizon, ascending a dozen degrees at midday and dipping after midnight to confer a kind of kiss upon the ice. The sun's rays here are always diffuse and soft, imbuing the frozen landscape with the out-of-place warmth of candlelight. Psychological studies have demonstrated the pleasant effect such orange-tinted light has on human viewers. A scene shot in the harsh blue light of day can't compare to the same shot taken during the rich afterglow typical of Ellesmere.

This land of the midnight sun, with its perpetual sunset, is truly a photographer's paradise. But it is a paradise with a price. The air is bitter, with a windchill around minus 80-degrees Fahrenheit, and the snow is so dry and cold it squeaks like Styrofoam under your feet. Offshore, in the fjords and sounds, ancient icebergs loom like hooded giants emerging from the frozen sea. For two months each summer, these crystalline monoliths drift about at random. The rest of the year, they remain shackled in place by eight-foot crusts of ice. During these periods of accessibility by land, Arctic wolves find the icebergs' altitude irresistible. Like many other predators, wolves are attracted to high vantage points. Exactly why is hard to say; they just seem to *like* climbing to the top of things. From the heights, they can survey their territory and keep an eye on new developments.

As a kid growing up on the Minnesota prairie, I could easily relate to the drawing power of a promontory. My homeland near the intersection of Minnesota, South Dakota and Iowa was as flat as a table top with one notable exception—the legendary Blue Mounds, several hundred feet of Sioux quartzite erupting skyward from a surrounding sea of crops and prairie grass. More than a century ago, Indians used to stampede buffalo off its massive summit. No doubt wolves, now extinct on the prairie, once howled there too. Half of my youth, it

seems, was spent exploring this geological wonder. It was where my obsession for wildlife photography started. Using a two-dollar plastic Argus camera, I shot my first fox photograph there.

Perhaps, on some level, the Arctic wolves on Ellesmere felt a similar affection for their iceberg. They certainly spent enough time there, gallivanting about its crannies and fissures, howling with each other, goofing-off, napping. It was nearly midnight when I noticed that the pack had once again taken off for the iceberg. As I carried my cameras through a perfect afterglow toward Eureka Sound, two thoughts kept running through my mind: *This could be the greatest photograph I've ever taken*, and *There is no way you can sneak up on a wolf.*

The leader of the pack was the first to notice my approach. He was big and white, the so-called alpha male, who would lead an attack whenever the pack went hunting for musk oxen. L. David Mech, Ph.D., a wolf biologist and my Ellesmere companion, went so far as to "name" this wolf "Alpha Male." While I used this name in conversation, I preferred to think of him instead as Buster, which was my father's nickname.

Buster's reaction to my approach was not one of fear. He seemed more intrigued, curious, maybe even bemused, as if he were saying to himself, "*That* creature is really trying to sneak up on *me*?" Several dozen yards ahead I spied a six-foot pressure ridge, an eruption of ice formed by frozen plates coming together under pressure. This ridge served as a makeshift tripod upon which I rested my 600 and 300-millimeter lens cameras. The wolves, some 150 yards further away, were scattered across the iceberg, which they had littered with droppings as territorial markers, a *Keep Out* sign to other packs.

After reaching the ridge, I began to shoot photographs frantically. Telephoto lenses require a lot of light, and since the midnight sun was so low and soft, I had to set the shutter speed at 1/30th of a second. At such a slow speed, a photographer's

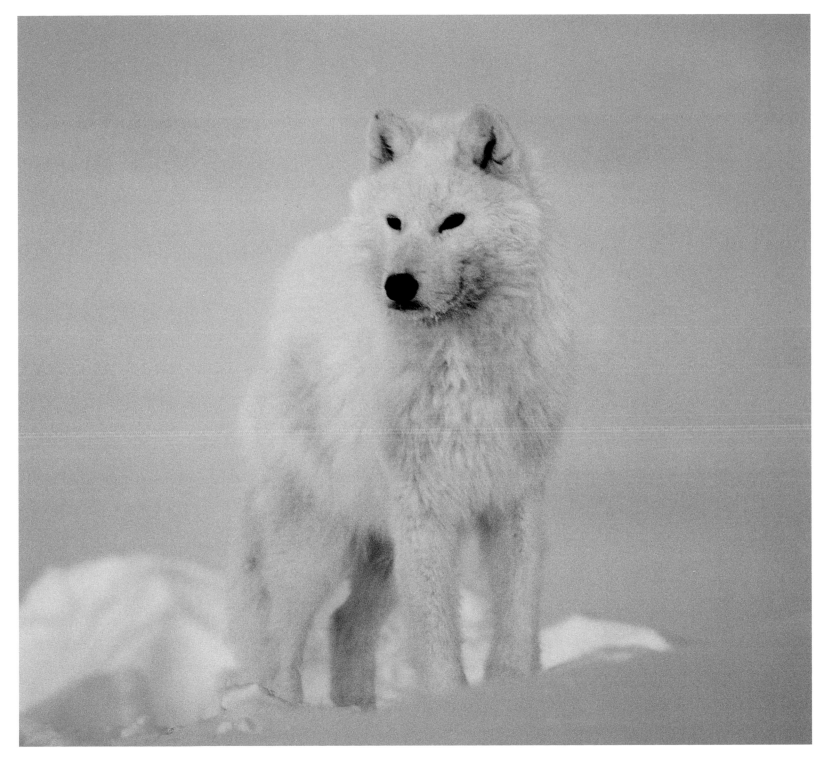

Buster, the Alpha Male, focuses his signature almond-shaped eyes into an icy stare that resonates with the minus-40 temperature. In March, the sun is just reappearing on Ellesmere after five months of perpetual darkness

slightest vibration will cause blurring. My heart, of course, continued to race from excitement and adrenaline. Meanwhile, the wind was gusting to more than 30 miles per hour. In my eagerness to capture the wolf on film, I mixed up my cameras and accidentally exposed a roll of film that I'd neglected to rewind.

I quickly took off my gloves and mittens in the 70-below windchill and reloaded the film, feeling like an Olympic high jumper who discovers, as he takes off on the leap of his career, that his shorts have fallen around his ankles. I pulled my metaphorical pants up and raced through another roll of film, but it was so cold out that the winding speed of the motor drive snapped the film in half. I reloaded and started again, in the process making numerous shutter speed and exposure miscalculations.

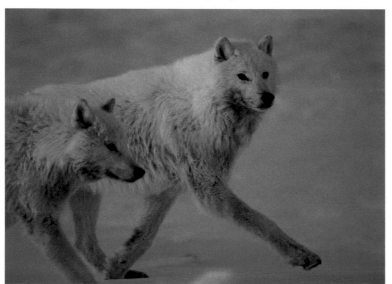

Body language, from cocky to cringing, is a telltale sign of status in the pack. (Opposite) Icebergs, accessible while the sea remains frozen, serve as both lookouts and play-grounds for the wolves.

In the midst of all this, Buster trotted over to a flat projection halfway up the iceberg, and from this makeshift throne he eyed me with a mixture of wariness and bemusement. A solitary shaft of light slanted sharply from the northern horizon, illuminating the wolf while leaving the surrounding iceberg in blue, muted shadow. It was the most exquisite composition nature had ever provided me. Even the texture of the background was perfect: a regular pattern of toothy grooves, chiseled by the summer sun and wind and filled during winter by repeated dustings of snow.

Buster sat there, in that perfect spot, for no more than 30 seconds. Afterwards, he and the rest of the wolves jogged about the iceberg, playing tag and cavorting. It was a rare moment; I knew that the image of the lone wolf, if it worked, would be the most treasured photograph of my career.

I forwarded the film to my editors at *National Geographic* for processing, nervous and pessimistic about the outcome. Did the wind shake the lens at the last second? Were the f-stops miscalculated? Were the wolf's eyes open, or did I catch him blinking at the instant I snapped the shutter?

Evocative memory and photography are often at odds. Memory tends to improve an image over time; with photographs, all the wishful thinking and nostalgia in the world cannot alter the truth the emulsion has captured. When the iceberg shots were finally processed, I called Kent Kobersteen, my photo editor in Washington, D.C., to hear the results. Like a nervous parent counting the fingers and toes of his newborn child, I rattled off my questions: What were the exposures like? Were they sharp? *How did they look?*

Though it seemed as if I had taken dozens of shots of the lone wolf, there were, in fact, only six photographs of him. Only one turned out the way I had hoped it might. Perhaps it is the tenuousness of this image, the fact that I came so close to missing it altogether, that makes me value the photograph so greatly.

Good photographs, like wolves, are elusive; good photographs *of* wolves could define elusiveness. It was a humbling realization, but a challenge too—one that would inspire me in the long months to come.

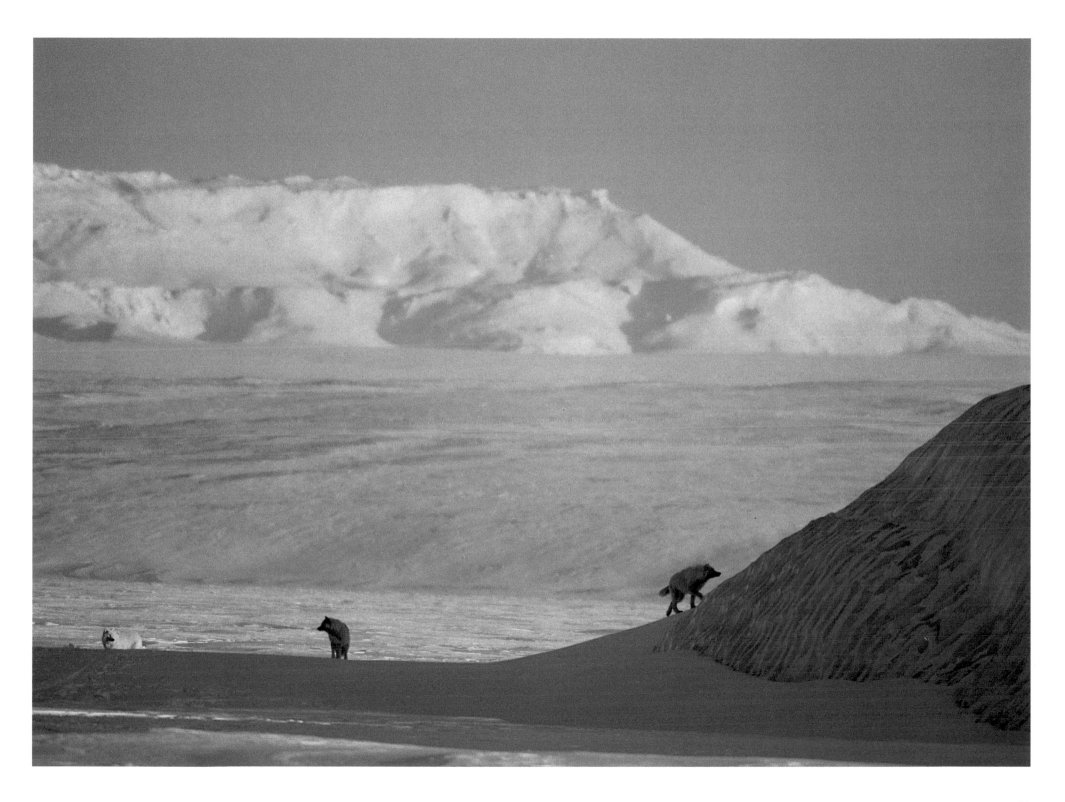

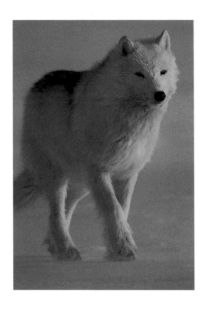

Midback, the Alpha Female and the best hunter in the pack, moves with surety and deliberation. In her wake, she leaves a windblown signature in the snow.

T he road that led me to the Arctic wolves was hardly a straight one. My home in northern Minnesota is on the fringe of the Boundary Waters Canoe Area Wilderness, the last significant refuge of wild wolves in the 48 continental states. The nearest source of supplies is the town of Ely, about a half-hour from my house. One day about four years ago, I drove to Ely on my weekly grocery run and noticed a very determined-looking fellow heading toward the woods with what appeared to be a month's worth of supplies in a huge backpack. My friend Steve Piragis, an Ely outfitter, told me that this guy was Will Steger.

I'd already heard the stories about Steger's compound in the woods, where he was training sled dogs to help him accomplish his dream: a re-enactment of Robert Peary's unsupported North Pole assault. I had a long-standing interest in the Arctic, having spent one long winter documenting the difficult lives of a hunting band of Canadian Inuits. After Steve introduced us, we headed into one of Ely's ubiquitous bars to discuss the opportunity for a symbiotic working relationship.

In the course of our conversation, Steger told me a story that captured my imagination even more than his planned North Pole journey. Two summers earlier, he had taken a trip to Ellesmere Island, hoping to travel by dog sled from one end to the other before the brief summer melted winter's shallow blanket of snow. About halfway across the island, he "ran out of winter" and was forced to continue his trek on foot. One night, two Arctic wolves appeared out of nowhere and began

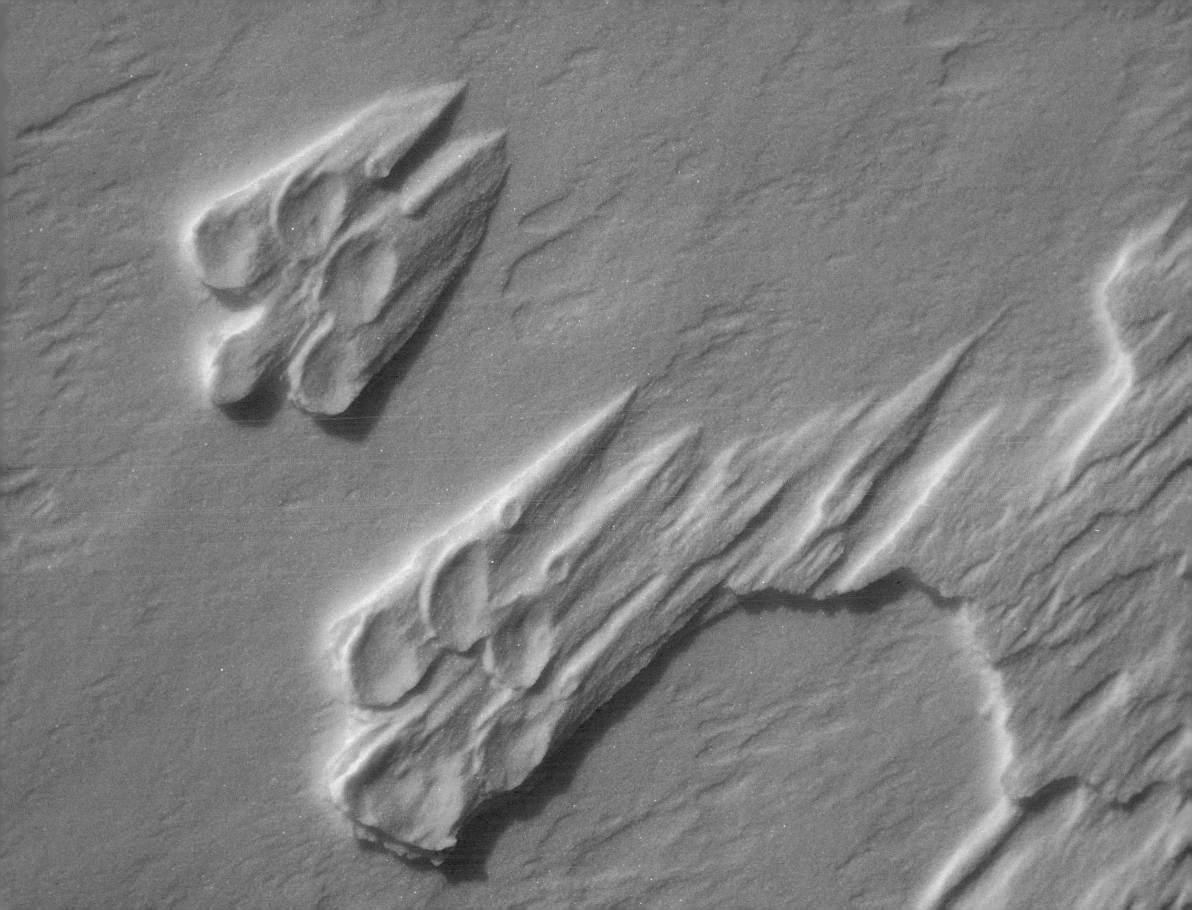

Ellesmere Island is a vast, lonely land whose inhabitants must struggle to eke out a living. Wolves are tireless travelers who roam the thousands of square miles of their territory in search of prey.

to play with the sled dogs. On another occasion, a white wolf actually stuck his head into Steger's tent!

I knew instantly that I had to go to Ellesmere. Wolves that live near populated areas are always extremely fearful of people, and for good reason. During the last few centuries, our species has dedicated itself to exterminating theirs. After 20 years of unsuccessfully trying to photograph timber wolves, I was thrilled to think that a pack without an ingrained fear of man might exist somewhere. Steger's sled dogs, I thought, must be the key—they had somehow lured the wolves in. If only I could travel to Ellesmere with a couple of dogs, I might be able to create the photographic opportunity of a lifetime.

After our discussion, I agreed to lobby for Steger's North Pole proposal with my editors at *National Geographic*. The magazine seemed a natural for the endeavor, since it had backed Peary himself 80 years earlier. The editors saw the project's potential and agreed to provide support. I would shoot the story. In the back of my mind, I resolved to be on the lookout for a chance encounter with an Arctic wolf.

The launching point for Steger's assault on the Pole was the northern tip of Ellesmere Island. Many Americans think Alaska is the most northerly part of North America, but Ellesmere, an island about the size of Nebraska located in Canada's Northwest Territories, is actually several hundred miles north of Alaska's northern tip. To give another perspective, Washington, D.C. is as close to Ellesmere as it is to Brazil.

From Ellesmere's tip to the North Pole measures some 500 miles across the Arctic Ocean. During the winter, and for the first 50 or so days of "spring," such as it is, the water is frozen six to eight feet thick most of the way to the Pole. Unfortunately, even during the best of conditions, this ice has little in common with the glassy ice familiar to figure skaters and cocktail enthusiasts.

Across its craggy, snow-blown surface, the ice cap is wrinkled with pressure ridges. These erupt in endless labyrinthine walls that can make forward progress an agonizing,

Sisyphean exercise. Even more treacherous are the frequent "leads"—yawning cracks in the ice that reveal open sea water. When a team of mushers encounters a lead, they have no choice but to circumnavigate it or wait for the minus 70-degree air to refreeze the brine and create the several inches of rubbery ice needed to support a sled loaded with supplies.

In 1909, the legendary Peary with his men and dogs braved this unforgiving habitat, aided by an army of Inuit assistants. But ever since Peary's North Pole adventure, which took place without external resupply, there has been rampant speculation as to whether he *really* reached the Pole. The reason for the controversy is largely climatological. Peary's expedition began in early March, when the sun momentarily rises above the Arctic horizon for the first time in four months. Peary had only about seven weeks to make it to the Pole and back to land before the ice cap break-up, a period many scholars consider impossibly short.

Steger and co-leader Paul Schurke were determined to try a second, unsupported trip to the Pole, putting the debate to rest, one way or the other. Before the Steger team could even begin, however, they had to get their expedition to the departure point, no small ordeal. Sleds, dogs, crew members and tons of supplies all had to be carried, by a succession of ever smaller aircraft, to the tip of Ellesmere Island in time for an Ides-of-March send-off.

The traditional first stop for all expeditioners is Resolute Bay in the Northwest Territories, the most northerly spot serviced by commercial airlines. From there, Arctic dreamers must cart their supplies several hours further north to Eureka Sound, where a permanent weather station is manned by a dozen men. To reach Eureka, it's necessary to charter 748s, DC-3s, or Twin Otters, the smallish, highly maneuverable aircraft with skis for wheels, "the workhorses of the Arctic." Finally, to traverse the approximately 300 miles from Eureka to northern Ellesmere, expeditioners and their gear are ferried by Twin Otters.

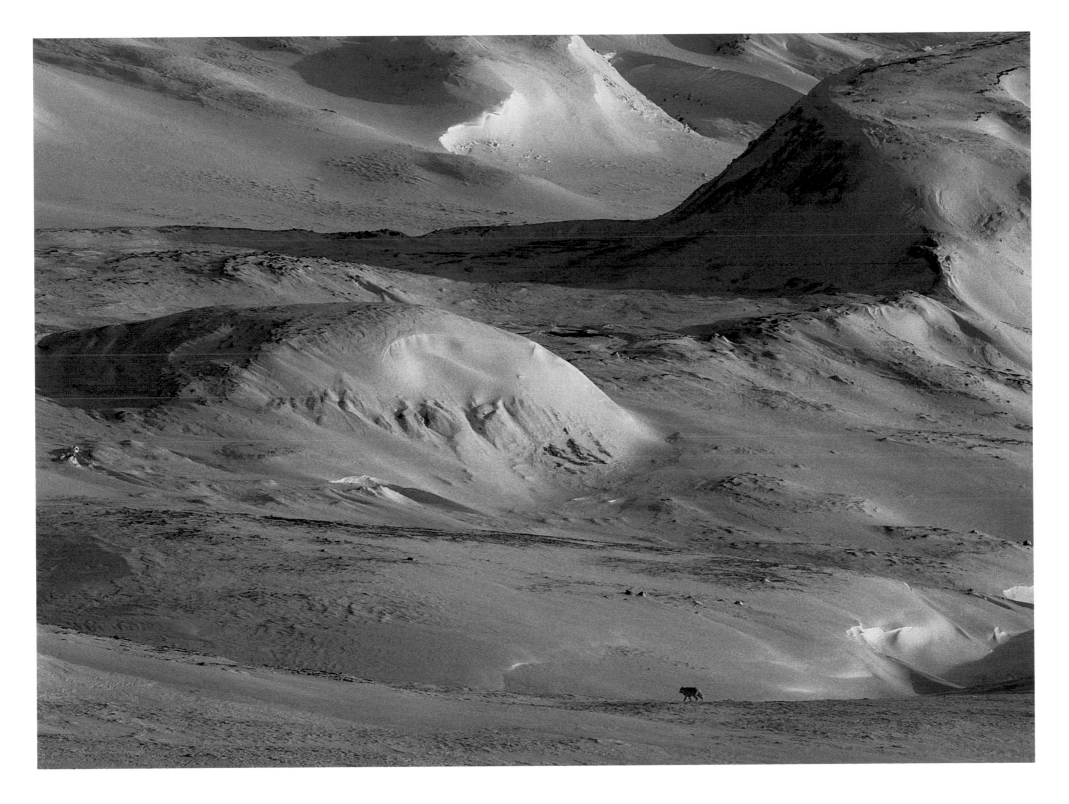

In early March, Resolute Bay is hardly the pristine, Jack Londonesque setting one might expect. Eccentric characters from around the globe gather in preparation for myriad assaults on the Pole, most of which are "supported" by frequent airlifts of supplies. An East Indian entrepreneur named Bezal Jesudason years ago saw the possibilities inherent in a supply outpost catering not only to the wealthy, globe-hopping set, but also to the oil company laborers, Inuits, weather station personnel and Canadian government bureaucrats who live and work in the Arctic. For the past 15 years, Bezal and his wife Terry have operated what I like to call their High Arctic Bed & Breakfast. As proprietors of this outpost, Bezal and Terry are an invaluable resource to almost everyone headed to the Pole.

I was no exception. Bezal outfitted me with equipment, taught me what to expect, put me up, fed me, and kept me in a fine mood with his good humor. Bezal never had to look far for sources of amusement. On one of my first flights from Montreal to Resolute Bay, I found the plane jammed with not only Steger people but a coterie of millionaires who would each be paying five-figure fees to be airlifted to the Pole for a 20-minute champagne toast. The plane was so crowded that there was only one open seat. I was wearing grungy Arctic gear and hadn't shaved; as I headed for the empty seat, I felt sorry for whoever would be my hapless seating companion over the eight-hour flight. I sat down in the only empty seat and looked over at my fellow traveler, who turned out to be a beautiful French film star. In my work for the *Geographic*, I've flown to exotic places all over the world. Of all the times and places to meet a beautiful movie star, it would have to be when I was dressed like a derelict who smelled like a musk ox. C'est la vie, I suppose.

Bezal, who plans to open a North Pole museum one day, has had guests who have tried to reach the Pole by foot, motorcycle, snowmobile and ultralight plane; presumably, a team will attempt it someday while pushing baby buggies. France, moreover, is not the only nation to send its movie stars to

Bezal's. In the room adjacent to mine, a Japanese starlet spent her days knitting and growing indoor herbs. Every spring she traveled to Bezal's to escape pressures of her profession and to gear up for a planned trip to the Pole via snowmobile.

In another nearby room, I could hear a northern European fellow talking into a telephone at night to an Italian radio station. He had told his audience that he would make it to the Pole. However, five miles out, he'd broken his arm and returned to Bezal's to recuperate. Naturally, he neglected to mention this setback to his listeners. Every night, from the comfort of an easy chair, his voice crackled with adventure and heroic intrigue as he recounted yet another day's "progress" toward glory.

After a week in this carnival atmosphere, the relative isolation of Eureka was a relief. The weather station, surrounded by what is in essence a frozen desert, made me think of what life must be like on a space station. My fellow inhabitants were all technicians whose lives revolved around the collecting of data and the combating of boredom. They drank, ate, slept, thought about meteorology, played cards, watched satellite TV and looked forward to an occasional risque video cassette. Depression was a problem, especially during the long months without sunshine.

The Eureka personnel rarely took advantage of the natural world outside. To be sure, the winter environment is about as hospitable to human flesh as outer space: a half-hour without your proper "space suit" and you will almost certainly expire. Still, after a few days at the station waiting out expeditionary snafus, I felt myself getting extremely jumpy from boredom and claustrophobia. For three days in a row, I had whiled away the hours by aiming my binoculars through the murky blue twilight at a distant herd of musk oxen, which looked like raisins in the snow. I thought it might be fun to take a closer look.

Bob McKerrow, a Steger team member from New Zealand, agreed to go along. We assumed the herd was very close,

A howling pack builds an acoustic wall to warn neighboring packs to stay out of their territory. Howls also allow separated packmates to communicate with one another across miles of cold twilight.

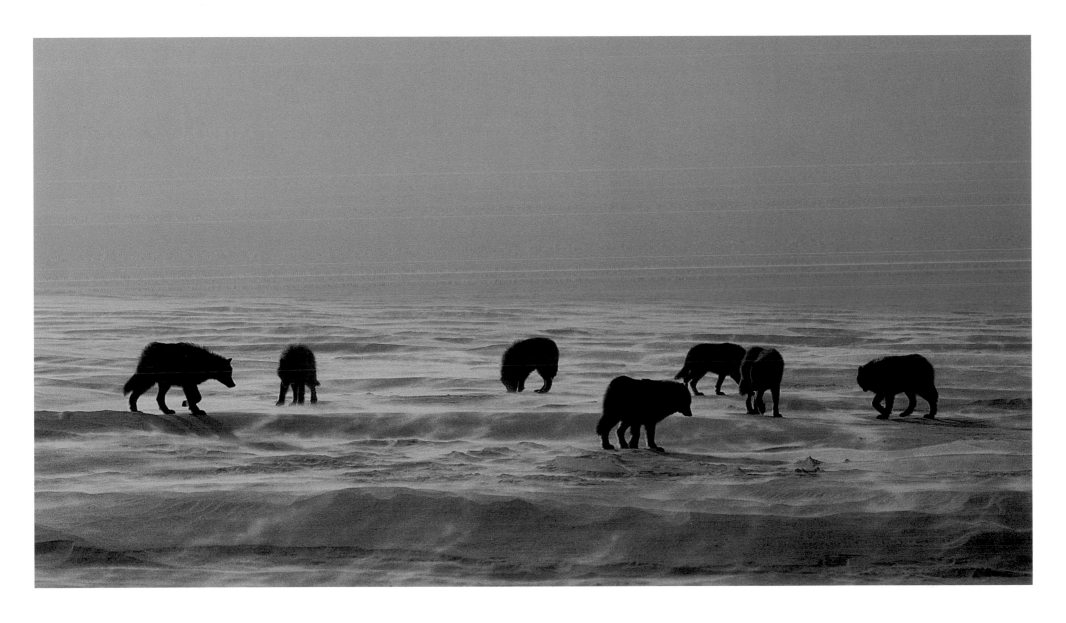

but after a half-hour of steady hiking, we realized that they were at least four miles away from the station. Lacking any experience with the animals, we approached with great caution. There are no trees to climb in the high Arctic, and we felt quite certain that the horns and hooves of an adult musk ox could make short work of us. As we came closer, the magnificent ancient beasts, living remnants from the Stone Age, came into sharper focus.

Having grown up on the prairie, I had expected musk oxen to be similar in size to buffalo. In reality, they are much smaller—about the size of cows, though they are more closely related to goats than to cattle. With their sure-footed hooves, they have little trouble scrambling along rocky precipices.

I could see the animals' extremely long guard hairs, almost a yard in length. Thanks to these hairs, which are prized for yarn, as well as their highly insulated undercoats, musk oxen are never affected by the cold, no matter how low the temperature drops. Noting their indifference to the climate, it occurred to me for the first of many times in the Arctic how nice it would be to have a little more hair myself.

At one point, we evidently got a little too close to the herd, because they quickly assumed their classic protective circle: a phalanx of horns and front hooves radiating at every point on the circumference, flanks shoved together at the center. This strategy, evolved over eons of living in a treeless environment, is a very effective way to protect the young against Arctic wolves, the major predator of musk oxen. It is not so effective against human predators like the Inuits who found the musk oxen relatively easy to kill.

McKerrow and I backed off and the musk oxen resumed their grazing, pawing holes in the snow to get at the frozen grass and sedge below. We studied them for hours, until finally cold and fatigue got the better of us and we decided to begin the long hike back to the station. The sun at this time of year lurks just below the horizon for most of the day, creating a kind of permanent blue dusk. On the way back, I trailed behind, taking photographs of the landscape. McKerrow was about a quarter-mile ahead when it happened.

A pack of six Arctic wolves, trotting in a direct line of march over a nearby rise, appeared like ghosts materializing from the blue ether. At first, I thought I must be hallucinating from cold, hunger and fatigue. Three of them split to my left. Three others swung around to a steep embankment that flanked a nearby frozen creek. They trotted to the top and sat there, eyeing me, their bodies silhouetted against the murky horizon. One wolf, which I thought might be the leader of the pack, sat on the ridge and inspected me with a kind of fearless, bemused curiosity. Much later, when I returned to search for a pack to live with and photograph, I would remember this individual wolf and be convinced he was the same alpha male I would come to know as Buster.

At that moment, however, I was not thinking about the future. I was, to say the least, flabbergasted. Reflexively, I pulled out my camera and began shooting photograph after photograph. It was at this moment that I first learned the difficulties of shooting in the Arctic when you are excited. The combination of exhaustion and exhilaration makes huffing and puffing inevitable, and one breath on the viewfinder enamels the glass with a 1/16th-inch coating of ice. This must be scraped off with your fingernail, which means removing your two sets of gloves, which means freezing your fingers.

After scrutinizing me for several minutes, the wolves stood up and resumed their pursuit of the musk oxen. Suddenly realizing that I might be able to capture wolves and their natural prey in the same photographic frame, I turned around and raced after them as best I could. A weary biped is no match for a species superbly adapted to the Arctic.

The paws of a wolf are large, and they can splay their toes so wide that their tracks in the snow almost resemble human handprints. Their weight is distributed evenly across the snow, so they can walk on top of the crust. In my mukluks, I was breaking through on every other step. After 20 minutes, I

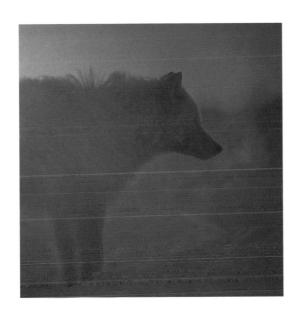

*During the author's
first contact with the
wolves, Buster leads his
packmates on a bee-line
to a musk ox herd.
Buster's breath hints
at the bitter cold of
late winter.*

was exhausted. As the dusk deepened, I snapped a few last shots of the distant wolves approaching the even more distant musk oxen. Then, with muscles aching, I turned back to catch up with McKerrow. When we were a half-hour away from the weather station, a Twin Otter flew overhead and dipped its wings—a not-so-subtle sign of concern and a reminder it was time to come in from the cold.

Back at the station, my mind reeled with wolf images. I'd been wrong in my interpretation of Will Steger's Ellesmere anecdote: sled dogs would not be necessary to lure wolves. Evidently the wolves' own curiosity, fueled by the absence of unpleasant experiences with humans in this remote corner of the world, was enough to allow some close encounters with the pack.

A few days later, we flew to Ward Hunt Island and waited for the first glimmer of sun to inaugurate Will's trek. On March 5, the sun appeared for a few moments on the horizon and winked at us before dipping down again below the earth's rim. This was the signal to begin, and off Steger and company went, in a cacophony of canine barks and human cheers that would soon turn to grunts. I was on hand to photograph the departure, and then flew back south by Twin Otter to Eureka.

At three points during the expedition, a Twin Otter was scheduled to fly in and airlift out sled dogs, a humanitarian alternative to Peary's policy of eating any dog no longer needed to pull supplies. The plane, of course, would *not* bring any supplies to the expedition. The *Geographic* had arranged for me to fly on these trips to photograph the team's progress.

In between shoots, I found myself with time on my hands and thoughts of wolves on my mind. I flew from Eureka to Resolute Bay and from there to Washington, D.C., where *National Geographic* has its editorial offices. For years I had been discussing with various editors the possibility of shooting a wolf story if ever a suitable opportunity arose. Ellesmere seemed ideal. But I had scarcely started in with my proposal when I was told that the *Geographic* had already commissioned a wolf story.

So I suggested instead a story I had proposed ten years earlier. The idea was to photograph the white animals of Ellesmere: Arctic fox, Peary caribou, hares, weasels, snowy owls, ptarmigan, polar bears, beluga whales, wolves. When I first suggested this story, I'd been turned down because of the expense of sending a rookie to such a remote place. Now, with time on my hands and the expenses already incurred whether I did extra work or not, *Geographic* editor, Bill Garrett, decided that it only made sense to go for a "two-fer." The white wolves, I figured, might be an interesting sidelight to this larger story.

In the end, Steger and his team would make it to the Pole in triumph, and their exploits would be celebrated in a *Geographic* cover story. The Ellesmere piece, with its well-detailed depiction of an exotic habitat, would also prove quite popular. But the wolf story, which evolved into a several-year obsession, would prove the most significant work of my career.

Packmates often indulge in play and roughhouse—behavior that takes on a heightened intensity during mating season. (Opposite) During five months of constant light, the wolves sleep whenever the urge strikes them.

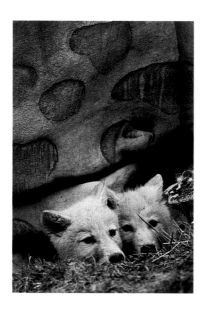

A couple of youngsters squeeze through the back door of the den. (Opposite) Scruffy, a yearling male with a namesake messy coat, baby-sits puppies by the den's entrance.

wo questions immediately come to mind when you are trying to photograph a wolf pack. First, how do you find a pack? And second, assuming you find one, will the pack members accept your presence without altering their behavior?

As soon as the *Geographic* had given me the nod to do an Ellesmere story, I called up fellow Minnesotan, L. David Mech, a wolf scientist and author of *The Wolf: The Ecology and Behavior of an Endangered Species* (University of Minnesota Press, 1970). Over the 18 years we'd known each other, Mech and I had always hoped to find a wolf situation that might lend itself to a successful integration of science and photographic aesthetics. In Minnesota, the latter component had simply proved impossible. Not only are the wolves extremely shy and elusive, but the dense spruce and aspen terrain make unobstructed photographs nearly unattainable.

The one occasion in 20 years when I actually had a chance to photograph a wild Minnesota wolf in the open illustrates some of the problems of wolf photography in even a best-case scenario. It happened several years ago when I was snowshoeing across a frozen lake near my home in Ely.

A large male timber wolf emerged from the forest a hundred yards away. With the wind blowing from his direction, he was unable to catch my scent. It was a rare instance where I saw the wolf before the wolf saw me. Immediately, I pitched myself forward in the deep snow and remained motionless. Within seconds, of course, he spotted a peculiar, out-of-place lump in his otherwise pristine domain. The wolf assumed a

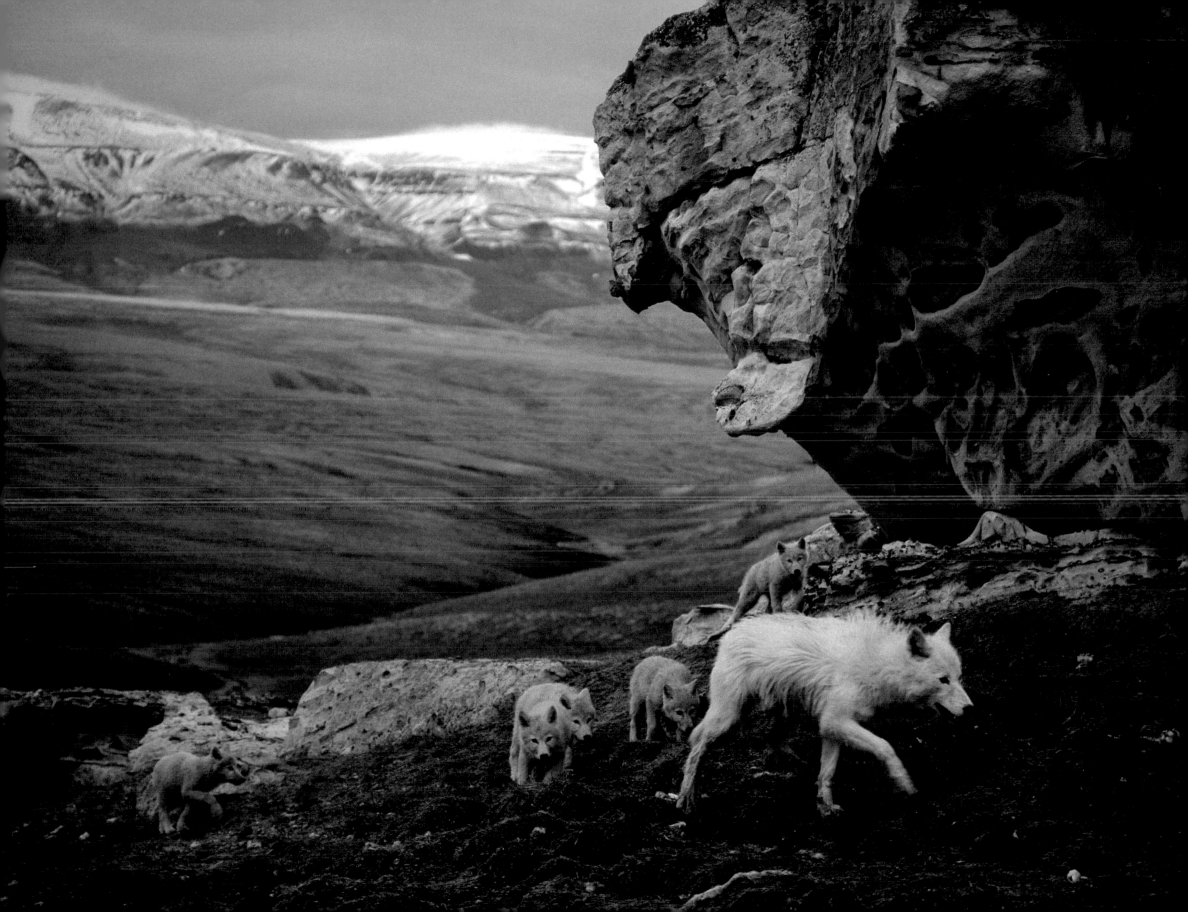

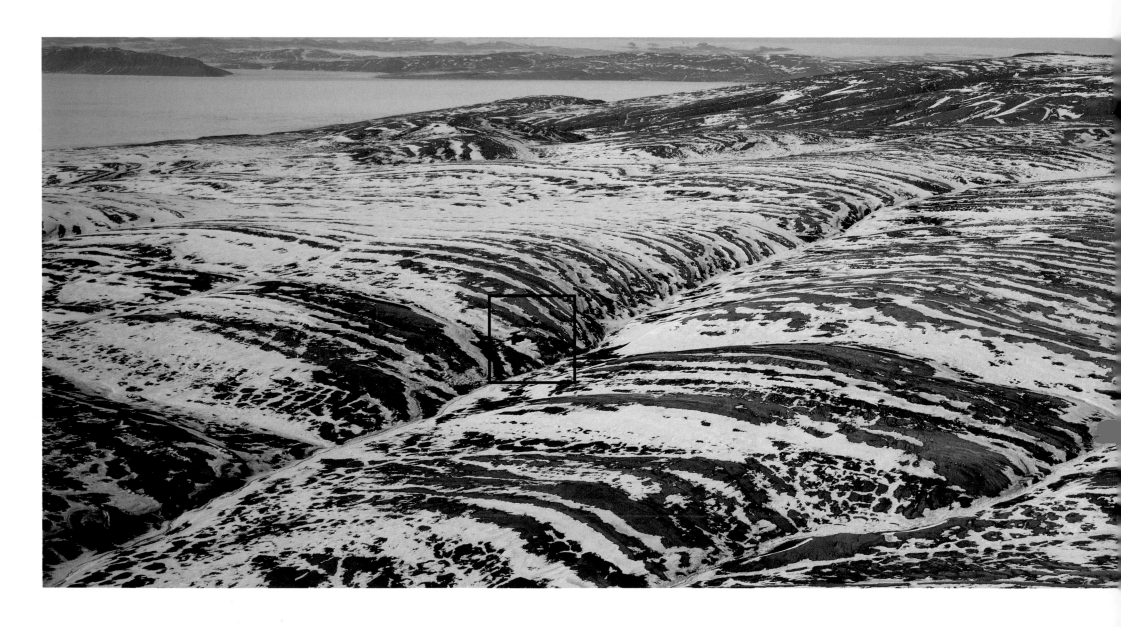

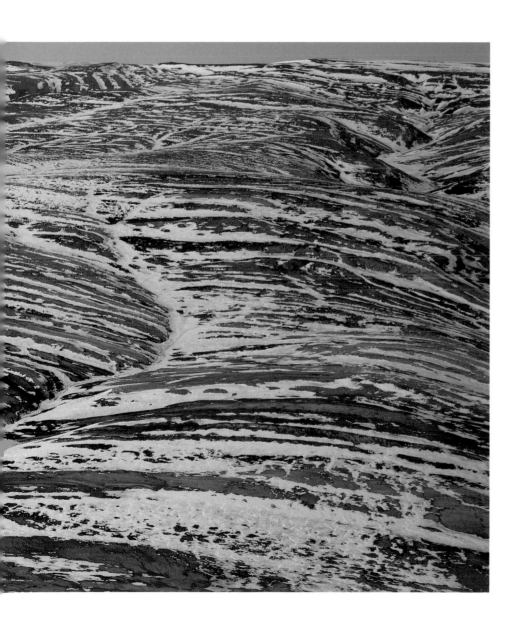

An aerial photo taken at the end of May suggests the enormity of the landscape. The inset square defines the den site. In the distance is Eureka Fjord, which the wolves often patrol in search of seals and other prey.

A close-up aerial shows Mom, the newborn puppies' mother, attending the entrance to the den.

27

crouch. For the next ten minutes, with his ears cocked forward like radar sensors, he stalked me. I remained perfectly still as he moved closer and closer. Finally, when he had approached to within 30 yards, I started taking photographs.

At this point, most animals would run like crazy. The wolf's reaction, however, was as different as it was unexpected. I hesitate to anthropomorphize, but the only word I could think of to describe his response was *embarrassment*. He didn't run, he just turned broadside to me, never once showing the slightest fear. Then, very slowly, as if trying to salvage some dignity after being hoodwinked by a human ape he'd perhaps mistaken for a moose carcass, he walked back to the forest edge and disappeared.

The photographs of this episode turned out terribly. Because of the angle of the wolf's approach and retreat, I had to shoot directly into the sun. Moreover, the wolf was wearing a prominent radio collar that seemed about as natural on him as a wristwatch. The photographs were never published.

Fortunately, the situation in the high Arctic promised to be vastly different. My single experience with them had already taught me that the Arctic wolves, at least in this region, were not yet afraid of humans. Equally important from a photographer's point of view, the largest trees on much of Ellesmere are the Arctic willows: ten-inch botanical midgets whose trunks grow parallel to the ground to foil the constant wind. A 50-year-old Arctic willow might have a trunk no thicker than a child's finger; I'd like to see a sheepish wolf try to hide behind one.

I returned to Ellesmere in April to look for wolves while simultaneously working on the "white animals of Ellesmere" story. During this trip, I made numerous contacts with a pack of seven adults, six of whom were almost certainly the same wolves whose path I had intersected earlier. Over time, they became habituated to my presence, almost to the point where they ignored me — an ideal state of affairs. In early June, Mech agreed to return to Ellesmere and search for the pack's den.

Since the wolves were almost certain to lead him right to it, it was a relatively easy assignment.

Except for a period of denning in the spring, wolf study can be extraordinarily difficult. For most of the year, a pack roams over its entire territory, which can be thousands of square miles. Each spring, however, the mother must take to the den to have her pups, while the rest of the pack remains nearby to help bring food to the pups after they are born. For a couple brief months, then, the pack is focused geographically.

Compared to the nearly impossible task of finding a wolf den in forested country, finding the Ellesmere den was easy. Mech and I immediately realized that this den would provide an excellent observatory for wolf behavior — assuming that our presence during this sensitive time did not cause the wolves to prematurely abandon their temporary home. I also knew the den would provide a superb backdrop for wolf portraiture.

Because the Arctic permafrost makes digging deep into the ground almost impossible, good wolf den sites are rare and extremely valued by a pack. This den looked as if it had been used by wolves for hundreds, perhaps thousands, of years. Such allegiance was understandable, for the den was almost perfect: a kind of Frank Lloyd Wright masterpiece of canine real estate set high on a hill.

It was probably formed by a glacial retreat. A broad sedimentary rock outcropping provided what was in essence a porch that funneled down into an entrance into the earth just large enough to accommodate a pregnant wolf. A hungry polar bear, in other words, could not squeeze in to make a snack out of the growing pups. Inside, an immaculate, bug-free layer of sand covered the ground well into a 20-foot cave. The rock walls offered protection from the bitter cold of spring and the occasional heat of summer.

Outside the den, high on the outcropping that formed the porch, a snow bunting had built its annual nest in a small cranny. Evidently, the bunting and its ancestors also preferred this setting. Scratch marks had been etched into the sandstone

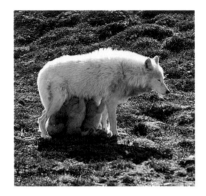

Mom stands patiently as her five-week-old progeny fatten up. When a little older, the puppies become keen students of their environment, scrutinizing the panorama beneath the den.

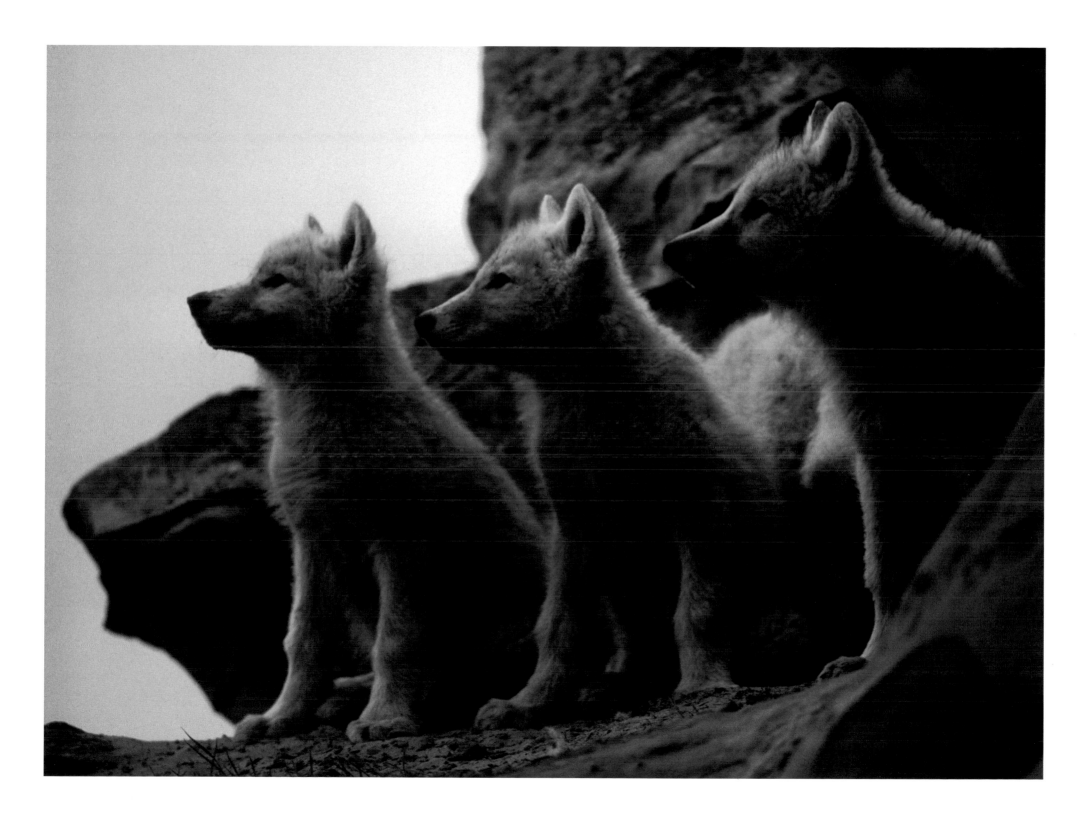

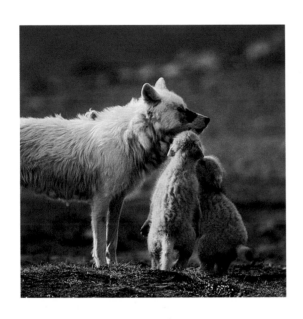

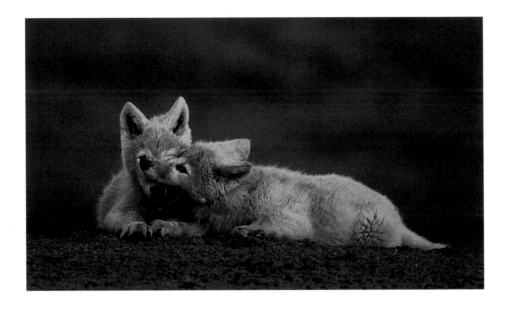

The puppies yip and
whine, beseeching
Buster for attention.
This behavior can
trigger a recently-fed
adult into regurgitating
chunks of prey for the
puppies to eat.

The constant playful-
ness of puppies belies
an early and earnest
struggle for dominance.
(Opposite) Scruffy
stands on the rooftop
of the den.

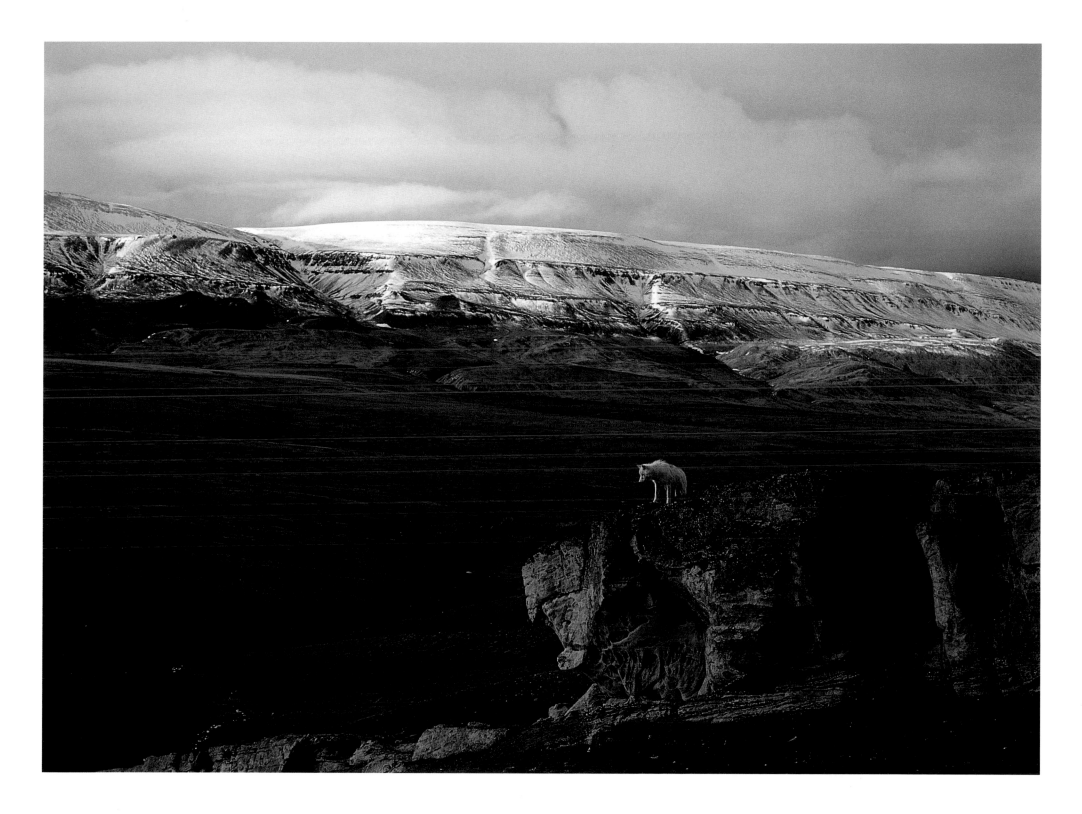

by generations of wolves unable to quite reach the meal that nested each year above them.

Of all the features of the den site, though, none so appealed to my photographic sensibilities as the spectacular view from the porch. Often the pack members would clamber up to rest atop the overhang and survey their territory. The vista extended for miles to the east and the northeast; the view was stunning in its primeval majesty. In the distance, herds of musk oxen often passed in parade to graze against a backdrop of greening sedges and yellow Arctic poppies. Two streams cut through the rugged terrain. Across a low plain, snow-capped mountains serrated the sky. Off the Arctic Ocean to the west, an incessant damp wind made the constant 40-degree Fahrenheit temperature seem a little colder. Despite the constant breeze, the landscape was almost preternaturally silent.

The only evidence of humanity was an occasional jet contrail from a British Airways, Lufthansa or SAS airliner, describing a perfect arc from Europe to Asia. This lone juxtaposition of high technology and the ancientness of the earth would sometimes take my breath away.

During the initial, investigative phase of our trip, we had not yet set up a permanent campsite. Since gray wolves have been reported to move their young if the den site is discovered by humans, we wanted to avoid stressing this pack in any way. We approached the den cautiously, alert to any signs that our presence might be causing consternation. The wolves never appeared overly nervous or bothered, though on one occasion the alpha female did sound several quick barks—a signal of alarm. We quickly retreated.

Pups, when they are very young, have great difficulty maintaining an even body temperature, so they spend their first weeks inside the den huddled around their mother for warmth. We had been eagerly anticipating our first look at them, and it proved well worth the wait. There were six puppies, cute little gray bundles of fur waddling around,

Day and night all summer long, the light in the high Arctic slants in from the horizon. A photographer can work any time during the 24-hour cycle.

seemingly discombobulated by the wide world. I estimated their age to be about five weeks.

Just a few minutes after we sighted them through our binoculars, the adults began to lead them across the hummocky tundra. The older wolves nudged and yipped at the pups, who tumbled and scrambled forward on their stubby legs. The little ones looked in the distance like a string of pearls. The adults continued to patiently urge them forward for about a quarter of a mile down a long slope and then across an open plain toward a pile of rocks.

All the while, the pups stumbled gamely forward on their short, fuzzy legs and oversized paws. It seemed miraculous to think that by winter they'd be running alongside their parents. For now, the puppies appeared to find their first taste of the roaming life both enjoyable and exhausting.

Throughout this migration, my feelings were mixed. On the one hand, my first look at the pups triggered an instant ecstasy. My mind reeled with the photographic possibilities. On the other hand, I felt an ineradicable sense of alarm. Why were the pups being moved? Was it possible that our presence had so disturbed the adults that they were changing dens?

The adults' motives would not become clear for several days. Meanwhile, much to my chagrin, a less-than-stunning rock pile became the new den. The pile of rocks contained numerous cavities too small for the adults but easily large enough for a bundle of puppies to crawl into. They proceeded to do so, tangling themselves into one large writhing ball of puppy fur, and fell asleep.

We had to decide our next move. Had we indeed agitated them into making the move, or was our presence merely coincidental to it? In my egocentric human guilt, the latter seemed unlikely. Still, scientists have long known that wolves will sometimes change dens temporarily as a means of ridding themselves of certain parasites, insects or other vermin. They travel to a new den that is free of such nuisances, while back at the original home, the pests eventually die off without hosts

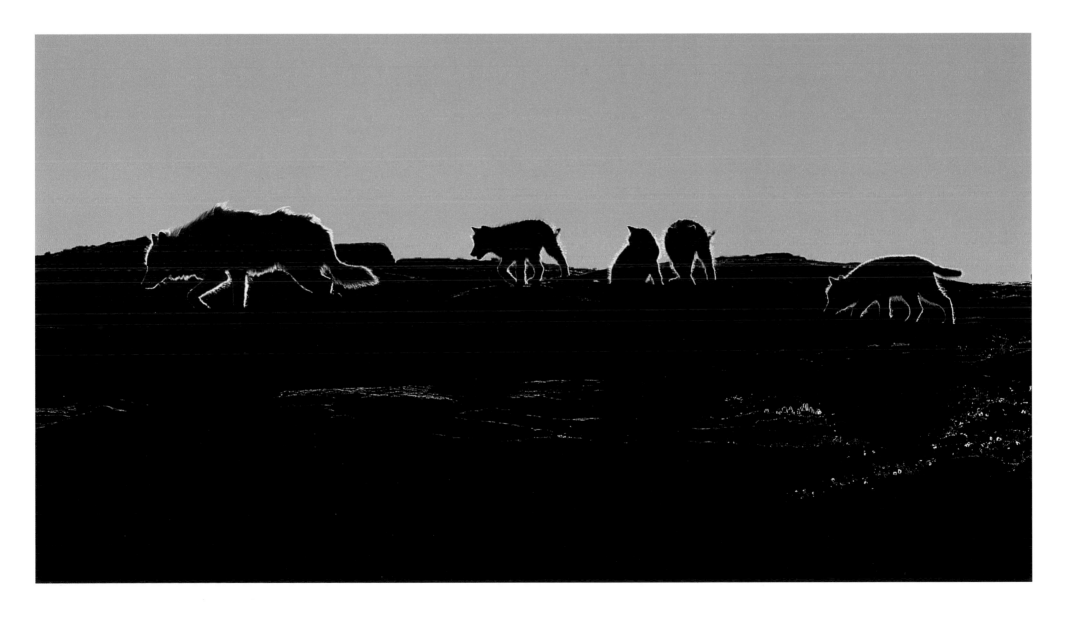

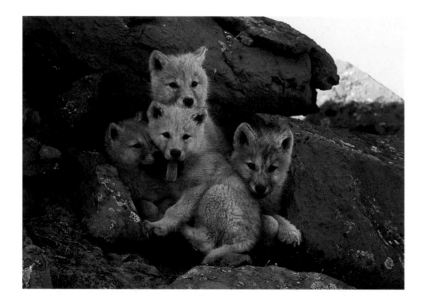

For two weeks, the wolves abandoned their classic den, presumably to allow parasites and other pests to die in the absence of warm-blooded hosts. The substitute den is a rock pile with cavities just large enough for the puppies to wriggle inside for shelter.

to support them. I found myself praying this would be the explanation—though part of me feared such thoughts were wishful thinking.

Even after the move, however, the adult wolves seemed unfazed by our presence. Admittedly, such an intuition on my part would be difficult to prove, but I am no stranger to canine behavior, and these animals simply weren't acting like creatures under stress. We decided to bide our time and see what would happen next.

We didn't have to wait long. The next day I set up a camera about 50 yards from the rock pile and was shooting photographs of the writhing ball of pups. All seven adults looked in my direction, stretched, howled a few times at the sky, and took off on a hunt. I couldn't believe it: not one adult stayed behind to bark at us and keep us at bay. They had left their precious offspring totally unguarded with us in full view a mere 50 yards away!

Never in the months of planning for this trip and conjecturing as to what I might find at a wolf den, never, indeed, in my wildest dreams, had I imagined the wolves would leave us alone with their pups. I was astounded at first, and then deeply moved. After 20 years of trying to get close to wolves, I felt at once a profound sense of privilege and an exhilaration at what the future might bring. Clearly, the wolves had not changed dens because they mistrusted us. It *had* been a coincidence. Now I could proceed in full confidence with my photography.

The wolves returned from their hunt several hours later. Within a few weeks, they would move the pups a second time, back to the original den. Though obviously they did not do this to appease my photographer's sensibilities, I had to thank them for the inadvertent kindness.

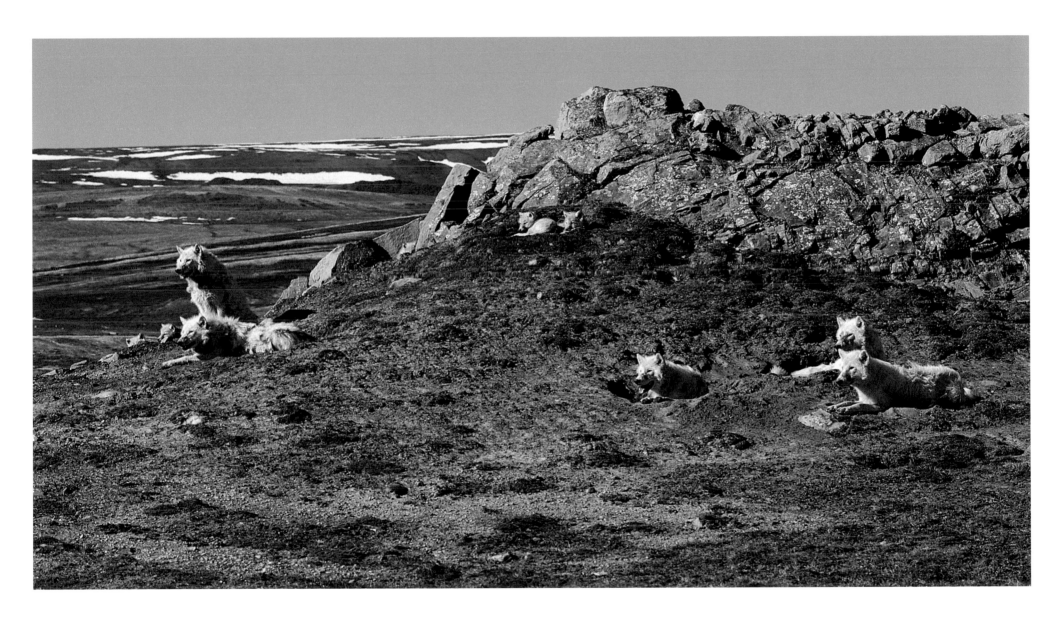

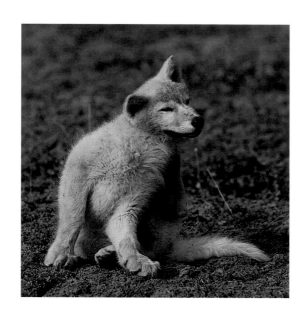 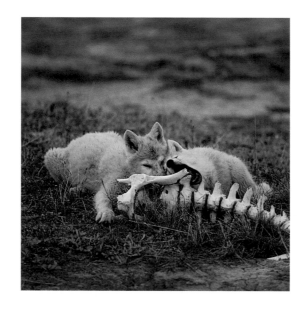 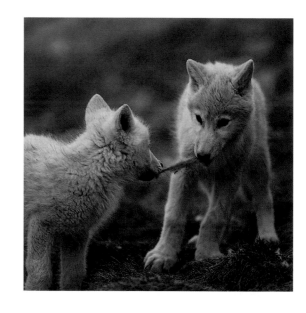

Puppies while away the hours by exploring the landscape near the den. As one pup scratches, another chews on a musk ox skeleton. Two littermates play tug-of-war with the hide of an Arctic fox. (Opposite) A prideful pup marches forward with a gull feather he's found—one of many "trophy toys" the youngsters seem happy to possess.

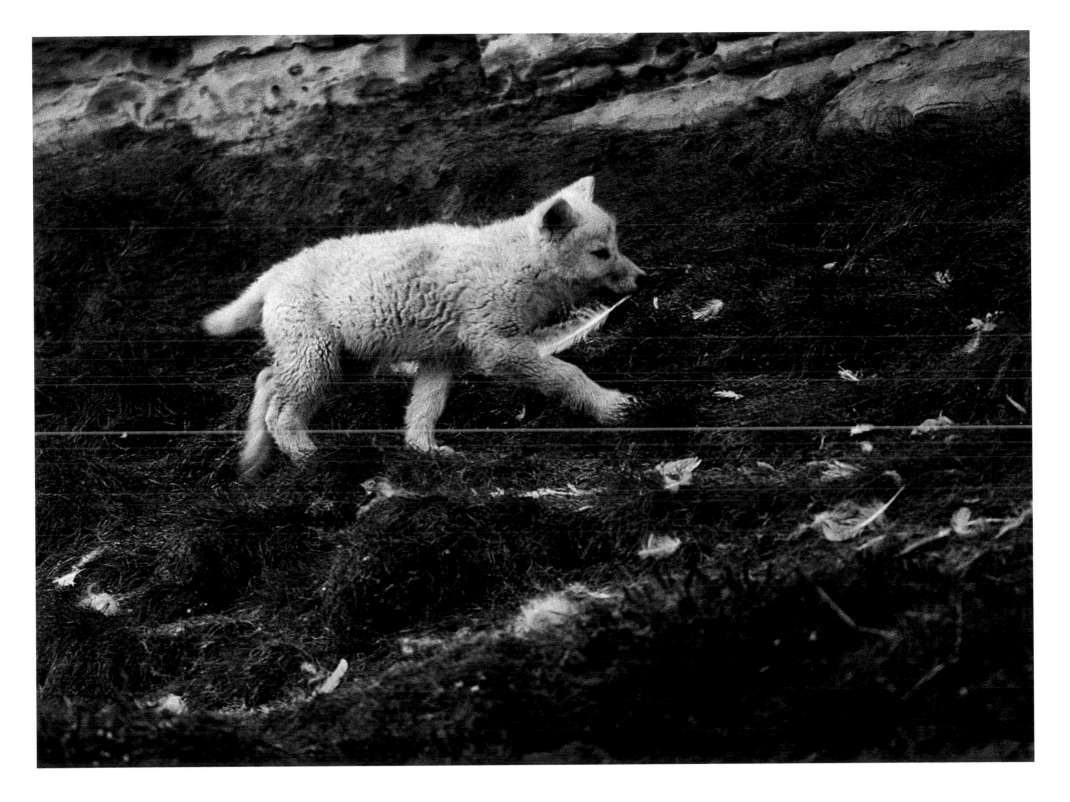

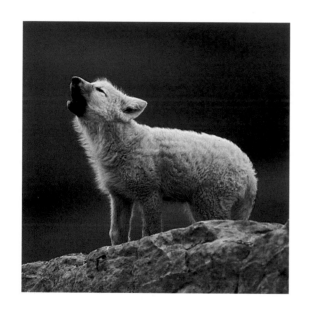

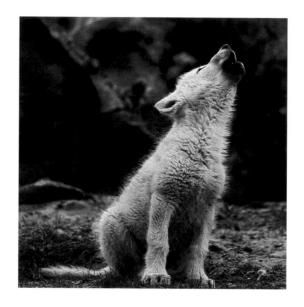

Puppies begin to prac-
tice howling very early
in life. Their high-
pitched efforts provide
an amusing addition to
the family songfest.
(Opposite) The rocky
outcropping at the
den's entrance has been
carved for eons by the
winds of the high
Arctic.

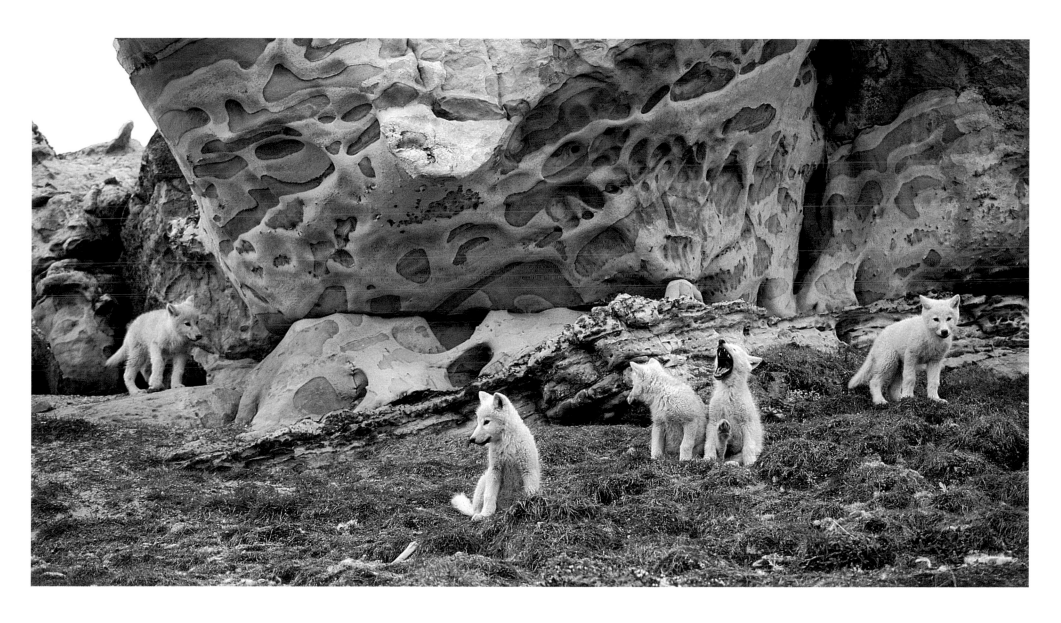

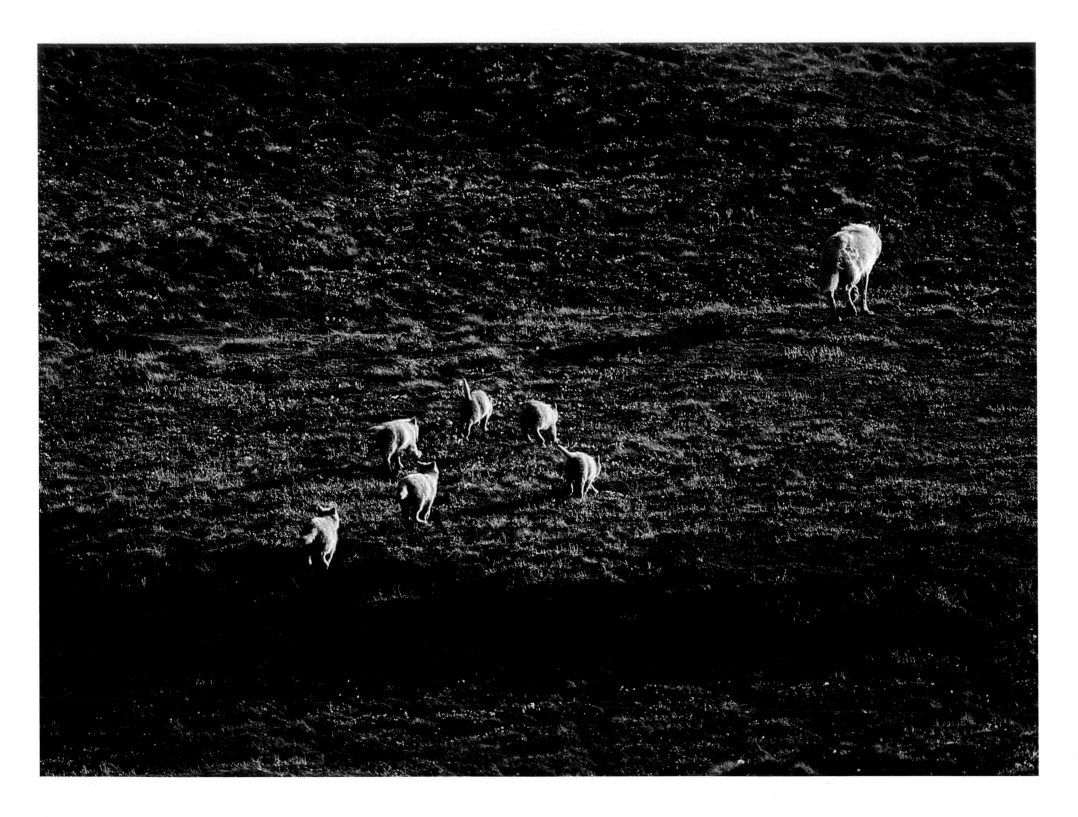

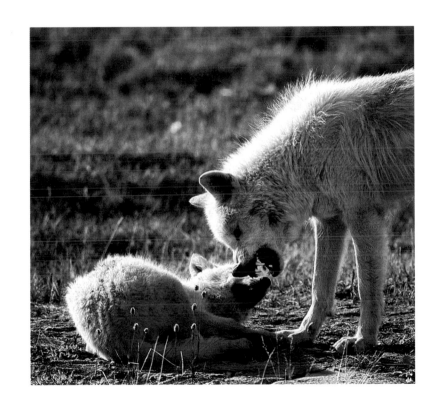

A weary Mom attempts to take a short break from her pestering youngsters. A pup that catches up receives a motherly growl for his efforts.

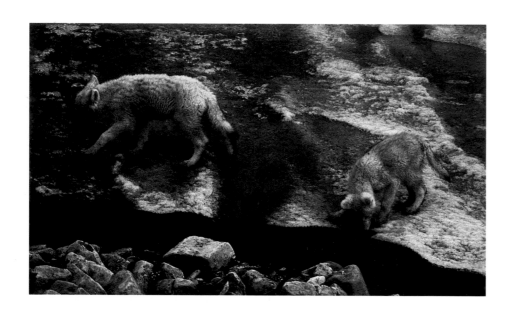

Two pups explore the edge of a permanent snow field near the den. Even in summer, when the temperature can rise to 70, the air directly above the snow stayed too cold for mosquitos—a fact not lost on the wolves.

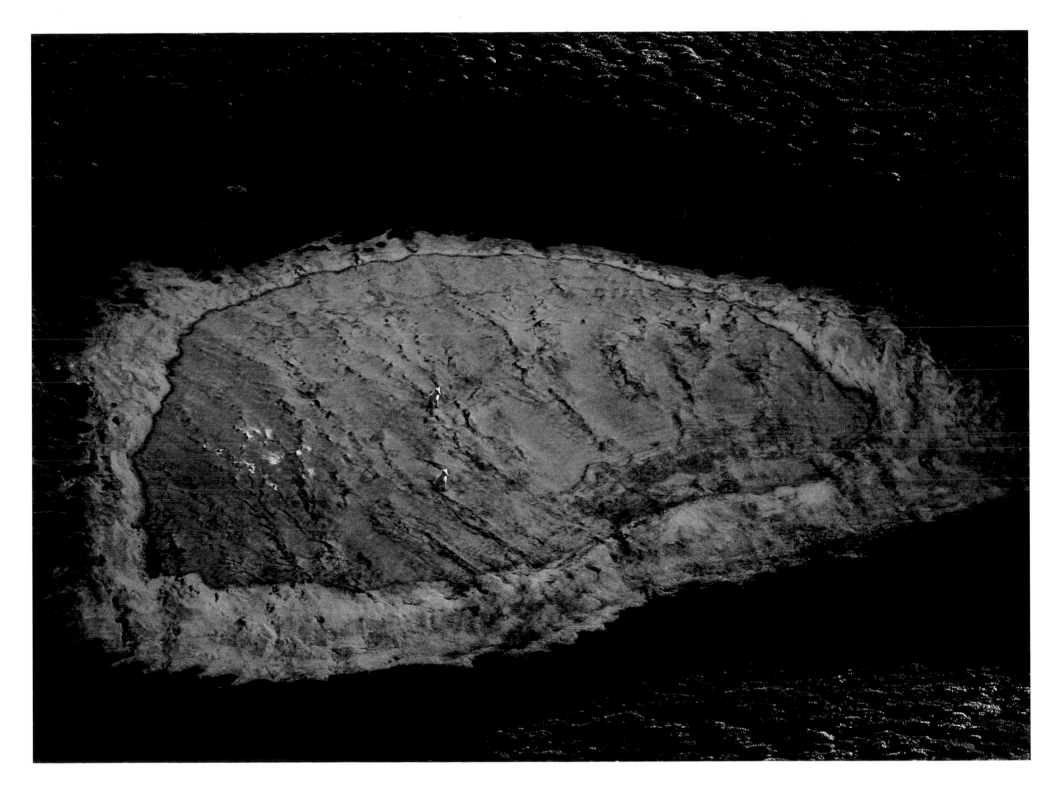

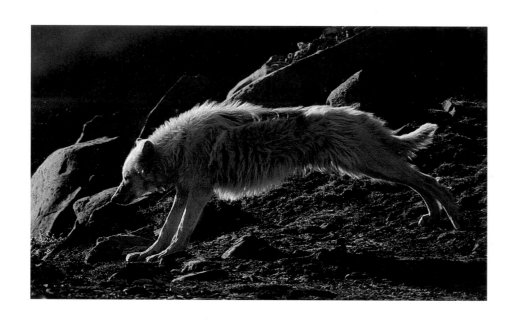

*Upon waking, adults
and pups alike indulged
in luxurious stretching
to loosen sleep-stiffened
muscles. (Opposite) A
pup peeks through a
protective forest of
adult legs.*

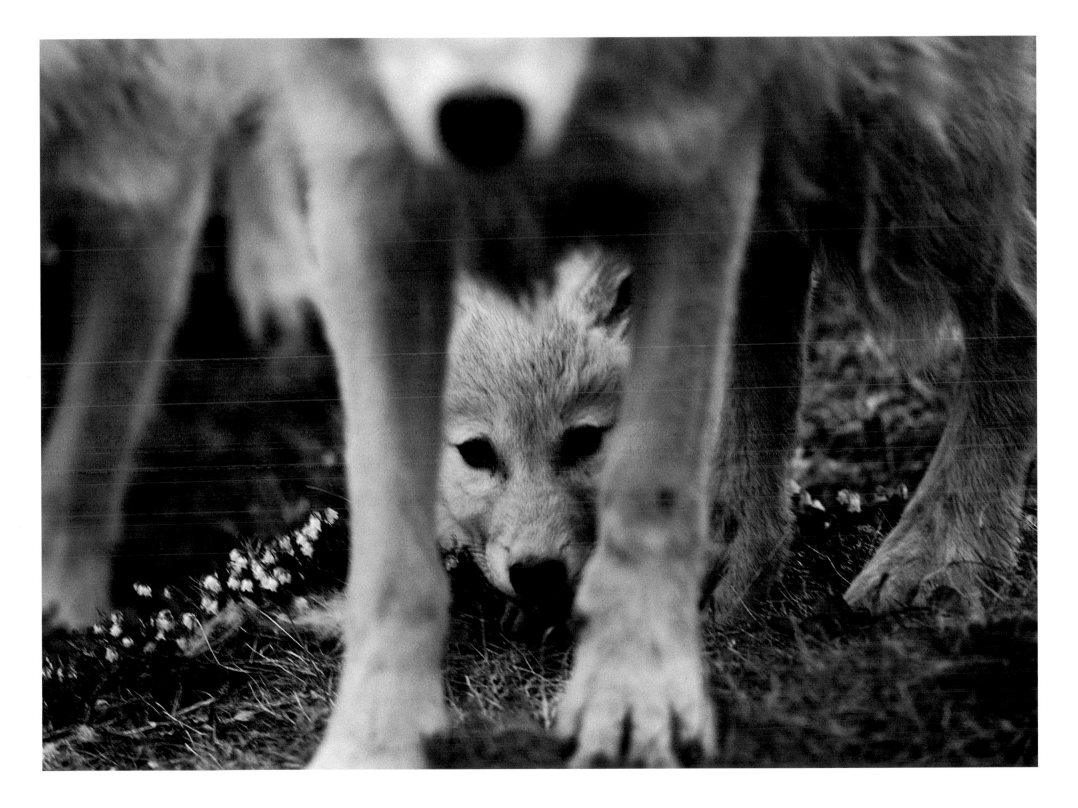

A summer snowfall temporarily dampens the prospects of an Arctic poppy. "Hairs" insulate the poppy's stem just as an under-coat of puppy down keeps a couple of snoozing pups blissful in the cold.

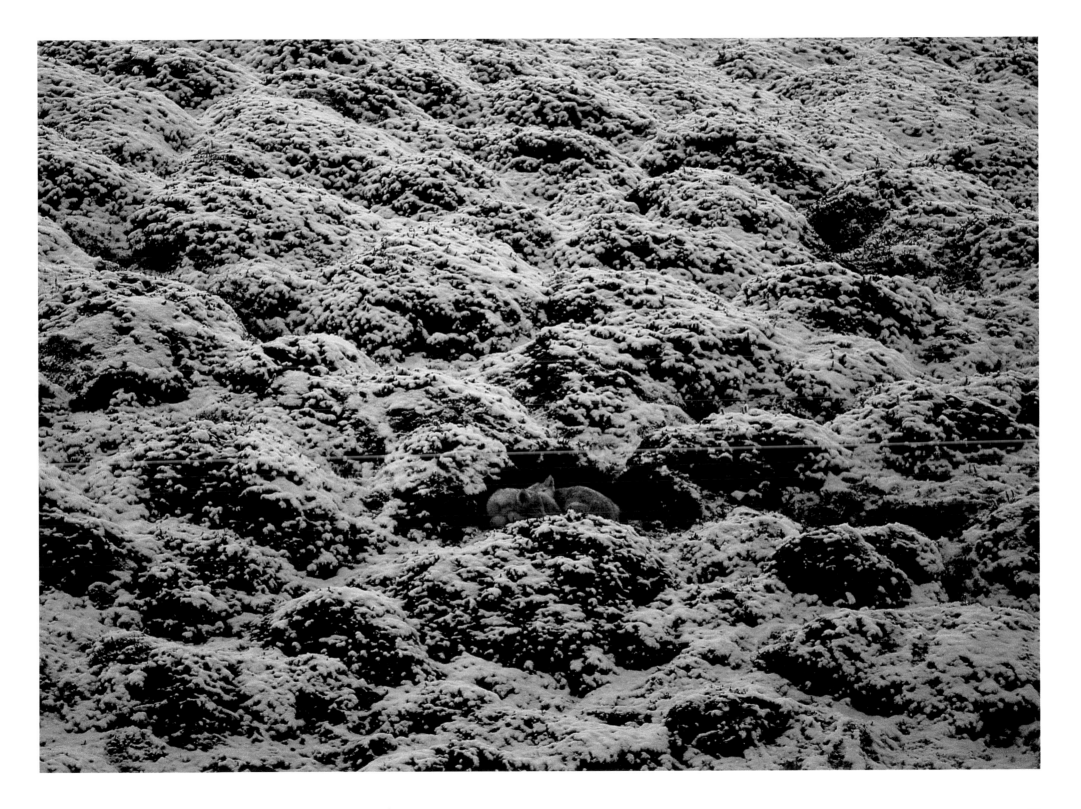

Energetic puppies play leap-wolf near a napping adult. (Opposite) The author's tent, shown on the far right in the photograph, is pitched a neighborly quarter mile from the site of the den.

W

hile Mech and I were searching for an ideal campsite, I happened upon what looked like a fragment of porcelain embedded in the powdery soil. I bent over and dug the piece out, discovering that it was the skull of a long since deceased wolf. The high Arctic is, in essence, a cold desert, with average yearly precipitation of three to five inches. Because of the absence of heat and moisture during most of the year and the corresponding paucity of insects and microbes that expedite rot, objects can survive intact for centuries. There are, for instance, spots where Peary and his men dumped their tin cans and other detritus; it looks as if this littering could have happened yesterday.

Similarly, the wolf skull I found could have belonged to the grandfather of today's wolves, or it could just as easily have belonged to a wolf that lived at the time of Darwin. What intrigued me most about this skull was not its age, however, but the evidence of its owner's astonishing survival skills. Puncturing the lower jawbone was the tip of a musk ox horn that had broken off, presumably during combat. I have found musk oxen skulls before, and I know that it is virtually impossible to break one of their horns. I can only imagine how the drama unfolded: the wolf darting in too close, getting hooked from underneath, then flipped howling and crying into the air. Did he gyrate wildly against the blue sky, his jaw hopelessly impaled as his packmates brought down the prey from behind? And how did he ever extricate himself from this mortal bond? Did he break the horn himself in his frenzy to

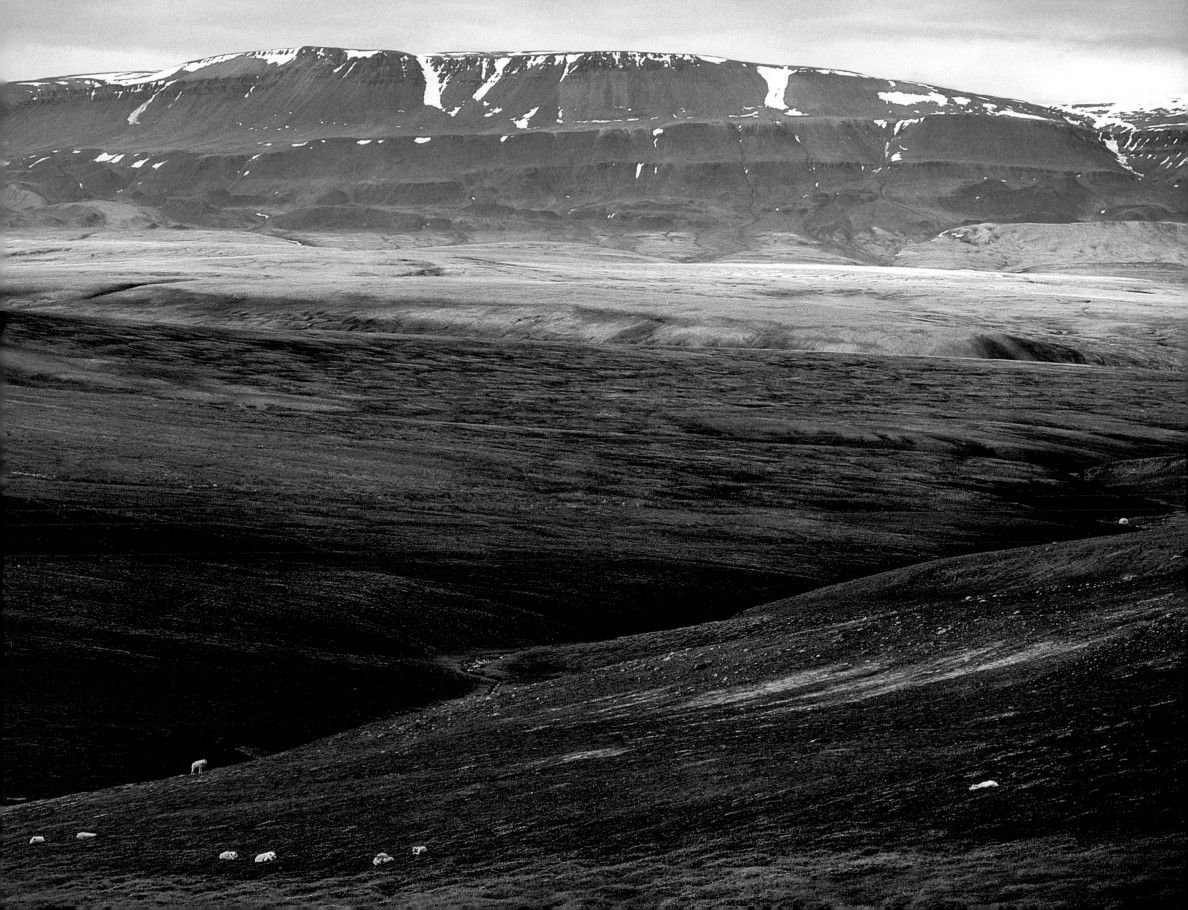

get loose, or did a fellow wolf bite him free with jaws capable of cracking moose femurs to get at the marrow?

All I could tell for certain was that the wolf did survive. Bone tissue had grown thick across the point of injury, showing that he had lived for at least several months after the battle. Indeed, the wolf's teeth were very worn; when he died, he was an exceptionally old wolf for whom the act of eating must have become a hellish choice between hunger pangs and arthritic agony. The discovery of this skull was doubly fortuitous. Not only did it lend cautionary insight into the dangerous way these wolves make their living, but it also provided a symbolic site on which to stake our own territorial claim for the summer.

This setting was a deep valley about a quarter-mile east of the den. We pitched our nylon, expedition-style tents ten feet from one of the small creeks that slice through the wolves' territory. On the top of my tent, I placed the skull— not as a threat, but as a talisman or a totem, a way of saying to the wolves around us: this is *our* territory. Against the colorful nylon, the skull had a primitive look that appealed to me. Its effectiveness as a warning sign, however, remained to be seen.

We set up a spotting scope to monitor the diurnal activities of the pack a quarter-mile away. Our presence did not seem to affect the wolves negatively. They made daily trips to our camp, apparently to satisfy their curiosity about us.

As an experiment, I decided to set up a secondary campsite on an opposite hillside about 200 yards from the den. I stayed here for a week, testing the limits of the wolves' tolerance for human beings. For one 24-hour period, I observed the pack's activities non-stop from the tent, with only my 600-millimeter lens protruding from the flaps. Though the wolves showed no overt signs of increased stress, I eventually retreated to the original camp, figuring it was better to be safe than sorry.

One day, Mech and I were near the den watching the mother wolf and her pups with our binoculars when we heard a commotion back at our camp. Looking back, we saw several of the pack members circling our tents. Discovering that we were not in them, the alpha male struck his head inside a porthole window, grabbed a red nylon mummy-style sleeping bag and dragged it out. He and his buddies were about to tear it to shreds when Mech and I did the only thing we could think of to save our property—we started to bark.

Barking is a sign of alarm to wolves. Coming from so close to the den, our woofs and snorts had a predictable effect. The happy marauders instantly dropped the sleeping bag, their faces etched with alarm, and ran full speed to the den to make sure everything was okay. We, in turn, high-tailed it back to our camp, retrieved the sleeping bag and began strategizing as to what we might do to frustrate future incidents of lupine curiosity and imperialism.

Because I was working on the Ellesmere story, which necessitated frequent explorations across the island, I knew there would be times when the campsite would be left unattended, perhaps for as long as a week. I was delighted that the wolves had accepted us enough to make themselves at home in our presence, but the possibility of sleeping on whatever shredded goose down and nylon strips we could salvage from the tundra underscored the downside of our newly-won popularity. Obviously the wolf skull perched on my tent was not going to do the trick.

My fears about what the wolves might pilfer fell into two categories: first, food, and second, everything else. The wolves' interest in food is understandable; they are relentless opportunists whose quest for calories drives them to explore every square inch of their territory. The interest in everything else, on the other hand, springs from the wolf's innate curiosity and love of the unusual. The den area, for instance, was littered with fragments of weather balloons. These usually ascend to 100,000 feet before exploding and falling to earth. Balloon fragments hardly make good eating, yet the wolf who discovers one of these trophy toys and brings it back to the

Mom's pleasant expression echoes her tolerant, maternal personality. (Opposite) The wolves' white coats, illuminated by the magical Arctic light, appear to glow against the dark, tundral landscape.

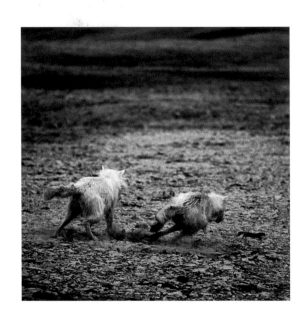

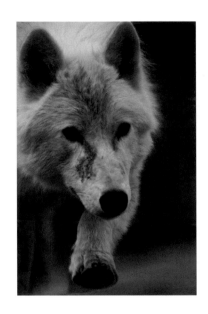

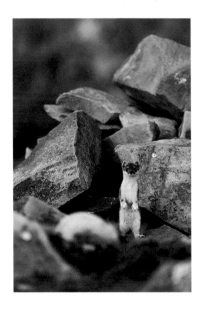

The pack gives spirited
chase to a hapless
weasel, who scrambles
to refuge in a rock pile.
(Opposite) An aerial
photo suggests the
powerful geological
forces that have carved
this land over the ages.

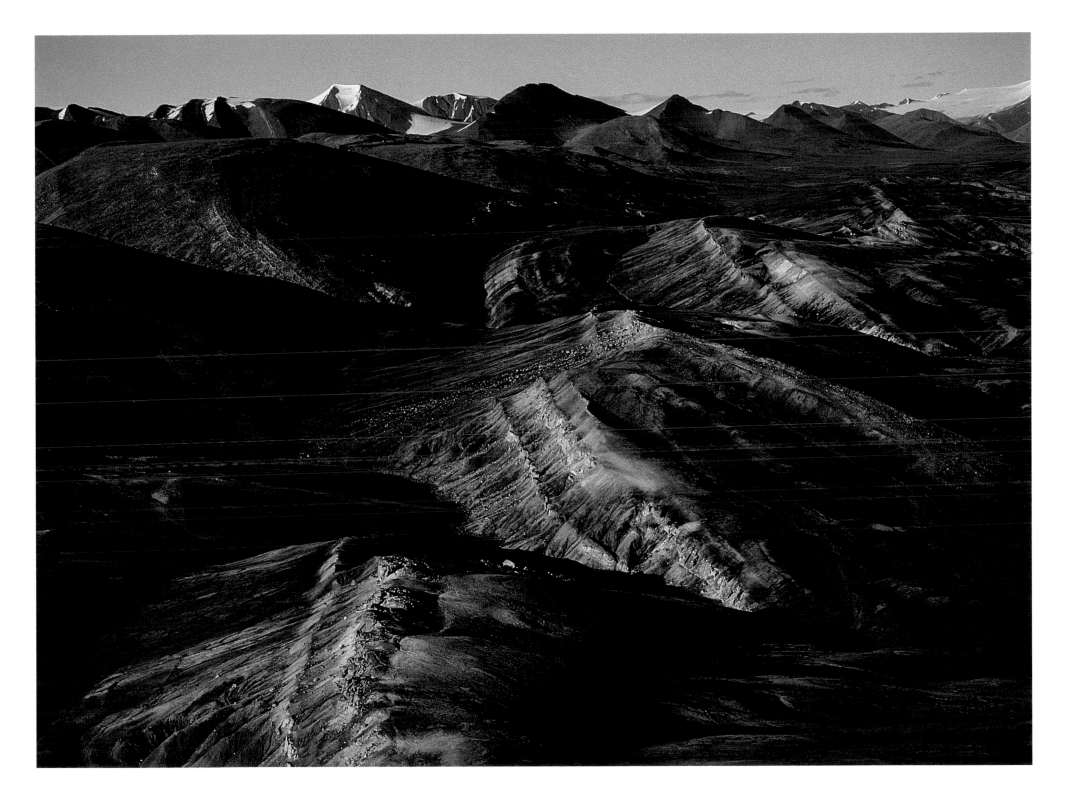

pack does so with the same haughty sense of entitlement as the wolf who carries back a haunch of musk ox.

We realized that the wolves would be more than happy to appropriate everything we owned. To combat their acquisitiveness, I decided to try erecting scarecrows. Since there are no sizable pieces of wood on Ellesmere, I built my four-foot tall ersatz men in the ancient tradition of the Inuit by piling stones atop one another. The Inuit call these rock scarecrows *inukshuks*, using them to herd caribou and as geographic markers to help guide themselves across stretches of wasteland. On the top of mine, I attached nylon streamers, hoping they would provide enough motion to scare the wolves off.

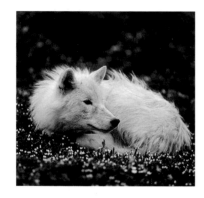

As for our food, we decided it would be dangerous to keep any of it in our tents. There was a remote chance that a polar bear might be attracted in by the scent, not to mention the wolves. About a hundred yards from camp, we dug a shallow hole in a rock pile, placed our food in plastic containers in the hole and covered everything with a lid made up of several flat, 60-pound stones.

With our supplies thus "protected" against adventurism, we felt safe enough to fly by helicopter to the north end of Ellesmere for a few days of photography. I was so confident that our precautions would be effective that by the time we flew back, I'd practically forgotten that the wolves might try some mischief.

This mischief, of course, was visible from the air several miles away. It was comical to see rolls of toilet paper streamed like spokes across a hundred yards of tundra, with our campsite serving as the wheel's hub. Somehow the wolves had even managed to get into the cache of food from our makeshift sarcophagus. Everything that could be opened had been; everything else had been shredded, romped with, dentally examined and dimpled with teeth marks. Evidently, their favorite items were our plastic pails of butter, which they had carted up to the den.

Scruffy curls up for a nap while an assortment of other adults and pups joins in for a good-natured family romp session.

In my mind's eye, I could reconstruct the whole scene. Probably the pack had descended on our camp within hours of our departure and tentative exploration was quickly replaced by reckless abandon. They must have grabbed and played with everything, food and trophy toys alike, their heads occasionally getting stuck in plastic pails as the games of tag and prideful possession stretched on for hours. There was no question in my mind that the wolves would remember this red-letter day for as long as they lived.

It took several days to clean up the landscape. Human garbage in such an unspoiled setting has the same effect on me as chewing gum wrappers in a church; we cleaned up every last shred, even the few plastic pails that had joined the weather balloon fragments as souvenirs. Throughout the cleanup, I was painfully aware of the ineffectiveness of our *inukshuks*, but the point was driven home with particular clarity late one afternoon when I was down near the creek. The alpha male, returning from some sort of exploratory sortie, sauntered over to one of our little rock men. As the nylon streamers flapped gently in the breeze, Buster lifted his leg and urinated. *No matter what you think*, he seemed to be saying, *this is still* our *territory*.

I should, I suppose, say a few words at this point on the subject of anthropomorphism—that is, the assigning of human characteristics, feelings and motivations to nonhumans. At best, this is a silly exercise leading to warm feelings; at worst, it can be downright disastrous as when a child, conditioned by cute cartoon depictions of animals, attempts to befriend a wild specimen.

Throughout my career, even when I've felt closest to my wild subjects, I've always preserved a boundary between us. This was the case with the pack, too: wolves *are* wolves, after all, and people are people, even though there are perhaps some emotional intersections between our species. How else could canines have won the title "man's best friend?" Satisfying though it may be to see a reflection of ourselves in other

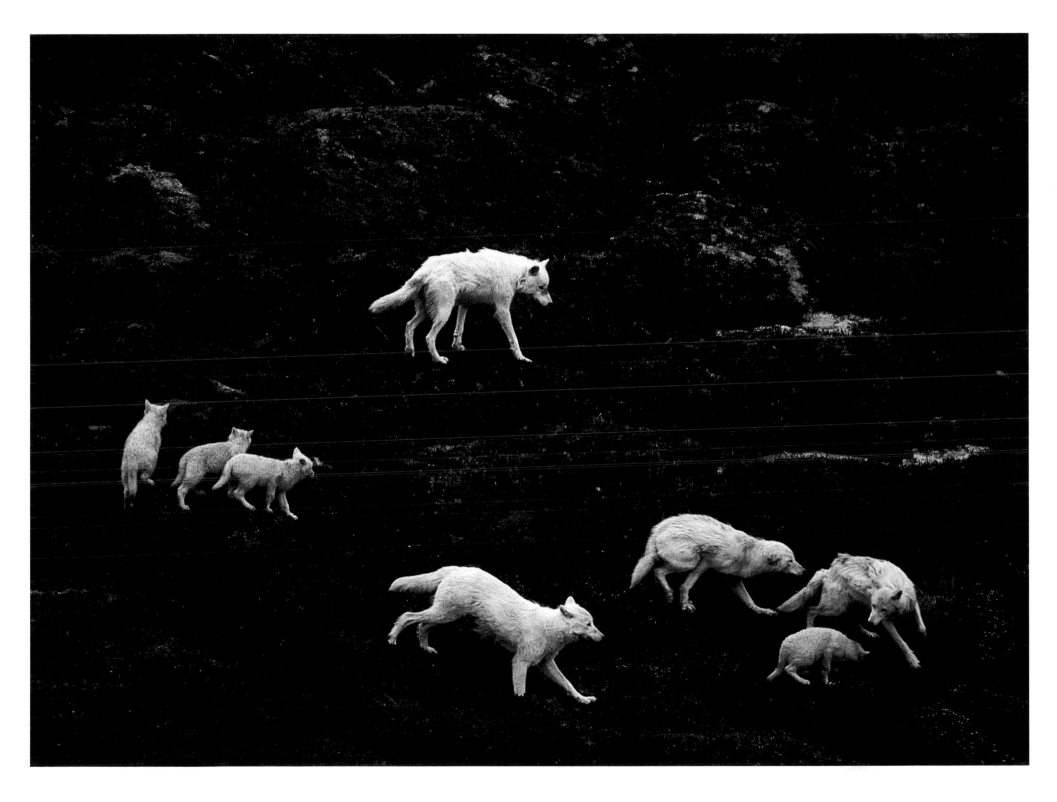

sentient creatures, however, I hesitate to suggest wolves think like humans; such an approach often creates an unnecessarily egocentric view of the natural world.

Yet, animals, especially mammals as sophisticated as wolves, are undoubtedly emotional beings. To ignore this fact, or to denigrate their emotional range as being somehow inferior to ours, is simply wrong. I genuinely believe a magic exists in creatures as perceptive and intelligent as wolves, a magic that is likely to forever elude the kind of clinical observation provided by radio collars and scat measurements. To be sure, science has its place; the work of dedicated scholars will doubtless prove invaluable to animal survival, but there is also room for an intuitive, emotional way of relating to animals. Indeed, I believe that wolves possess a kind of spirit we can only begin to understand through our emotions.

As a photographer, I have always allowed myself to be guided by intuition. My best images have resulted from an emotional relationship to my subject, and rarely from calculation. If I err on the side of being emotional, it is simply because my livelihood *depends* on it. I believe most animals move and respond according to how they feel. And I respond to them in kind. Sometimes I find it amusing to wonder if wolves have ever surveyed me and ascribed wolf-like emotions to my odd human behaviors. A sort of *lupomorphism.*

Throughout our time together on Ellesmere, Mech and I approached our work from the different perspectives of our not always overlapping professions. For the most part, we complemented each other with Mech concentrating on collecting data on previously uncharted behaviors, while I focused on the aesthetic aspects of the wolves, trying to find ways to communicate with optimal visual impact the beauty and profundity of these creatures' lives. Though Mech and I were often in each other's company, we rarely spoke near the den—doing so somehow seemed a violation of the Arctic environment. Our goal above all was to blend in, to lie low without trying to hide or trick the wolves; we wanted, in short, to have as little an impact as possible on the world we were documenting.

The one perhaps unavoidable exception to this approach was our means of locomotion, our Suzuki all-terrain vehicles (ATVs). We used these four-wheeled buggies to carry in our equipment and to keep up with the free-roaming pack. It's nothing for a wolf to conduct 40-mile sorties at a steady pace of six miles per hour. Once, later in the summer, we followed the pack for 17 hours straight, during which time they covered more than 70 miles. To keep up with them on foot during this outing would have been impossible.

Most of my time, of course, was spent not on the ATV but loitering within camera range of the den. Since the sun was up 24 hours a day at this point, it was hard to adopt a regular sleep pattern. The wolves, for their part, slept at such seemingly random times of the day and for such seemingly random durations that I never could discern any patterns. As with their diet and hunting, wolves are opportunists when it comes to sleep; they seem to know when it makes sense to be asleep and when it makes sense to be awake.

Sometimes they would take a short nap and wake up refreshed and ready to explore; other times, they would nod off for 12 hours. I tried for about a week to synchronize myself to this "schedule" before giving up. More often than not, I found myself staying up 20 hours or more at a stretch, fearful that if I did fall asleep, the wolves would do something never before documented. I would grab my sleeping bag and telephoto lens and curl up on the hillside overlooking the den, taking catnaps and every now and then cocking an ear or raising an eyelid toward the activity across the way. More than once I fell asleep in spite of myself, only to wake to the curious sniffing of a wolf a few yards away. There was a satisfying sense of reciprocation at these times: the creatures upon whom I was keeping a watchful eye were, I was glad to see, keeping a similarly watchful eye on me.

A wolf leaves a muddy footprint in the shadow of the tiny Arctic willow tree. (Opposite) A solitary wolf seems dwarfed by the vastness of his striated homeland.

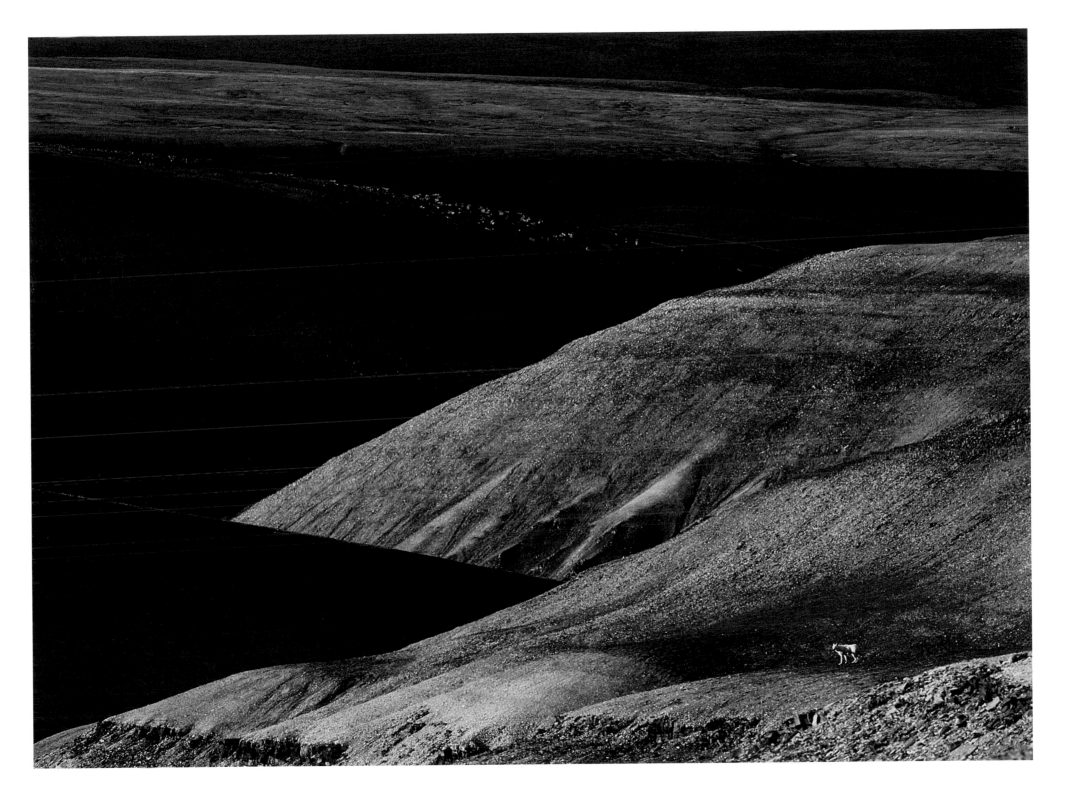

A two-month-old puppy delights in the novelty of midsummer snowflakes. (Opposite) Scruffy, the pack's adolescent goofball, rouses himself mid-nap for a lazy peek at the camera.

espite diligent study, it took weeks before I could begin to tell the seven adult wolves apart. Discrimination was especially difficult while they still sported their thick winter coats. At times they all seemed to me like big, white, identical copies hardly more differentiable from each other than one puffball puppy was from his or her littermates.

To make matters even more confusing, it was rare that all seven would hang around the den simultaneously. More often than not, they would split into groups of three or four and take off on separate hunting expeditions. Whether the subgroups remained constant or shifted from day to day according to some inscrutable lupine whim or scheme, I could only guess.

From occasional glimpses of the wolves' teeth, which were in good shape and not worn, I could tell they were all relatively young animals in good health, but telling them apart was a different story altogether. Still, the human sense organs, though feeble compared to those of the wolf, do boast a certain plodding efficiency. Over the weeks of watching, listening and even, I suppose, smelling the wolves, I found myself becoming more and more attuned to their various idiosyncrasies.

As the wolves began to shed their winter coats, subtle features emerged. I also noted patterns of dominance and submission played out again and again between different individuals in the pack. This was classic top dog-underdog body language, the former bristling and cocky, the latter cringing and appeasing. By simply remembering who deferred to whom and

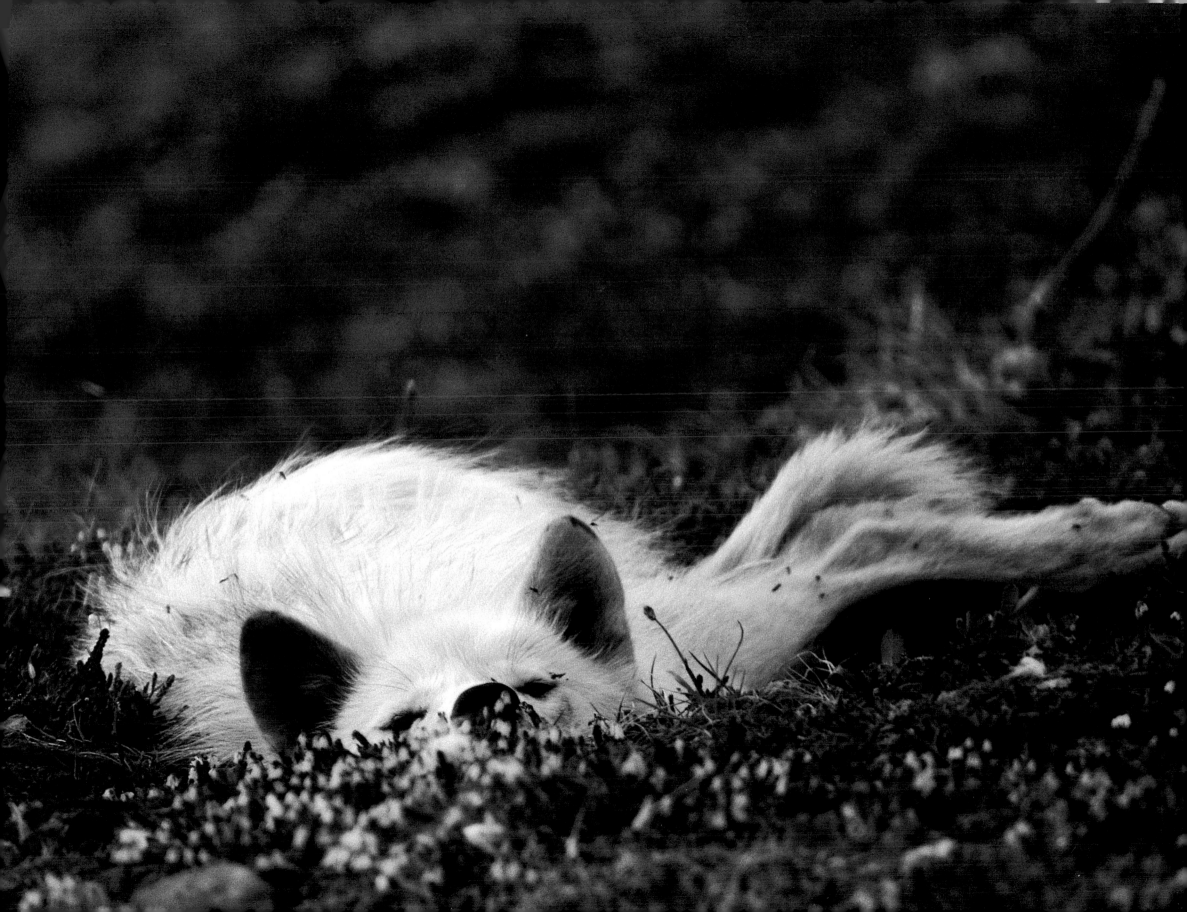

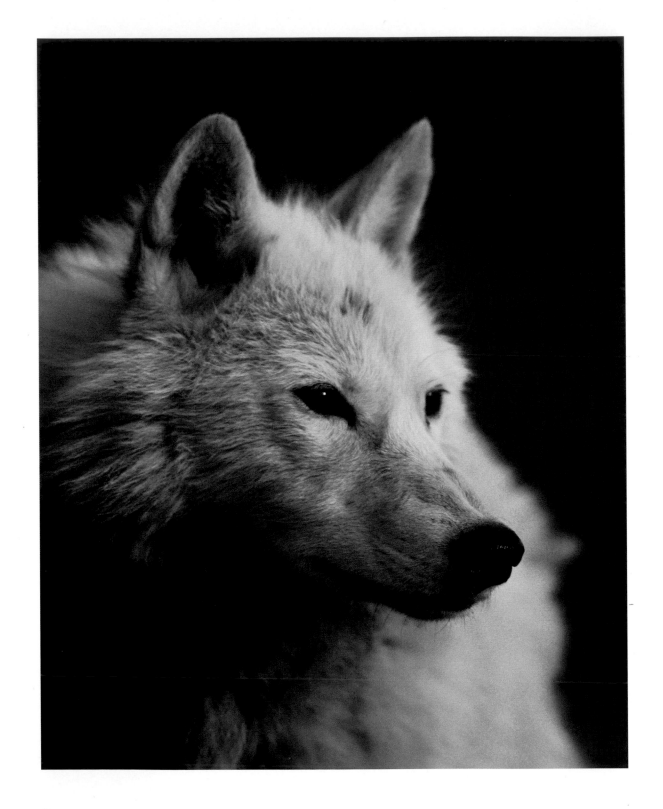

Mom's serene disposition makes her by far the most tolerant member of the pack. Buster, her mate, is much more skeptical—here he strikes a typically assertive, in-charge pose.

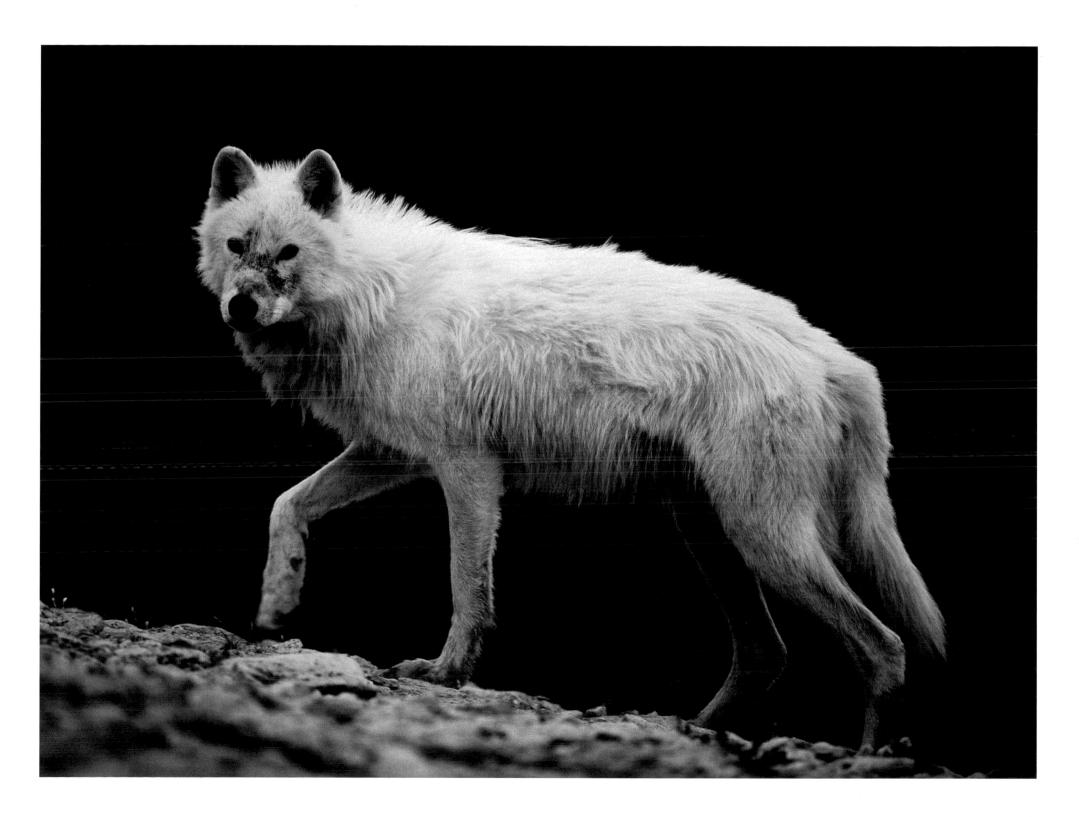

cross-referencing this information with facial features, body scars, distinctive personality quirks, and the like, I got to the point where I could usually distinguish individuals at a glance, except for the puppies, who remained indistinguishable.

Puppies aside, the *dramatis personae* of the pack properly begins with the alpha individuals, one male and one female, each "in charge" of its own gender's pecking order. I say "properly" because our brains are similarly hard-wired to notions of hierarchy; human society is nothing if not an array of pecking orders, from the military to corporations to class structures.

The alpha male, a.k.a. Buster, was dominant over every other pack member including the alpha female, though in this case the relationship verged on parity. During musk oxen hunts, Buster was typically the first to attack. After a kill, Buster would begin feeding first, though he was very quickly joined by the alpha female. Often Buster would stand guard against the other wolves while the alpha female ate, an act that bordered on chivalry. Not until after these two had their fill could the rest of the pack even entertain hopes of coming to the table.

Buster's most defining characteristic was his eyes, which were alternately piercing, expressive or quizzical. He weighed less than 100 pounds and had thin, very long legs that made him taller than even the largest German shepherd.

The alpha female, on the other hand, was smaller but possibly the most intelligent member of the pack. We nicknamed her Midback because of a swath of dark fur running down her back, a common characteristic in the pelage of female wolves during summer. Of all the wolves, Midback was by far the least tolerant of us. When the wolves decided to move the pups from the first den to the rock pile, for instance, Midback initiated the move. She goaded the puppies on, nudging them across the tundra.

While she was not the pups' mother, she was probably the most protective "parent" they had. Her behavior toward the pups reminded me of a dominant-aunt situation sometimes seen in human families; she seemed to serve as adviser, disciplinarian, nag and potential usurper of the real mother's authority. At times, such behavior elicited what seemed to be a jealous response from Mom. I remember one instance in particular, when Midback trotted over to the den to spend some time alone with the pups. Mom saw this and raced over to intercept her. Midback responded by acting haughty, as if she couldn't see what the big deal was.

Midback was also notable for the extreme quickness of her motions; no other wolf could rival her prowess at hunting. In fact, I sometimes referred to her as Hunter because of her exceptional hunting skills. She was particularly gifted at catching Arctic hares. While some of the less competent hare hunters in the pack might circle frantically after the prey, sometimes losing track of the original target hare and taking off after a well-rested one, Midback was rarely fooled. She also had a knack for knowing precisely when to make the cut that would land the hare in her jaws. Afterwards, she generally ate the front half of the hare herself and strutted over toward the pups with the rest. When she then bestowed the gift on the pups, her smugness and haughtiness were so extreme that it seemed a deliberate signal, a gesture of dominance to the other adults in the pack.

Of all the pack members, the pups' mother, a.k.a. Mom, was my favorite. As with humans, you tend to like best those who like you, and Mom was by far the *nicest* wolf. In contrast to Midback's skepticism and sharpness, Mom's personality was stereotypically maternal: calm, extremely tolerant, and so trusting of us humans that it never fully made sense to me. Perhaps it was simply a matter of habituation. I spent the most time with Mom since she was tied most closely to the den.

Mom's facial features seemed to mirror the serenity of her soul. They were fine and delicate, and the look on her face was lovely in its peacefulness. If Botticelli had wanted to cast

Left Shoulder shows no sign of favoring his namesake wound, which was probably caused by a musk ox horn or hoof.

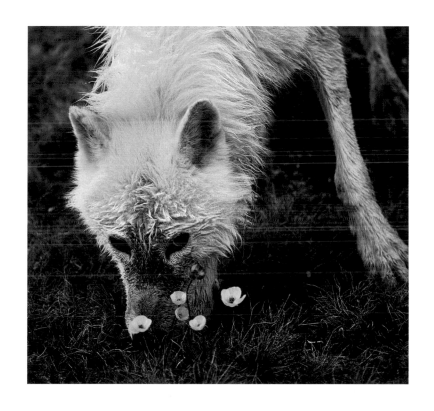

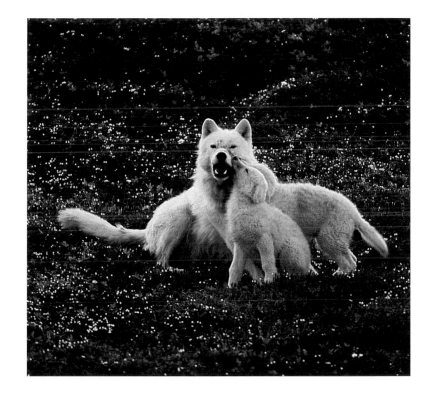

Buster, fresh from a
swim in the fjord,
shows his softer side.
Here he sniffs Arctic
poppies before letting
his pups tug on his lip.

the Madonna as a wolf, he could not have hoped for a more perfect model than Mom. Probably because she was sedentary and could not generate heat by running and other physical activity, Mom kept her winter coat longer than the others. She was also expending a great deal of calories on lactation. Her weight dropped to under 70 pounds during the period of nursing, and she looked to be getting thinner in inverse proportion to her ever-fattening offspring.

Other than the various primates and perhaps the cetaceans, it is hard to think of a species where there exists so much personality variation among individuals. A perfect example of one end of the wolf personality spectrum was Scruffy, an "adolescent" who was almost certainly an offspring from the previous year. Why he alone from that crop of puppies was still with the pack is hard to say. Typically, the young spend almost a year with their parents before dispersing the next spring as mating commences. Reports from the weather station personnel indicated that the pack size typically decreased by as much as half at mating time.

Perhaps Scruffy had been the dominant pup in his litter and had thus been able to resist being driven off by the adults. Or it could have been the reverse—maybe Scruffy had been a submissive, low-status pup who did not seem a threat to the existing hierarchy and so was allowed to remain in the pack.

Whatever his status in the litter had been, Scruffy's position now was clearly at the absolute bottom of the pecking order. His scraggly summer coat that gave rise to his name seemed one part fashion statement and one part teenage gawkiness. Throughout the shedding period, Scruffy had huge, messy balls of hair hanging from virtually every part of his hide. These clumps hung on for weeks, a symbolic badge of unkempt adolescence.

There was a certain degree of silliness and foolhardiness in Scruffy's behavior as well. I recall once when he tried to dine at the nesting site of some long-tailed jaegers, fascinating Arctic birds that look like a cross between ravens and sea gulls. The other wolves would occasionally cruise the area in search of eggs or chicks to eat, but Scruffy just seemed inadequate to the challenge. Time and again, the adult jaegers would bombard him and knock him on the head with their feet. Each dive bombing would leave the poor fellow disoriented, perplexed and with a kind of *"Why me?"* look on his face.

Scruffy, perhaps because of his inexperience, was rarely allowed to go along on group hunts. More often than not, he or Mom would remain behind to baby-sit the pups, a subservient position that he appeared to accept, since it gave him a chance at last to act dominantly over somebody, at least when Mom wasn't looking.

The remaining three adults in the pack I knew less about, partly because they spent less time at the den site. Left Shoulder, a male, was the largest, whitest wolf in the pack. Despite his size, he was submissive to the point of groveling in the presence of both Buster and Midback. Left Shoulder's name derives from a three-inch patch of missing fur on his left shoulder. The wound was probably the result of a musk ox encounter, but he had evidently healed completely because we never saw him limp or favor his leg in any other way.

Lone Ranger, who I suspect was a male, had a definite dark mask around his eyes and muzzle that gave rise to his name. Shaggy, most likely a female, had a very shaggy coat. These two individuals had low status in the pack, to the point that they even exhibited neutral sexual tendencies—squatting to urinate and the like. Other than identification, I never got a sense of their personalities.

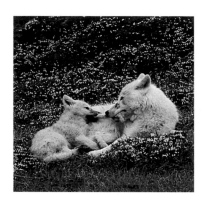

Baby-sitter Scruffy encourages the pups to practice "killing," over and over again, the well-shredded hide of an Arctic fox.

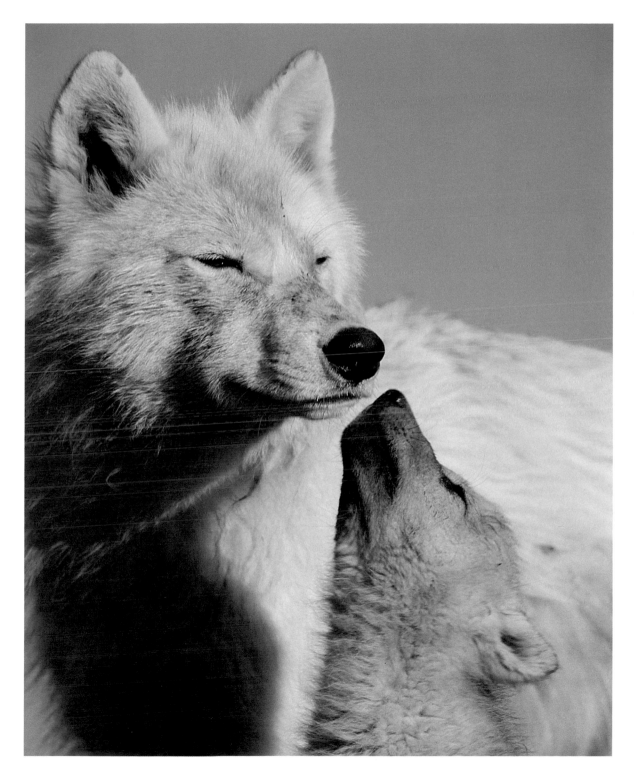

Though the lowest-ranking member of the adult hierarchy, Scruffy basks in the respectful adoration of his youthful wards.

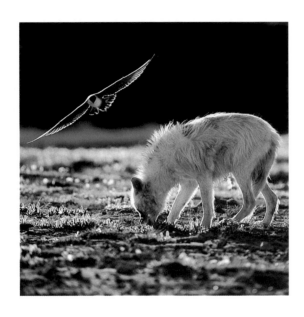

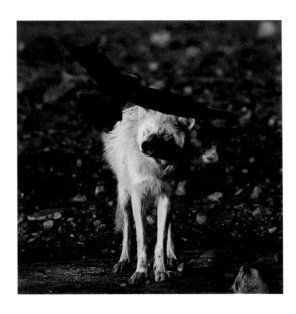

*While scavenging the
nest site of a long-tailed
jaeger, Scruffy is dive-
bombed and knocked
in the head by an irate
parent. Tail between
his legs, Scruffy retreats
with a "Why me?" look
of befuddlement.*

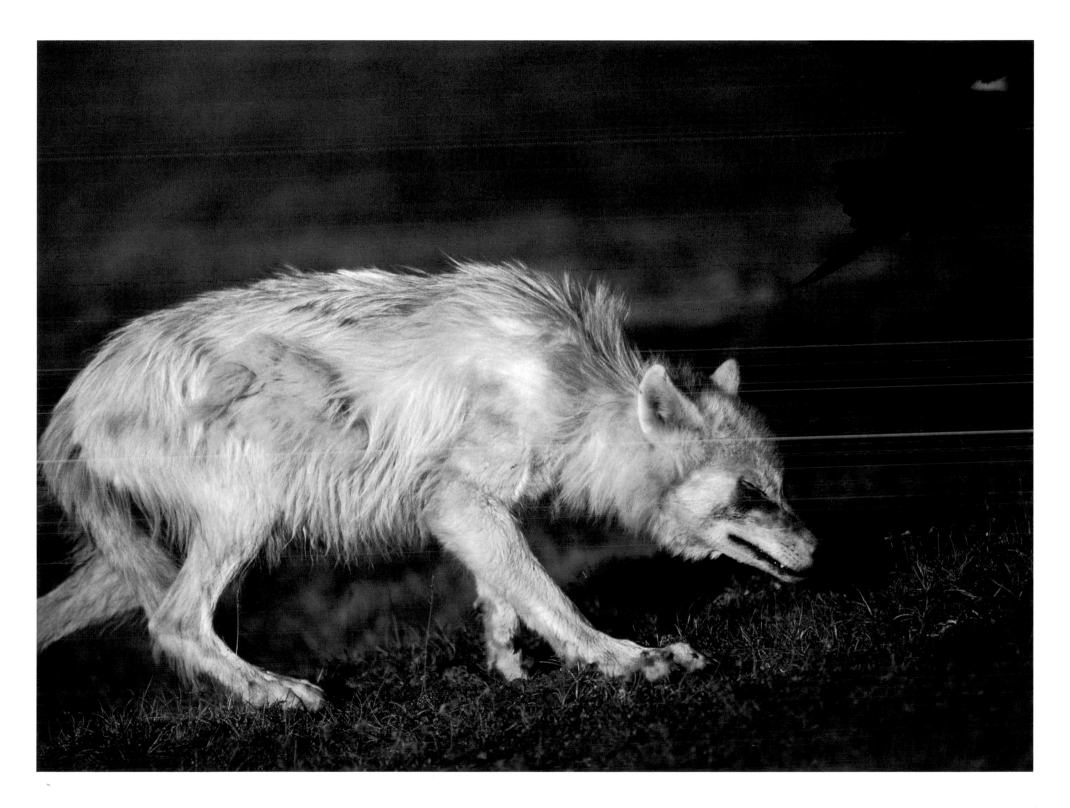

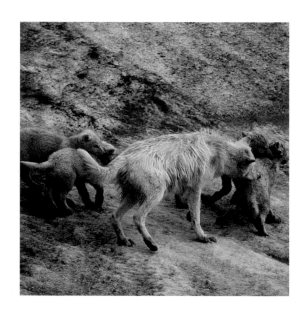 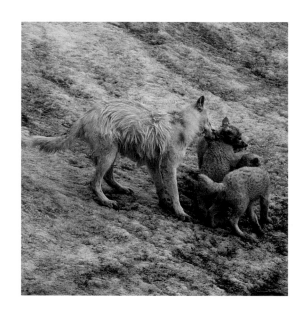 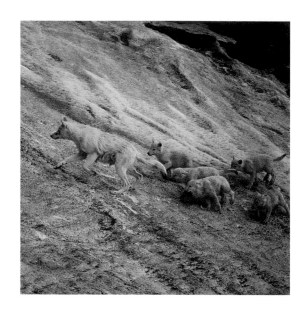

Scruffy knocks the puppies down and makes them yelp. A rigid hierarchy is crucial to pack cohesion and survival. Though such

bullying behavior may seem cruel, Scruffy's school of hard knocks teaches the pups early the importance of knowing one's place in the pecking order.

(Opposite) Exhausted from the session, babysitter and pups nap while a paw over the nose gives protection from the irritating mosquitoes.

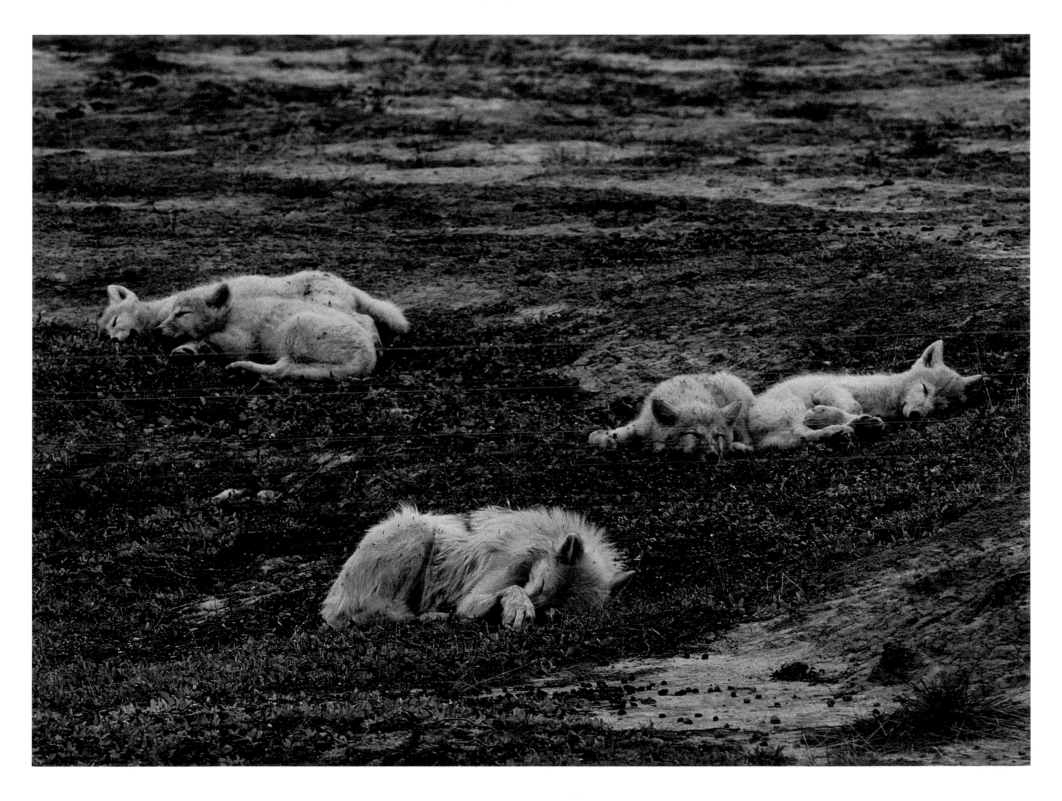

Though Ellesmere Island is one of the most inhospitable habitats in North America, the Arctic wolves are well adapted to the hardships they face.

From their physiology to their behavior, wolves in general and the Ellesmere wolves in particular are consummately adapted to the harsh demands of their environment. Consider, for instance, the digestive tract. Dog owners who have paid vets to repair their dog's intestinal perforations from chicken bones know how dangerous it can be for canines to swallow bone fragments. Fortunately for the wolves, their primary prey are covered with hair, not feathers. I found many wolf scats consisting of sharp pieces of bone neatly wrapped in a protective coat of musk ox or caribou hair. It is no accident that the evolutionary process would develop such an effective safeguard to the intestinal tract.

Likewise, consider the lupine ability to not only survive but thrive in bitter cold. Even during winter, when the sun does not appear for four months and temperatures can plummet to minus 70-degrees Fahrenheit, the wolves sleep outside. Evidently, they prefer a view to shelter—in any event, I never observed a wolf who acted chilled or uncomfortable. Predictably, their winter coats are superbly insulated, making their legs look twice as thick in winter as they do in summer. This was one of the more prominent differences between the Arctic wolves and their close timber wolf relatives in Minnesota, where the temperature rarely drops below a moderate minus 40-degrees Fahrenheit. As a result, the wolves I was used to seeing never developed the "leggings" effect, and it took me a while to get used to how stocky the Arctic variety appeared by contrast, at least during the cold season.

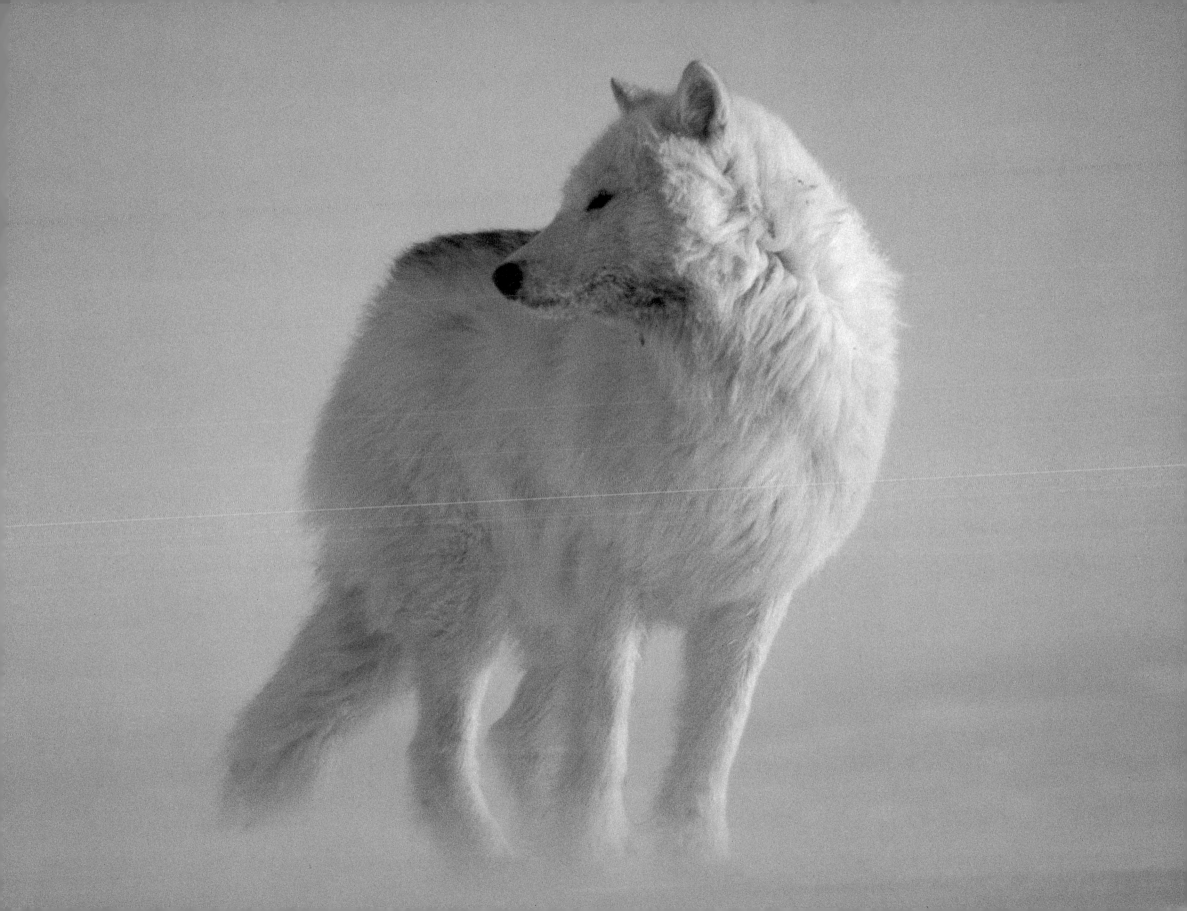

Arctic wolves also grow very long hair right on the bottoms of their feet. An obvious protection against extreme cold, the hair practically bursts through the spaces between their toes, all but hiding the footpads. During a later trip to Ellesmere, I was able to see this adaptation up close on the feet of a dead wolf I found one day while hiking. Another cold survival strategy used by the wolves is behavioral. To reduce the amount of body surface exposed to the air, they curl into tight balls and place their bushy tails over their noses as makeshift breathing masks.

As warmer weather approaches, the wolves begin to shed. At one point or another, all of the wolves trailed great gobs of shedding undercoat in wakes as long as two feet behind them. This short, luxuriously dense hair reminded me of the contents of a milkweed pod that puffs so extravagantly as it's released from compaction.

As a photographer, I will confess to a touch of aesthetic vanity. In summer, when the wolves were at the peak of their dishevelment, I could barely contain my urge to approach them with a dog brush and comb out this bumper crop of flotsam. Though they would never have consented to such an indignity, they might have appreciated the gesture. On hot days, the wolves appeared to find their excess hair a bother, and they would often take to a favorite spot of dusty sand to roll around on their backs and try to rid themselves of it. All summer, I waited for the moment when all the old excess hair would be gone and the wolves would seem eminently sleek and smooth, but such a day never came. No sooner had the last vestiges of the old been shed than the coming winter's fur began to appear.

None of this is meant to suggest that the wolves were free from vanity themselves—or at least a primitive sense of hygiene. Most had a definite interest in staying clean and white. One of the most remarkable scenes I have ever witnessed in the animal world involved Buster's fastidiousness in this regard.

During a particularly muddy day in the spring, he scared up an Arctic hare and proceeded to chase it in ever tightening circles. Though out of camera range, I was able to watch him through binoculars. It took him close to ten minutes to catch up with his prey and in the process he had turned almost black with accumulated mud. While I expected him to lie down in panting triumph and eat his meal, he instead held the dead hare firmly in his jaws, trotted with his head held high to the nearest fjord and hopped into the water. For the next few minutes, he swam around until he had washed off all the mud. He climbed out of the water, sleek with brine, the hare still untasted in his mouth. Then he began to shake himself dry in that telltale canine fashion that begins with a vibration of the head and shoulders and culminates with a whiplashing of the tail. Only then, when his coat was restored to immaculate condition, did he begin to eat, like a nobleman who would not think of coming to the table without the proper dinner jacket.

Etiquette probably had little to do with Buster's behavior. In a year-around environment of snow and ice, white fur provides great camouflage. Whether the urge to stay clean is instinctive, learned, or some combination of the two, there were definite variations among the wolves in terms of the premium they put on cleanliness.

Left Shoulder was a particular stickler for cleanliness; his coat was always the whitest of the pack. Scruffy, on the other hand, seemed to have a typically adolescent repugnance for the bath. Perhaps, being a young wolf, he had not yet learned how much easier it was to wash off mud and blood *before* it had had a chance to dry into a kind of Arctic adobe.

Another fascinating aspect of the wolf coat took me a year to figure out: the dark masks that would appear and disappear on their faces. In the case of Lone Ranger, the mask was pretty much a constant, but the others would develop similar masks for weeks on end. At first I speculated that the masks were an odd artifact of the summer pelage, like the temporary dark streaks females like Midback would develop on their

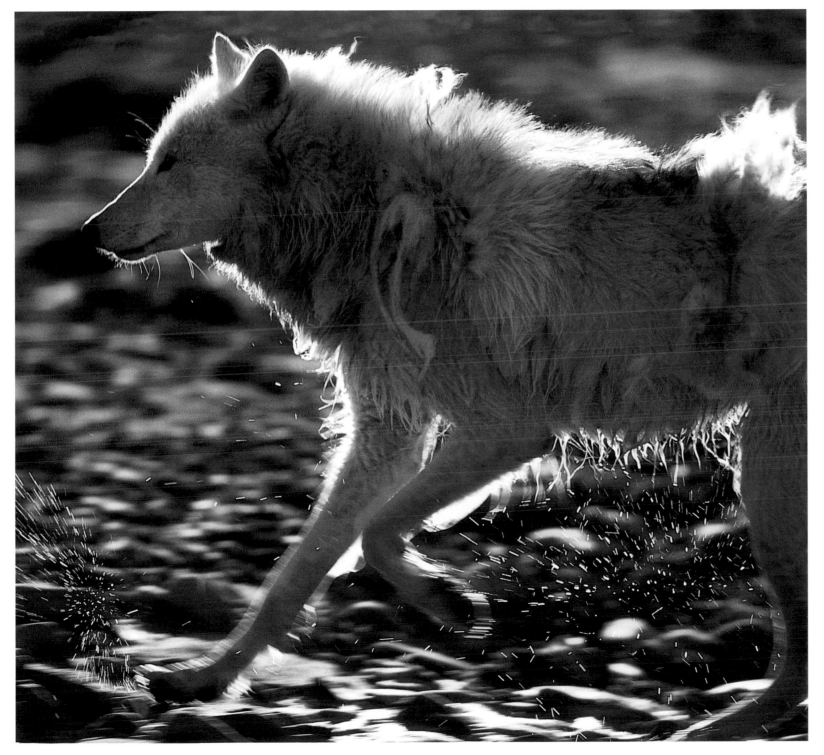

Shaggy tries to stay cool and clean on a warm summer day. The wolves spend much of the brief summer shedding their winter coats. By the time they finally lose the last trailing gobs, the coming winter's undercoat begins to grow again.

backs. It wasn't until I witnessed a musk ox kill that I learned the masks were actually bloodstains mixed with dirt; they occurred after every feeding in which the wolves would thrust their snouts into a fresh-killed carcass. Though I sometimes saw a submissive wolf lick the still-wet blood from the muzzle of an alpha in an ultimate appeasement gesture, more often than not the blood was still viscous when the wolves went to cache the excess meat. To do this, they dug shallow holes in the dirt, deposited the meat, and then used their noses to tamp a layer of soil on top of it. Given the exigencies of such feeding practices, the masks were inevitable.

The legendary olfactory acuity of wolves is another example of their superb adaptation to their environment. It has been reported in the scientific literature that the surface area receptive to smells in the nose of a wolf is 14 times larger than that of a human. Some scientists estimate that wolves can smell a hundred times better than we can. Humans are like the blind in comparison. Between poppy blossoms and offal, there is an extraordinary rich and detailed world of smells that is beyond our abilities to detect. For wolves, though, a breeze provides a constant stream of information about their world.

As with many predators that rely on wind-borne scents to help them find prey, the Arctic wolves tested the wind constantly; their snouts are always cocked in the direction of the prevailing breezes. They seemed particularly agitated and disgruntled on excessively windy days, no doubt finding the flood of random information at once tantalizing and annoying. On these days, they would avoid hunting altogether and wait for a day of steady and moderate information flow.

On one ideal, low breeze day, I followed the pack members on a hunting expedition. They were loping along in their typically indefatigable fashion, testing the breeze occasionally as they proceeded upwind. Suddenly, Midback began to act very excited and focused, and her mood was quickly picked up by her fellow hunters. I could neither see nor smell any reason for

this exuberance, but I raced ahead, skirting a small rise in the direction they were headed. There, off in the distance, was a musk ox herd.

On another occasion, I followed several of the wolves to a nearby beach, where they located a dead fish washed up on the shore. The fish, an Arctic char, had been dead for some time; it smelled quite rank. The wolves, who were usually so fastidious with their white coats, lay down on the fish and began rolling around on it until they had all become steeped in the stench. It seemed bizarre. When they took off on a hunt shortly thereafter, it began to make sense. They were evidently masking their own scent with something their prey had no fear of. While I did not join them on this outing, I wondered if the stratagem proved successful. No need to worry, a hapless musk ox might have reassured itself on some primal level of consciousness: *It's only a dead fish stalking me.*

The wolves' eyesight and hearing were in many regards as impressive as their sense of smell. Once I noticed Buster looking very intently at something across the valley from the den. Because he was staring downwind, I knew it was not smell that had attracted his attention. Try as I might, though, I was unable to glimpse anything unusual. Then I got my binoculars and began carefully scanning the area Buster found so fascinating. After a few minutes of searching, I finally saw an Arctic hare so far away it barely looked like a dot to me without the binocular's magnification.

To test the wolves' hearing range, Mech and I once tried a little experiment. After synchronizing our watches, he headed off to the distant hinterlands while I remained near the den. At a prearranged time, Mech howled. He was much too far away for me to hear, but the wolves appeared to have no trouble whatsoever. They cocked their ears in curiosity, then tilted their heads back and emitted a chorus of replies.

Excellence in all these sensory departments allows the wolves to do more than just locate prey efficiently. Wolves probably are one of the most social animals outside of the

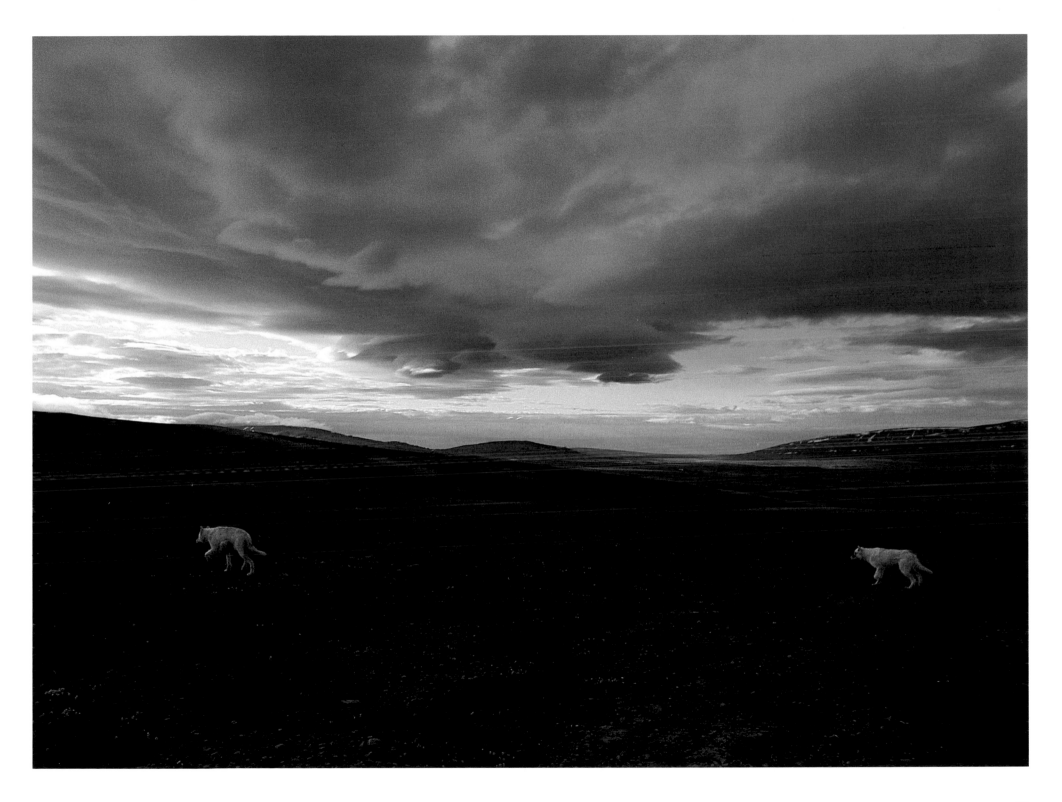

Wolves sometimes seem to howl just for the fun of it. When two packmates hit the same note, they change pitch until discord is reestablished. Such contempt for harmony has a practical side — perhaps a discordant pack sounds larger and more formidable to neighboring packs than a concordant one.

primates, and the success of the pack depends strongly on a highly developed system of communication, not only within a pack but between neighboring packs as well. Smell, vision and hearing play crucial roles in such communication.

Consider, for example, the role of scent marking. Whenever the pack was out roaming around, they would stop every so often to urinate on prominent marker spots, the fire hydrants of the Arctic. Boulders, their favorite iceberg and other prominent spots like our *inukshuks* and tents were regular targets.

They were not doing this to relieve their bladders. In typical canine fashion, they were so adept at rationing small squirts of urine that it seemed they would never run dry. There was one spot in particular, about 15 miles from the den, that they would greet with exceptional tail-wagging excitement. Every time they came to this spot, each wolf would sniff happily and appear to scrutinize the reams of messages they and their fellows had left over the decades. Then they would urinate and defecate once again, adding yet another chapter to the olfactory history of their clan.

Theories abound as to why wolves indulge in scent-marking. Some scientists suggest that the wolves are actually setting out a mapping system to help them pinpoint their exact location within their territory. Their evident excitement at discovering a traditional marking spot tends to reinforce this theory. When I watched them come upon such a spot, they seemed almost to emit a great collective sigh of relief — home again.

It is likely that the wolves are, via the mapping process, simultaneously erecting a boundary to tell adjacent packs to stay out. One evidence for this is the fact that wolves leave their "calling cards" with much greater frequency on the perimeter of their territory rather than in the interior. I am virtually certain that individual wolves can distinguish the urine of their packmates from that of strangers. As with human tribes, clearly defined boundaries reduce internecine fighting;

good fences, even olfactory ones, do make good neighbors. Wolves, ill-suited to the art of construction, build instead a kind of Urine Curtain; the more pack members there are to participate, the stronger the wall and the greater the deterrence against invaders.

The sonic equivalent of scent marking is the wolf's howl. Often I watched the whole pack, including the pups, join ranks in a great collective songfest. Each had his or her distinctive voice and a preferred range of notes. Midback, for instance, had a high-pitched, almost whiny cry that stood out in comic contrast to human stereotypes. Left Shoulder, on the other hand, would howl in the lower octaves. One thing was certain. Whatever their preferred notes, wolves seem to hate hitting the same note as a packmate, and when this happened by accident, they frantically shuffled about until discord was once more reestablished.

This is a fascinating behavior that I had previously witnessed in Minnesota with a pack of five captive timber wolf puppies that I had occasion to raise near my home. "The boys," as I referred to them, had accepted me as a surrogate packmate. Many evenings, I'd howl back and forth with them, apparently to our mutual delight. Whenever I would try to match a note that one of them was hitting, however, he would immediately change pitch. This was but one of many captive timber wolf behaviors that correlated almost exactly with behaviors observed in the wild Arctic pack.

The reason for the wolves' contempt for harmony is well-rooted in evolution. Studies have shown that their predilection for cacophony is highly pragmatic. By varying their tones, a pack can project the impression of greater size; adjacent packs presumably will think twice before engaging in territorial encroachment, dissuaded by the rank on rank of phantoms echoing in the night. I know I have been fooled. Once, while winter camping in Minnesota, I heard a wild pack howling in the distance and estimated the size to be at least eight wolves. Later, however, while snowshoeing across a cedar bog, I came

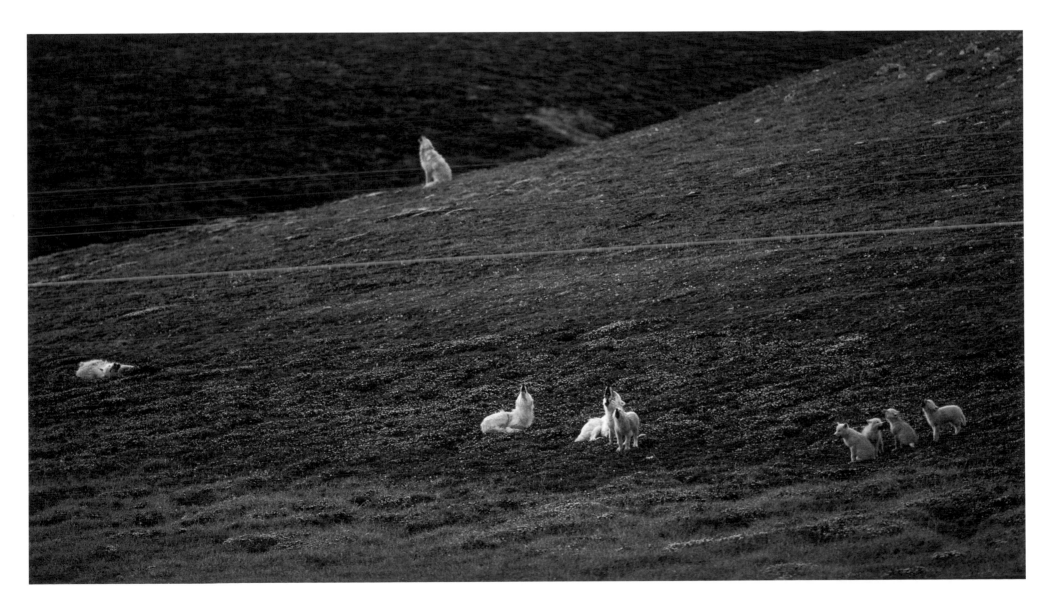

across the pack feeding on a previously killed moose. The entire pack consisted of only four wolves.

Howling begins at a very early age as an offshoot of the yips and food-begging whines that pups offer whenever they are hungry, that is to say, at practically every waking moment. Within weeks of their emergence from the den, the pups cock their tiny snouts to the sky right alongside their parents.

Wolves howl for many reasons beyond signaling their location to other packs. When several pack members are left behind at the den while the others go off on a hunt, both groups will sometimes howl back and forth; the former perhaps out of hunger and disgruntlement, the latter perhaps to communicate their position and keep in touch with the home base.

After a long sleep, too, wolves will howl, perhaps to work up group enthusiasm for the next hunt. In this regard, they reminded me of team athletes shouting in unison before a big game. Often on Ellesmere I watched this lupine *reveille*, and the ritual seldom varied. One wolf, usually the alpha female, would wake up first, yawn, stretch a few times, and walk around sniffing her packmates. Then she would begin to howl, as if to say, *Hey guys, it's time to go hunting.* One by one, the others would rise up and start howling, the pups included, and soon their voices would echo through the surrounding valleys.

Beautiful as this chorus was to me, to any prey within earshot it must have been a worrisome sound. Perhaps this was yet another reason for howling—an attempt to add one more enervating stress to the lives of those they wished to catch. Sinister overtones aside, sometimes wolves seem to howl purely for pleasure. It's impossible to watch them singing, in their animation and amiability toward one another, and not get some sense that they are enjoying themselves.

At times like this, the urge to start howling with them can be overwhelming. In northern Minnesota, I had done this many times at night, not only with the pups I raised but also with wild packs living near my home. It is hard to describe the satisfaction that comes from such "discourse." When Mech and I got to Ellesmere, though, we resolved to steadfastly avoid giving in to this impulse near the den site for fear it would upset the pack.

For most of the summer, we kept to this agreement. Late in the season, however, with Mech back in the United States, I found myself one sunlit night listening to a magnificent song session. At this point, I had been living alone with the pack for a couple of weeks, and the absence of human communication might have influenced me. In any event, the temptation to join in and howl overcame me. I just couldn't contain myself. My head snapped back, my lips pursed, and I raised cupped hands to my mouth in makeshift simulation of a resonant snout—*Aaaah ooooooo! Aaah aah aah oooooooooo!*

I had barely enjoyed a single moment of trans-species satisfaction when Buster and his cohorts cut short their own howls and began acting in an unusually agitated way. Surveying me with eyes more piercing than I had ever seen in them, the alpha animals became especially "hyper" and suspicious. Buster immediately took charge of the investigation. His ears stiffened, his tail became erect, and he started to prance nervously as he approached me.

Perhaps he and the others assumed that another pack was lurking right behind me. Or maybe they thought I had metamorphosed into a strange, deformed wolf of bipedal design. That they became so upset should not have surprised me. If one of them had started to blather away in English gibberish, I would have been upset, too! They remained agitated for much of the next week before they settled down. I, of course, did not repeat the experiment. For whatever reason, the wolves preferred to think of me as anything but another wolf.

Midback, the most ambitious in the pack, wakes up ready to hunt. She attempts to rouse her packmates by nudging them one by one. When this fails, *she begins to howl. No one can sleep now. Soon the other adults join in the chorus until the whole pack is ready for a hunt.*

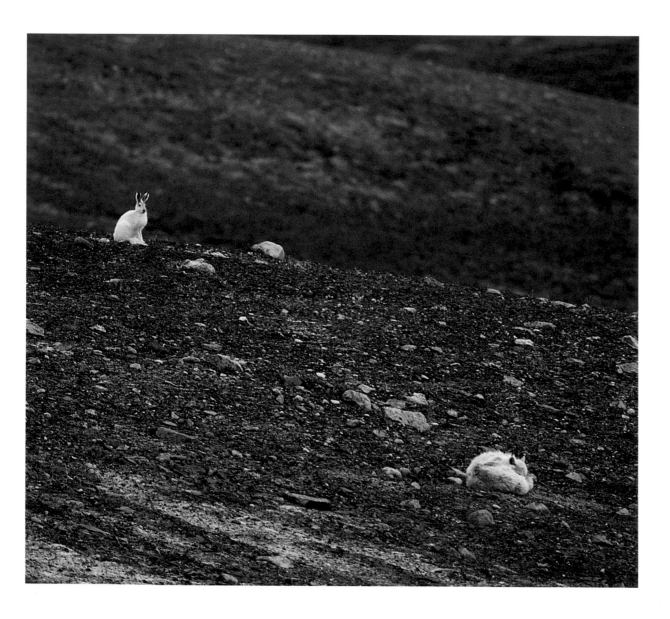

An Arctic hare inadvertently hops over a rise where Lone Ranger lies sleeping. He wakes and gives chase, quickly joined by several scampering packmates.

Overhead, a long-tailed jaeger joins in the fray, hoping to snag a scrap if the wolves' chase proves successful.

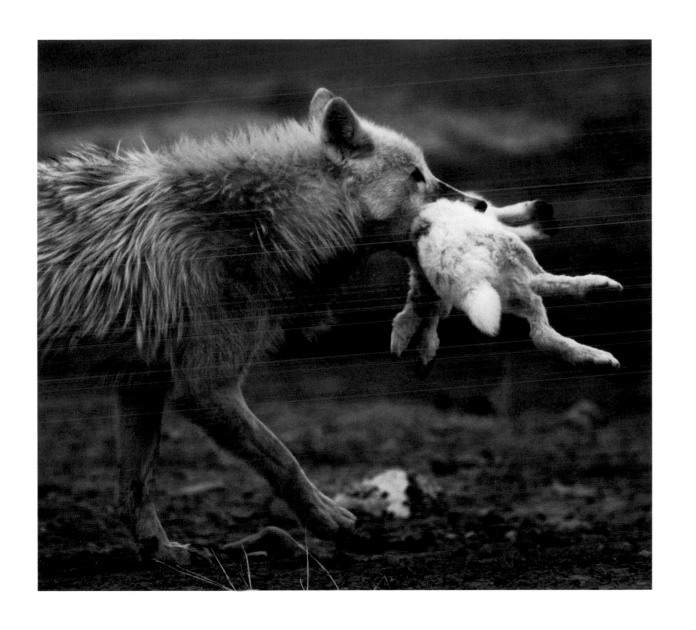

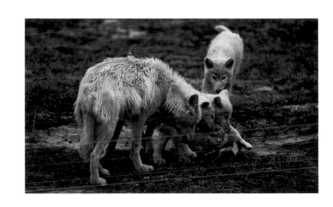

*Midback, the pack's
most agile hare hunter,
catches the prey and
carries it, with haughty
pride, to bestow upon
the grateful puppies.*

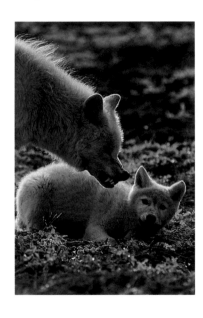

The pups receive constant growling reminders from Scruffy of their low status in the pack. (Opposite) Scruffy, the yearling scapegoat, receives similar messages from his own elders.

s with any society, the threat to a pack's survival is as likely to be internal as external. Each wolf depends upon the harmony of the pack, and lack of cohesion among pack members can be as devastating as encroachment by alien wolves. My howling had demonstrated the wolves' reaction to a perceived external threat. Earlier in the summer, however, I'd experienced an even more severe reaction. That time I had inadvertently overstepped my "place" in the pack's hierarchical structure.

It was the only occasion during my stay with the wolves that I experienced fear. As a result, the incident made a great impression on me, and I came away from it fully appreciating the deadly earnestness with which the wolves take the whole business of pack hierarchy and the gestures of dominance and submission by which this system is maintained. Late one morning I discovered Buster chewing on a seal pup carcass he'd either killed or found washed up on the beach. I'd been living with the wolves alone for nearly a month, but this was the first time I'd seen a pack member eating seal meat. Unfortunately for me, Buster had dragged the carcass into a slight valley where the lighting was poor for photography.

After about 20 minutes of munching, he stood up and trotted away. Assuming he was finished with his meal, at least for the time being, I walked over to the seal and began to pull it into the light. It never occurred to me that Buster would be vexed by this; I'd lived with the wolves long enough that I certainly felt no reason to fear any reaction he might have. This

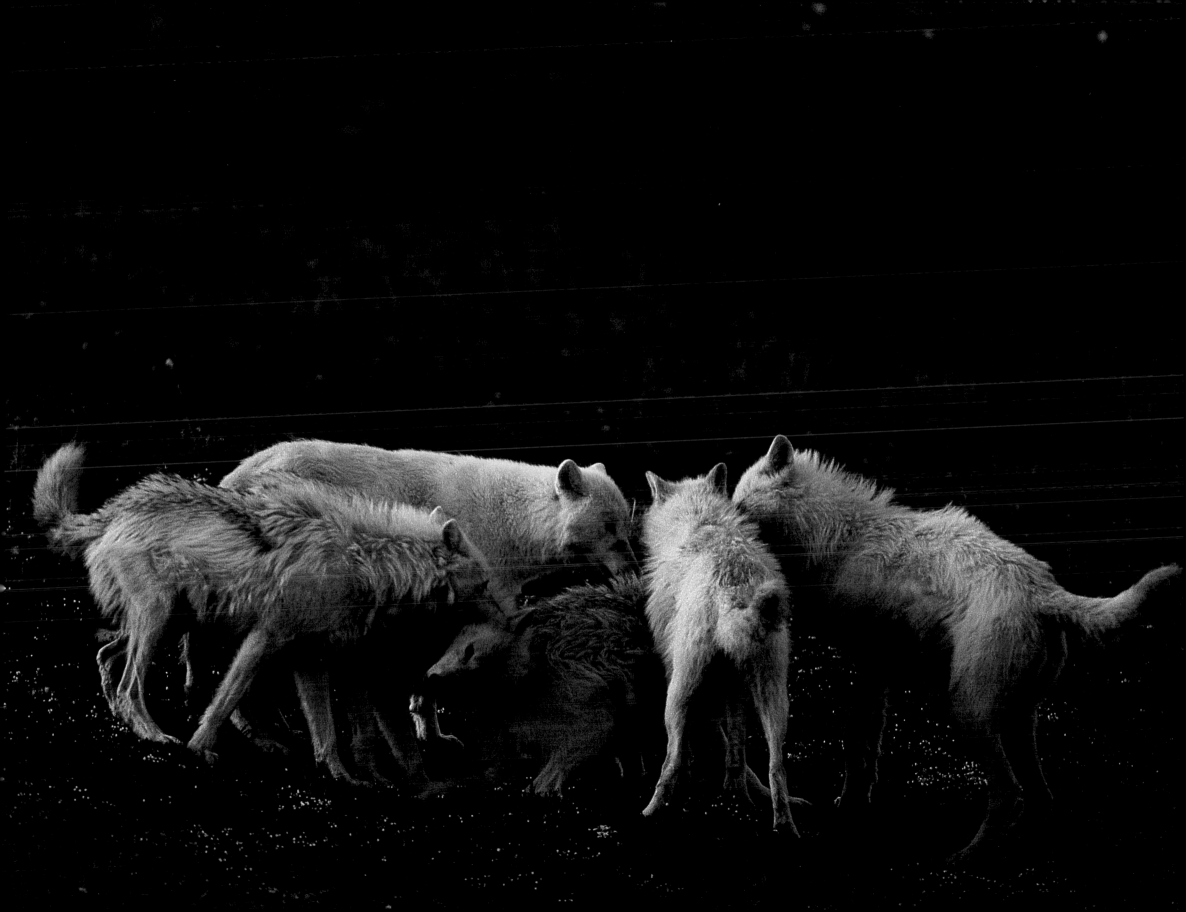

was a big mistake. Within seconds, Buster was nearly upon me, his hackles raised, his ears cocked forward. He had a look in his eyes that was unmistakably threatening. If I had run, there is no question in my mind that he would have attacked. Instead, I immediately dropped the seal and very slowly, with all the submissive posturing I could muster, backed out of the area.

I assumed that Buster would treat me with increased skepticism for the remainder of my stay, and I berated myself for having indulged a bone-headed move that might jeopardize my relationship with the whole pack. As things turned out, though, this self-criticism was unnecessary. Following my fearful retreat, Buster began to treat me with *less* suspicion—indeed, he seemed noticeably more relaxed around me than he had before. It was not until much later that a plausible explanation occurred to me: in my groveling retreat, I had demonstrated my submission to his dominance. On some level, Buster *knew* he'd sent me fleeing with my tail between my legs. With our respective places in the greater scheme firmly established, he was free to ignore me, secure in the knowledge that I posed no threat to his dominance. Ever since this episode, I've joked about building a mechanical tail for myself that I could raise and lower with a concealed string.

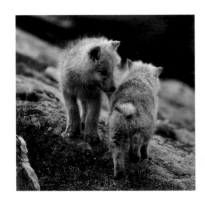

Among the wolves, symbolic displays of one's place in society are no laughing matter. Such displays occur almost constantly. I shot a very telling photo sequence of Left Shoulder sitting next to Buster and begging for his attention. Despite Left Shoulder's most earnest sycophancy, whining and licking the dominant animal's muzzle, Buster paid no attention to him.

Clearly, there are reasons for such behavior, and the wolves are not indulging themselves in an attempt to be cute or to imitate human corporate etiquette. The natural scheme is the arbiter of the final rules. For eons, evolution and natural selection have been optimizing solutions to the major problems wolves are likely to encounter. A well-entrenched and frequently reinforced hierarchy solves at least two problems splendidly. First, the pack must function as a solitary unit to bring down large and dangerous prey and it makes sense to have a strong individual to take the lead during hunts and allow the pack to function as if with one mind. Second, a hierarchy permits the individuals in the pack to conserve their energy instead of squandering it in constant intramural bickering and fighting. For the less aggressive wolf, it is far better to roll over and expose one's genitals than to stand one's ground and be attacked.

Dominance and submission are communicated largely through body language. In any given exchange, the dominant animal tends to appear cocky and aloof. He or she stands tall, with ears pricked forward and tail held relatively high, filled with an unmistakable confidence. The submissive animal, on the other hand, seems to slump as close to the ground as possible, almost as if seeking refuge in the earth. The tail curls between the legs, the ears are tucked back, and there is an expression on the face that seems to say, *Like me, please—or if that's not possible, at least don't bite.* Indeed, the lower-ranking wolves are so conditioned to respond this way that a single stern glance from an alpha wolf is usually enough to put them in their place.

How alpha status is established is not fully understood. It is known that patterns begin to unfold very early in life. Though the puppies all looked the same to me, they began to evince behavioral differences almost from the first day they emerged from the den. One pup in particular liked to jump up and knock the others down. This pup, whose gender I never determined, always got first crack at the food.

In watching this behavior, it was interesting to note that the dominant pup was not the biggest one, but was apparently the most aggressive of the litter. The same situation existed among the captive pups I raised in Minnesota where the most dominant at an early age was a rather small female. Some scientists have hypothesized that hormone levels play a major

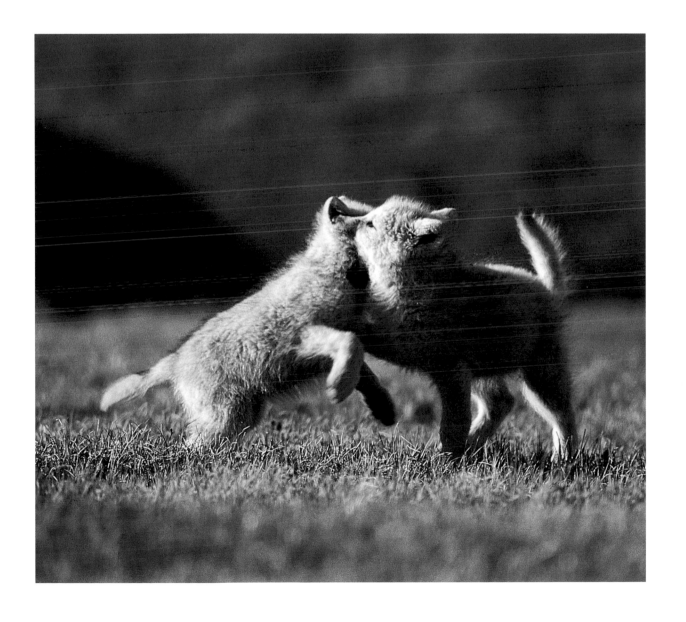

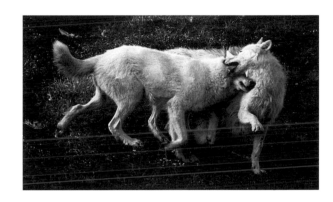

At a very early age, the puppies begin to jockey about for dominance over their littermates. For pups and adults alike, it's not always the biggest but the most aggressive wolf that wins these tests of will.

85

Despite the deadly earnestness with which the pack must pursue its struggle for survival, the wolves find a surprising amount of time to goof off and play.

role in determining early dominance, but the road from dominance in puppyhood to being the alpha male or female in a pack is a long one. Young wolves work their way up by means that are at once highly complex and no doubt quite dependent on the pre-existing pack structure. Take Scruffy, who was the lowest ranking member of the adults. In his role as baby-sitter, Scruffy seemed to enjoy being able to dominate for a change. Many times, when I watched Scruffy and the pups "playing" together, his behavior seemed, to human eyes, almost cruel. He would tackle the little wolves, bowl them over, nip at them, and make them yelp in pain.

Still, what seemed to be happenstance bullying, a kind of compensation for Scruffy's own declasse status, was much more complicated than it appeared. Even the beatific Mom also knocked her pups down on a number of occasions. If a pack's survival depends on the acceptance of hierarchy, then it is crucial to learn this lesson well and early. As headmaster of the Arctic School of Hard Knocks, Scruffy taught the youngsters a little of what they would need to know to survive.

Not that the pups were supposed to become uniformly meek and cringing animals socialized to sublimate all of their needs to the wishes of their adolescent "superior." As they grew a little older, the pups took an occasional stand against Scruffy as well as the other adults. One pup, for instance, secured a scrap of food for himself after scavenging around the den site. When Left Shoulder approached, the pup growled in a proprietary way. Though evidently hungry, Left Shoulder deferred to this juvenile declaration of ownership and retreated.

By adulthood, alpha status ultimately seems to be most crucial in reproduction and eating. After a group kill, the alpha male and female almost always eat first, and not until they have glutted themselves do the lower-ranking pack members feed. Still, at least they *can* feed. When it comes to reproduction, they are not usually so lucky. It is not for want of trying. I've heard reports that during the early spring, many wolf pairs will attempt to mate, but generally only the attempts by the alpha animals prove successful. This is because the alphas, spying a potential tryst by subordinates, will run over and knock the would-be lovers down, interrupting their copulation. The genes of the subordinates are thus passed on only indirectly, through the reproduction of their alpha relatives.

However, it is interesting to note that in this particular pack, the alpha female did *not* mate with the alpha male, a perfect example of the danger of generalizing. Though it can be comforting to project neat patterns, life tends to be much more complex than theory. Perhaps a wolf's position in the pack changes at different times of the year. Maybe Mom, free from maternal duties, usurps alpha status from Midback in the winter months, when it is too dark and too cold for humans to observe.

Indeed, much of the pack's interaction remains mysterious. Dominance works in inscrutable ways. Consider how hunting decisions are made. One day, I saw the adults wake up and trot in single file about a mile from the den. They gathered in a small valley. I watched through binoculars as they proceeded to howl, wag their tails vigorously, sniff one another and generally yuk it up in a kind of wolf huddle. After about ten minutes of this, Scruffy and Mom headed back to the den while the others left on a hunt. Judging from Scruffy's disappointed expression and frequent whines, this was evidently a decision that displeased him.

To reach this decision, the wolves had engaged in some kind of discussion, with the alpha animals perhaps having the greatest say. But whether Buster and Midback in some sense ordered Scruffy and Mom back to the den, or whether the whole pack decided this in a manner suggesting some odd lupine democracy, it is impossible to say.

Time and again, I found myself impressed by the elusive intelligence of the wolves. They knew what they were doing even if we didn't have a clue why.

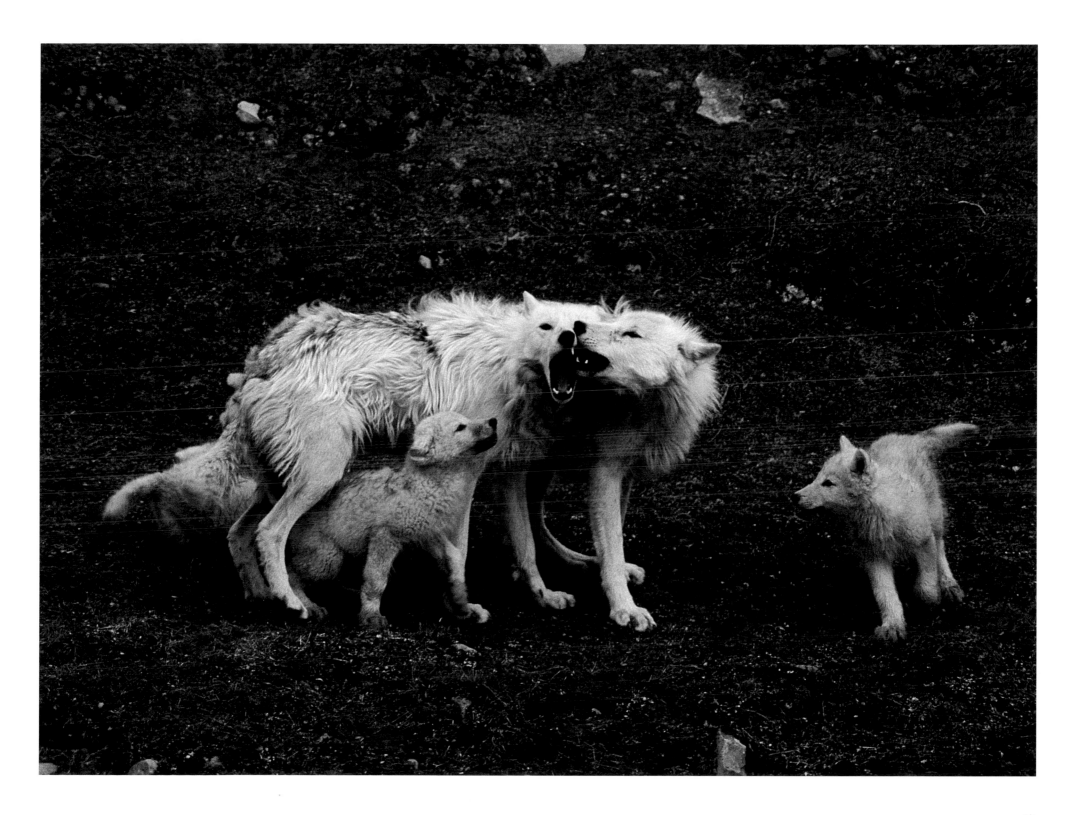

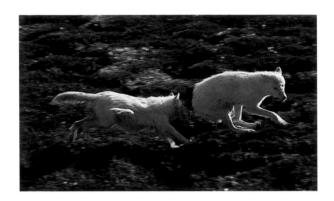

Two young adults play wolf-tag—a sort of intramural scrimmage that hones their predatory skills.

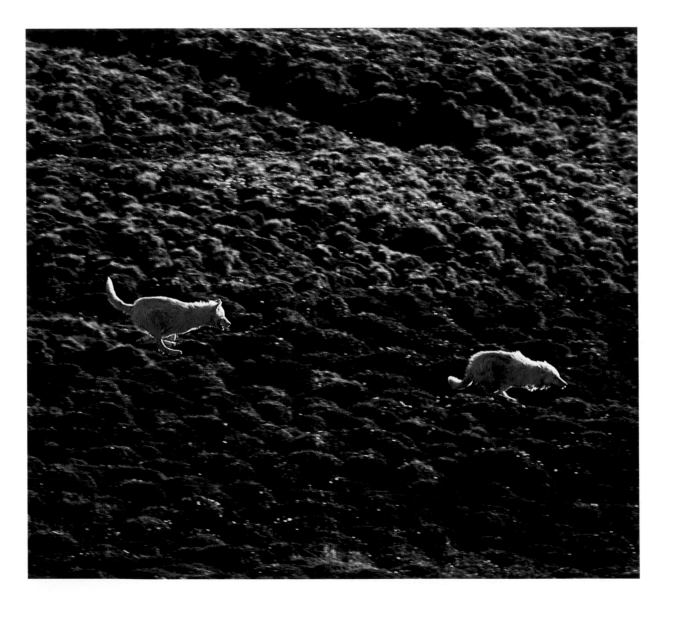

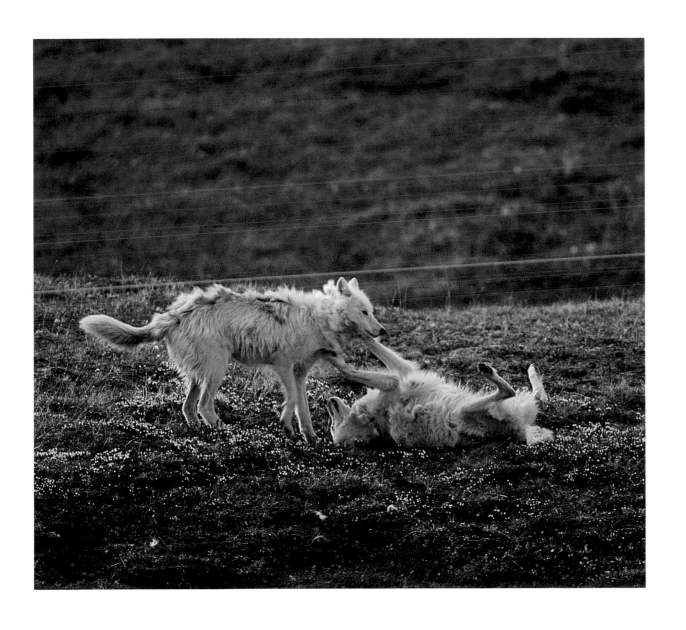

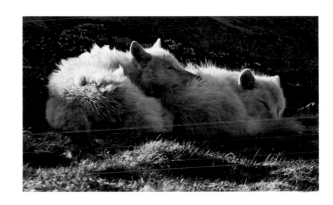

When the game's over, the wolves enjoy a tender moment before curling up for a side-by-side nap.

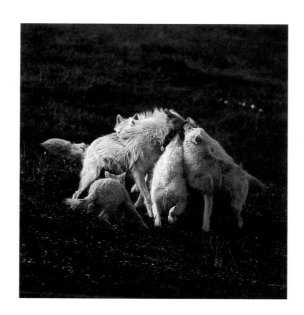

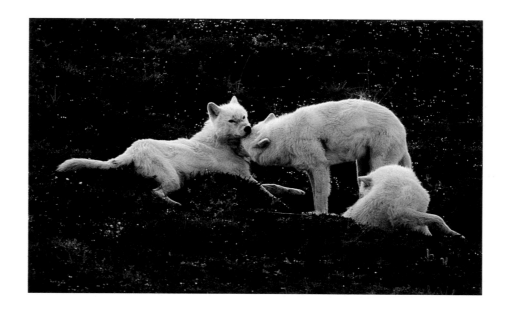

The wolves seem to constantly reassure one another with physical contact. A bundle of wolf-flesh comes together at an apex of five noses; Buster enjoys an appeasement gesture from the larger but subordinate Left Shoulder. (Opposite) Buster himself appears to bow before a respectful offspring.

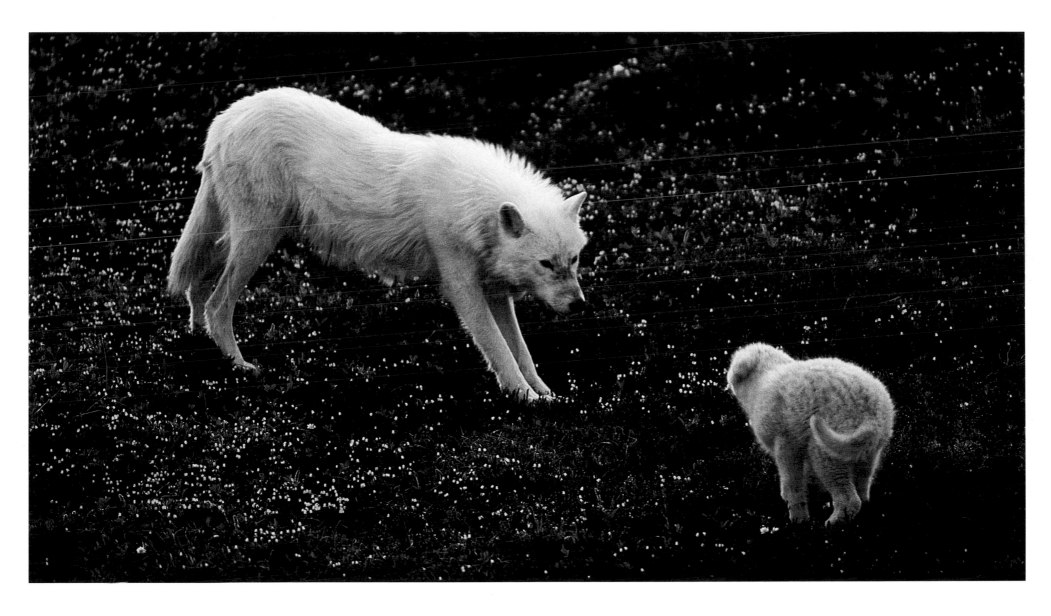

For a few brief weeks in summer, Arctic poppies bloom a foot above a thousand-foot crust of permafrost. (Opposite) The wind carves moguls into the ice pack offshore.

J

he high Arctic setting in which the wolves play out the intricacies of their lives is as beautiful as it is severe. The lack of winter daylight, the bitter cold and the desert-like aridity combine to make Ellesmere an extraordinarily difficult place for life to gain a foothold. Over millions of years, however, a stalwart crew of species has managed to survive and establish a food chain that eventually winds its way down the wolf's alimentary canal.

There are abundant lichens, those strange, often multicolored amalgams of fungus and algae that conspire to eke out a collaborative living on bare rocks. The acids produced by this symbiosis leach into a stone's surface, and over time, boulders begin to break down to sand and soil. A variety of grasses and sedges can, in turn, find cracks in which their root systems can proliferate, further expediting the breakdown of rock.

Grasses and sedges are closely related. The former are characterized by smoothly circular stems, the latter by multisided stems, like pencils, that rattle when they are twirled between the fingers. Both are prized by Ellesmere's indigenous grazers. In an environment where the number of plant species is so constrained, most herbivores are adapted to eating just about anything that grows. Sometimes the wolves, like their relatives, domesticated dogs, chewed on a stem of grass. Such forays into vegetarianism were almost always followed by regurgitation; the wolves were evidently using the grass as a purgative.

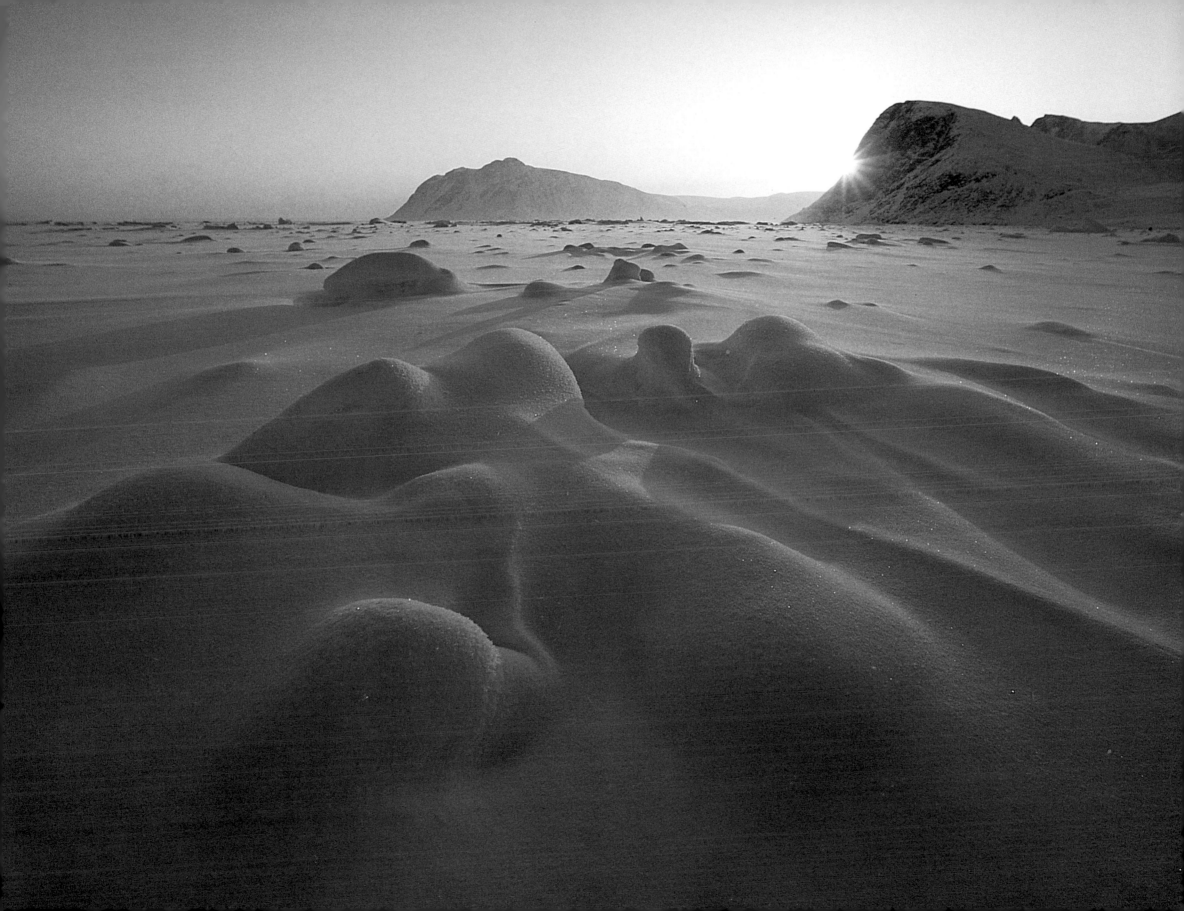

The Arctic fox, one of Ellesmere's most superbly adapted carnivores, turns dark grey during summer months. Wolves view the fox as a competitor and take every opportunity to kill them.

The tiny Arctic willow, a true perennial, is the only tree living on the island today, but it is dwarfed by various flowering plants which can grow to a relatively towering ten inches high. As the wolf puppies grew older, I often witnessed them sniffing these flowers—poppies, mainly—that blossom in a brief, erratic explosion during warm weather.

Insects exist on Ellesmere in all the typical groups seen in more moderate climes, from moths to bumblebees to mosquitos. But the life cycles of these creatures are exceedingly peculiar. One type of woolly caterpillar, for instance, closely resembles an American variety that takes a year to go through its metamorphosis from egg to moth. On Ellesmere, however, this same metamorphosis takes a dozen or more years. Every summer, the caterpillar emerges from dormancy, eats a little greenery to fuel its painstaking quest for wings, then returns to dormancy for another winter. Knowing all that they had been through, I found myself thinking twice before I would swat a moth.

I was not so altruistic when it came to mosquitoes. During much of the summer, these bloodsucking banes of the north were virtually nonexistent. Every once in a while, when it got warm and wet, a satanic brood of them would hatch to make our lives miserable. One day there were so many mosquitoes landing on the lens of my camera that the resulting photographs looked like they were taken in heavy fog.

On another occasion, I was attacked by a massive swarm just as a freak summer snowstorm began cascading from the sky. I expected that my tormentors would disappear in the thick wet flakes, but the horde kept up its attack, flying through the precipitation like a squadron of fighter pilots negotiating flak. Finally, they began landing on an unguarded patch of throat here, a sliver of unsleeved wrist there. They crept and crawled around, looking for any spot to penetrate. Most of the time, I could swat them before they bit.

The wolves had their own ways of dealing with the mosquitoes. While the pups generally retreated to the den, the adults would light out for the windiest hillsides they could find, hoping the air flow would provide relief. On still days, when the situation was close to unbearable for me, the wolves took the attacks stoically. They curled up in tight balls with their tails looped protectively over their noses and slept, reflexively twitching their tails all the while. On such days, I greatly envied their hides and equanimity.

Birdlife on Ellesmere consists of a few species living year-round in the Arctic and a larger number of species spending summers there. The rock ptarmigan is perhaps the best example of the first group. This plumpish white bird survives the winters thanks in part to its great feathered coat; even the ptarmigan's feet are feathered.

Long-tailed jaegers, those scourges of Scruffy's existence, are another indigenous northern species. They have adapted to the environment by more or less splitting their personalities in two. During the summer, they nest on land and feed opportunistically on small mammals, carrion and other scavenged meat. In the winter, they fly out to the open waters of the Arctic Ocean. There, using their duck-like webbed feet for propulsion, they swim and float about for months.

The list of migratory birds on Ellesmere includes Arctic terns, ivory gulls, snowy owls, snow buntings, ruddy turnstones, red knots, gyrfalcons, and Arctic loons. While all are fascinating birds, none so captured my imagination as that of the Arctic tern, a black-headed bird with sharply angled wings and a tail with twin points. Every year, this bird flies 24,000 miles from Ellesmere to Tierra del Fuego, the longest migratory route known. It lives most of its life in constant daylight, alternating between the 24-hour days of the far north and the far south.

One of the most poignant scenes I witnessed during my stay with the wolves involved a colony of these terns nesting two miles from the den. One afternoon, I was following Left Shoulder on his scavenging rounds through the neighborhood. It began to rain, and the rain soon turned to sleet and ice. Just

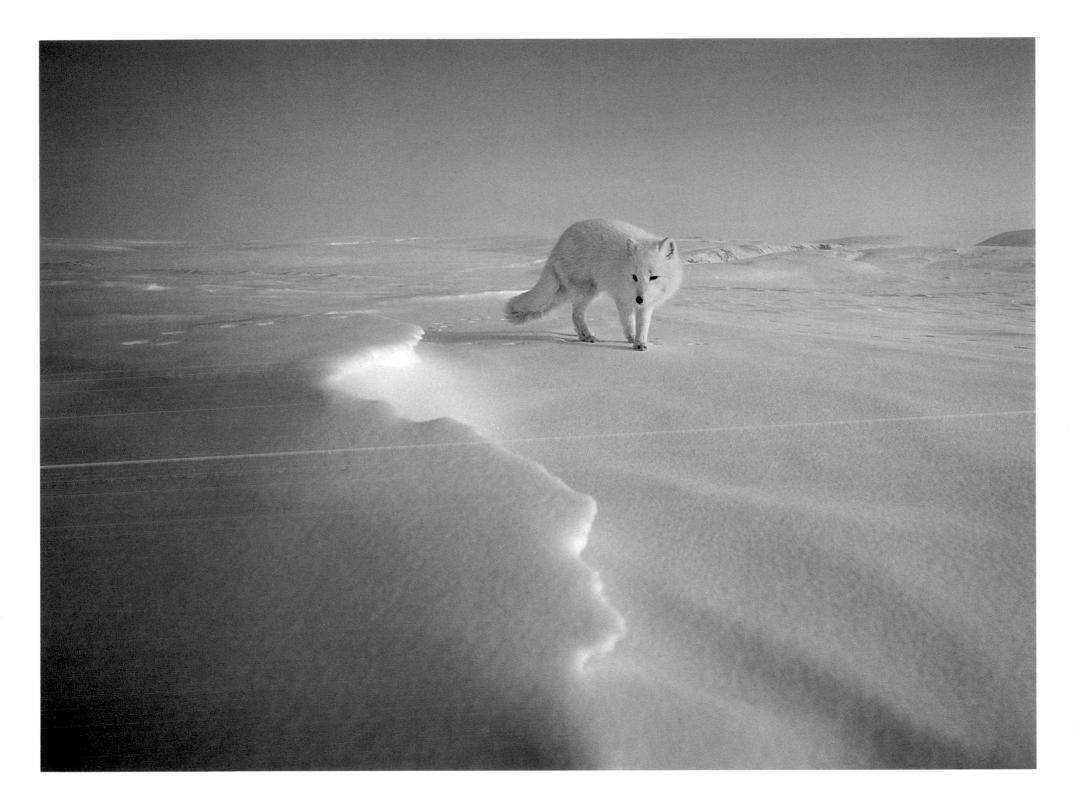

then, Left Shoulder discovered the colony and began to cut a hungry swath through the nesting birds. Predictably, the parental terns began to flock about him, dive-bombing his head in an attempt to protect their young. Had he come across the nests an hour before or an hour after the sleet storm, this strategy probably would have saved most of the offspring. But as I backtracked through Left Shoulder's line of march, I found dozens of young birds dead from exposure in their nests, victims of their parents' best instincts.

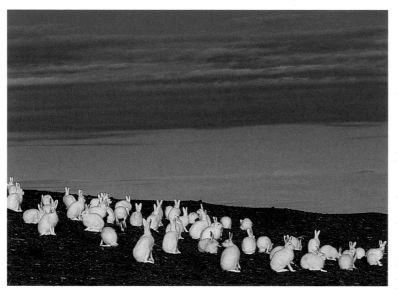

This struck me as very sad. After flying virtually across the entire earth to reproduce, the adult terns watched a year's worth of progeny wiped out by the casual stroll of a wolf seeking a few extra grams of protein. I found myself almost angry at Left Shoulder. However, survival is a precarious business for all species, and natural selection has never found much room for altruism between predator and prey. Every fall the terns would fly back to South America, fatten up and ready themselves to try again.

Ellesmere Island was also home to a variety of fish and aquatic animals. The Arctic char, which is related to trout and salmon, has been described as the best-tasting fish in the world. The wolves regularly patrolled the beaches near the den hoping to find char washed ashore. In fact, the most popular photograph I took of the wolves, *White Wolf*'s cover shot, shows Buster leaping from ice floe to ice floe, looking for just such a delicacy.

Buster often took charge as the wolves investigated every nook and cranny of their considerable territory. On this occasion, the wolves had just spent hours trotting at a steady pace

In early autumn, herds of 200 or more Arctic hares assemble in the hills for reasons that remain mysterious.

along the beach. What they hoped to find on these ice floes, which were floating about a dozen feet from shore, is hard to say. Perhaps they were only taking a break, having some fun. Buster jumped to and fro for several minutes, apparently enjoying himself, before bending to drink some water. Though Eureka Sound opens out to the ocean and its water is definitely salty, I suspect that a thin layer of fresh water, the result of melted ice, was floating on the surface.

Large sea mammals also live in the waters off Ellesmere. White beluga whales swim in smallish groups in the inlets, and one day I watched about 200 narwhals, the unicorns of the sea, herding offshore. The wolves must dream of the day when one of these leviathans will wash up on the beach.

On the east side of the island, walruses abound. Seals were also common. According to the weather station personnel, the wolves sometimes stalked the seals that lounged on the ice. Though I did not see this myself, I was told that the wolves worked in pairs, the first one pacing back and forth to distract the seals, the second sneaking up to pounce from behind. Though I have no reason to doubt this observation, I should add that I never watched the wolves employ this strategy with other prey.

Hunting Arctic hares, for example, might be expected to lend itself to the pairs approach, but I never saw the wolves go after them in anything but a random, every-wolf-for-itself kind of way. These huge white hares, weighing about 12 pounds each, spent the fall in tight herds designed to confuse their predators. Whenever the wolves approached a grazing herd, the hares behaved at first like a flock of birds, moving in synchrony as if possessed of one collective mind. After a while, though, this organization would give way to a randomized blur of white puffs scattering in every direction. All the while, the hares hopped along on their hind legs, bobbing almost like miniature kangaroos across the tundra. A wolf caught in such a maelstrom would, I suspect, find it difficult to keep track of any given hare and would quickly exhaust itself

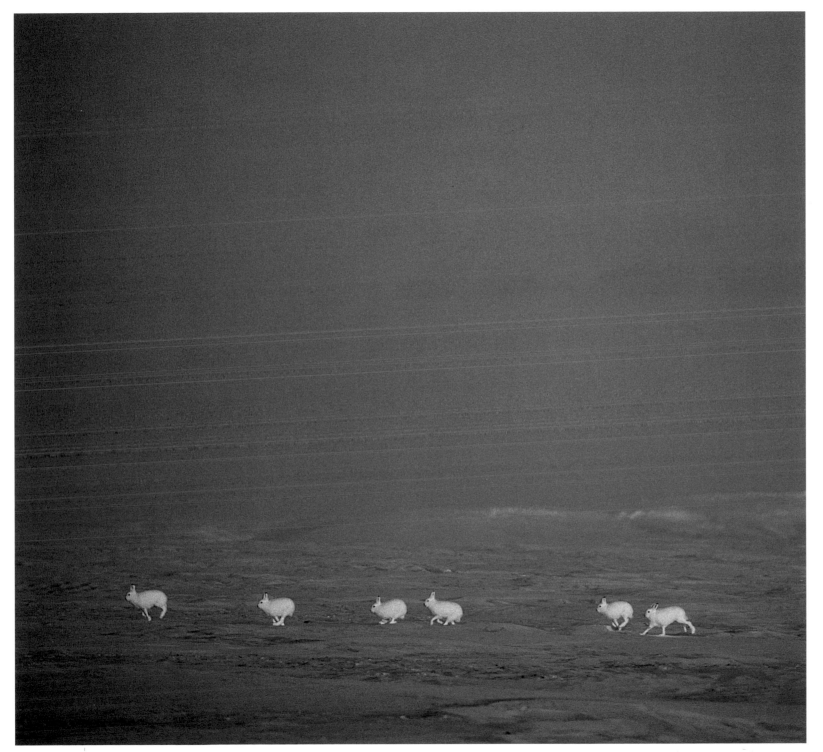

Arctic hares, which can weigh up to 12 lbs. each, must dig beneath the snow for vegetation to eat.

in the hopeless pursuit of one doppelgänger bunny after another.

The other major mammalian predator of Arctic hares is the Arctic fox, which ironically is smaller than its prey. These foxes are beautiful white animals that for some reason, probably competition, seem to be utterly despised by the wolves. Once, Midback spied a fox, quickly caught and killed it, and brought it back to the den as one of many trophy toys she gave the pups. Scruffy joined in during the presentation, and the two of them encouraged the pups to "kill" the already dead fox over and over again. One pup would grab it by the throat and shake it ferociously, growling. Another would join in, and the two would play tug-of-war for a while. Eventually, another, typically the most dominant pup, would steal it away and run in a spiral of figure eights with his littermates in pursuit. When the pups tired of their game, however, Scruffy or Midback would push what remained of the fox back toward them in an effort to get them to kill and quarter it all over again. After several days of these lessons in the art of becoming a wolf, all that remained of the fox was a mass of mashed bones, a skull, and a well-chewed shock of fur. Eventually, this spent rag doll joined the other skeletal remains of foxes that littered the sand outside the den.

Curiously, the wolves never seemed to eat foxes, though they ate almost anything else that moved. Their favorite prey species were the large grazing mammals, primarily musk oxen and caribou. One variety of the latter, the so-called Peary caribou, was especially delightful. These whitish, elfin creatures seemed to be characters straight from a fairy tale. They derive their name from the famous explorer, who along with other explorers almost wiped the species out by using it for food during expeditions. Though Peary and others took a similarly harsh toll on the indigenous musk oxen herds, the musk oxen populations have rebounded. A series of severe ice storms over the past 20 years, however, has made rebounding difficult for the Peary caribou. Apparently, these storms covered the dormant grasses and sedges with a crust of ice too thick for the caribou to penetrate, and they suffered mass starvation.

It is unlikely that wolves play much of a part in the problems of the Peary caribou, though lupine hunting pressure cannot be completely dismissed. Throughout my Ellesmere story, I never saw the wolves stalk Peary caribou. I did find a carcass several miles from the den, however, and several times ran across evidence of predation such as caribou hair in wolf scat. Newborn calves seem most vulnerable because of their temporary immobility, but within as little as two days they can run nearly as rapidly as their mothers.

I'll never forget my first encounter with Peary caribou. I spotted a herd about a half-mile away, and in my excitement I tried to sneak up on them. Of course, they saw me sneaking and ran off into the distance. I was acutely frustrated; I'd been searching for a herd for weeks, and I desperately wanted to photograph them. Knowing it was hopeless to try to catch up with them on foot, I turned back toward camp.

As soon as I turned my back, they began to scamper back toward me. Once again, I was impressed by the amazing sensitivity some animals seem to have to human moods. It's uncanny, this almost telepathic awareness of subtle vibrations of humans trying to be sneaky. For the next several hours, I moved in as natural, open and non-threatening a manner as I could, approaching as close as 20 feet, taking advantage of their natural curiosity. From this distance, I could even see the lines on their muzzles where the hair had been shaved off by crusts of snow.

The ability to successfully graze through snow, of course, is a *sine qua non* of ungulate survival. All winter long, the musk oxen too will use their horns and hooves to scrape aside the snow and ice that blanket their food. Fortunately for all the grazers of the high Arctic, the grasses and sedges that make up the bulk of their diets are high in nutritive value even during the long dormant season. In this regard, these plants are

The hares on Ellesmere sometimes stand on their hind legs and hop along like miniature kangaroos. This added height affords them a better view of lurking predators.

Close relatives of European reindeer, the diminutive Peary caribou derive their name from polar explorer, Robert E. Peary, who took a major toll on Elles- mere's herds to feed his men and dogs. Decades later, the population has still not rebounded.

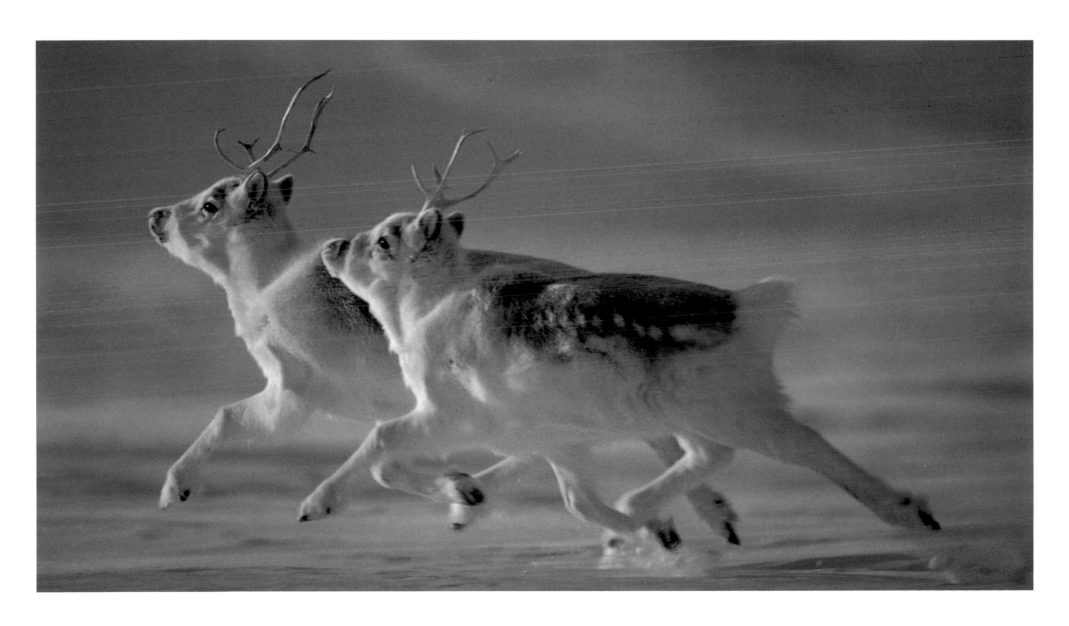

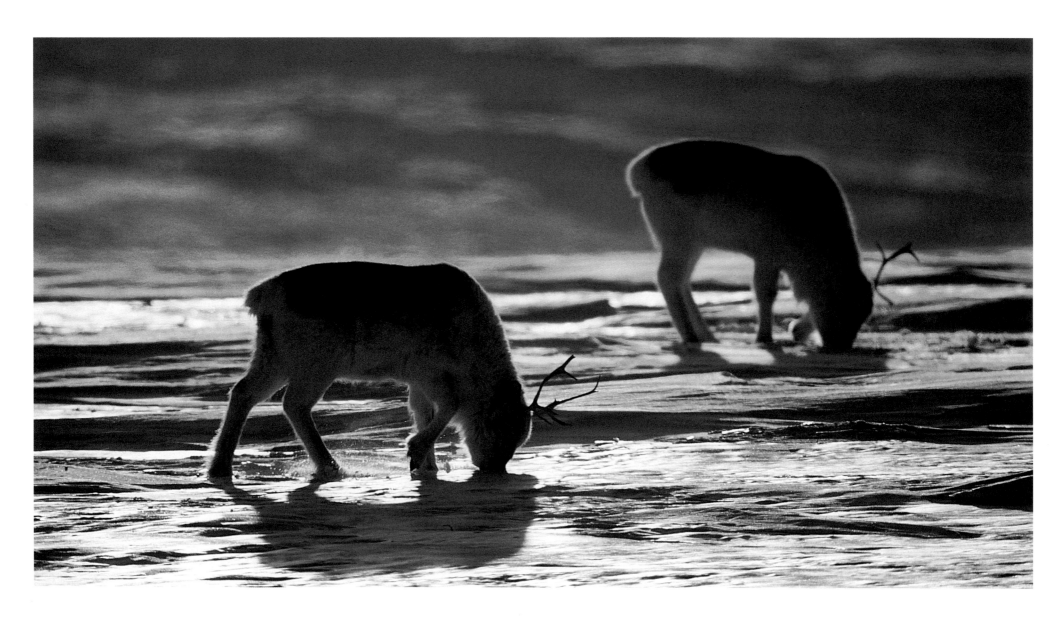

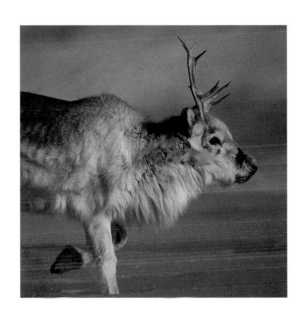

As Peary caribou graze on dormant grasses and lichens beneath the snow, the ice crust shaves an inch band of fur off their muzzles. A series of ice storms in the 1960's made this crust too thick to penetrate, and many of the animals starved.

not unlike hay harvested on the temperate plains and stored in barns for winter.

At the pinnacle of the Ellesmere food chain are the large predators: wolves, polar bears and humans—three occasionally competing species whose interactions are not always harmonious. The polar bear can weigh over a thousand pounds and is covered with fur that is actually not white but translucent, somewhat like a mat of fiber optic channels conducting light to a black skin underneath. The range of the polar bear is truly awe-inspiring. On giant paws that can as easily traverse the snow and ice as paddle through the open sea, polar bears are perfectly adapted to the kind of ice floe habitat that so tested Peary and Steger. They have been spotted swimming hundreds of miles out in the Arctic Ocean, far from the home of any wolf.

Polar bears, however, do roam through wolf country at times. A fight between a single wolf and a single bear would almost certainly favor the bear. Given even a small pack of wolves, though, the odds would change quickly. My experience suggests that most bears are frightened of canines; once I even witnessed a barking chihuahua scare off a black bear. That bears would indulge their fear to such lengths shows that the behavior has deep evolutionary roots. Over the millennia, bears have apparently learned the value of avoiding anything that travels in a pack.

A report from Canadian military personnel reveals the antagonism between the two species. During the same winter I stumbled across the wolf pack, a group of soldiers were on an offshore reconnaissance mission, reportedly drilling holes into the ice pack to insert listening equipment designed to detect submarines. Unless there happens to be a sub around, this can be pretty boring work, with plenty of free time to scan the horizon. On one slow day, the crew saw a pack of wolves harassing a polar bear that had wandered to within a couple miles of the den. The wolves kept up their barking and feinted attacks until the bear at last retreated.

Why wolves chase and harass bears is an open question. They may compete for food, especially carrion, but I suspect that a wolf pack could take over anything a bear happened to find or kill. The wolves might have been protecting their den, even though in this case the den would not be used for several months. Perhaps the wolves were trying to teach the bear a lesson that would discourage the bear from returning when pups were present. A polar bear has a very long reach and conceivably one could extract pups from a shallow den. But even this seems unlikely. Not only had the wolves left their young unguarded in our presence, but they also frequently allowed the pups to roam by themselves as far as a quarter-mile from the den. To me, this suggests that there is very little in this territory that a wolf has reason to fear. It seems plausible, therefore, that wolves chase bears just on general principle, an instinctive enmity built up over the millennia.

Fortunately, on at least this section of Ellesmere, no such enmity existed toward humans. In other regions, a different sensibility almost certainly prevails in the minds of wolves. A few are killed each year on Ellesmere, primarily by Inuit hunters who can sell the luxurious pelts for $300 apiece. For 40 miles around Grise Fjord, the center of an Inuit hunting community on the southern part of Ellesmere, there are few wolves and very little big game of any kind.

Though many Native American tribes once accorded wolves an almost religious kind of respect, the economic incentive provided by pelt sales and bounties has completely changed the relationship. Years ago, I lived with an Inuit family for six weeks and one evening while we were seated around the camp, a wolf appeared on the horizon. One of the men became extremely animated as soon as he saw it. Grabbing his gun, he stalked the wolf, and once in range, began to fire, killing it after several shots.

I asked him later what had been going through his mind, but he never explained it very well. I was left with a vague sense of territorial invasion: the Inuit saw the wolf as a

Though a single wolf is no match for a polar bear, a pack can easily keep a bear at bay.

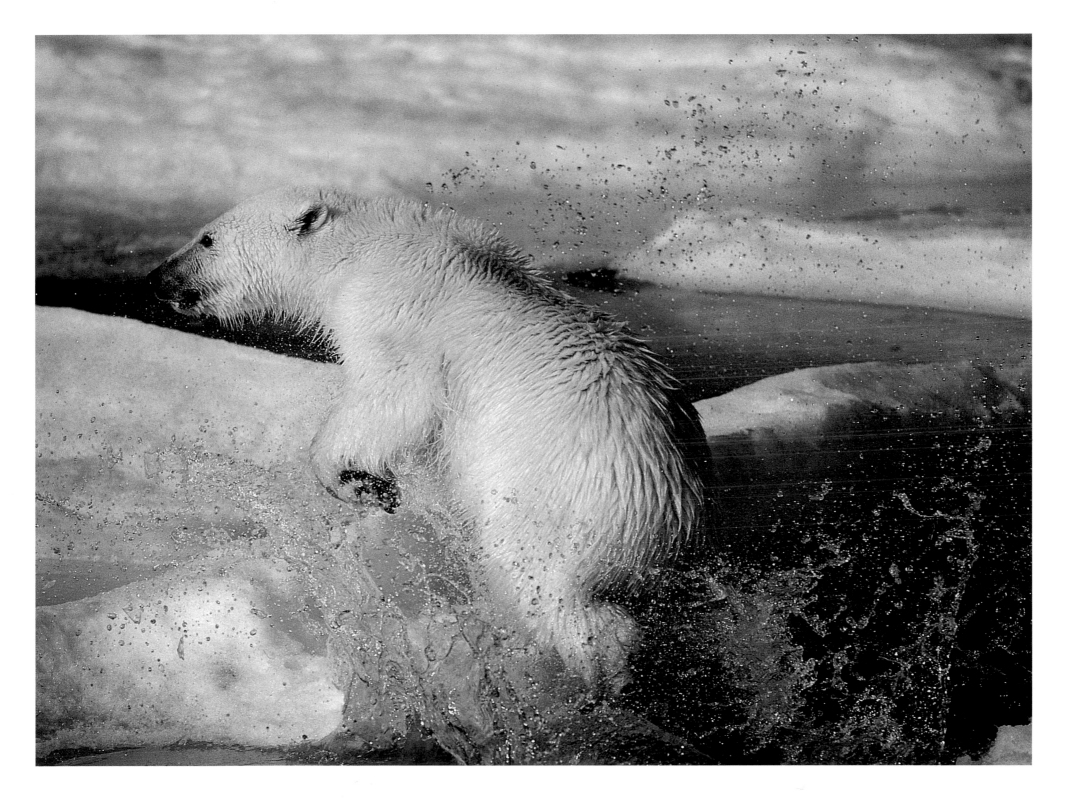

competitor who had unwisely crossed a boundary he held sacred. There was nothing bloodthirsty or macho about the killing; it seemed instead to reflect a characteristic of hunting people that those of us who live in relative technological comfort may have trouble understanding.

The story has an ironic epilogue. Not too long after the Inuit shot the wolf, one of the man's relatives was accidentally shot in the neck and killed. He was buried on the outskirts of the Inuit community in Bathurst Inlet, in the Northwest Territories. I went back once to visit this site, and I found wolf tracks leading directly to the grave. Wolves had dug through the shallow layer of rocks that covered the man's body; his skull was exposed, and his hair locks blew in the wind.

My feelings about the wolf hunting that still goes on in the Native American community are decidedly mixed. I cannot deny the Inuit a way of life, nor will I judge their behavior the same way I judge hunters who shoot wolves from airplanes for bounty or for "sport." When I was a teenager, I earned a decent income running trap lines a hundred miles across the prairies, successfully catching everything from muskrat to fox. Once I made a trip to the border of Minnesota and Canada and fantasized about bagging a wolf. At the time, I thought success in such an endeavor would pretty much define manliness. I loved the idea of wolves—the *romance* of wolves—and had spent my childhood reading about legendary wolves from the pioneer days, wolves like three-legged Lobo with his preternatural wiliness. I admired wolves greatly, but still I had a great desire to kill one as a demonstration of my own prowess. I've met a lot of people who never grew out of that mentality. Thankfully, I did not end up shooting a wolf. Over time, in fact, I found hunting and trapping increasingly repugnant, and I traded my guns for cameras. Today I play out my role as a predator symbolically by bringing back images instead of pelts.

Wolves have more than people to worry about. For instance, a host of parasites can enervate and sicken them.

Wolves are also extremely vulnerable to injuries, and because they are so dependent on speed for hunting, a broken bone can be devastating. One day, for instance, Buster returned from a lengthy hunt limping badly. Though I could not be certain, he seemed to have injured one of his foot pads. During the two weeks it took him to heal, he became noticeably thinner. It was easy to imagine that a more severe injury, during a year when game was scarce, could have had a much less happy ending.

Musk oxen, too, are a potential danger. Once I happened upon the remnants of a musk ox that had been completely eaten except for the bones and the hide. Nearby was a dead wolf, presumably killed during the hunt. About 30 yards away was another dead wolf. When this scene is added to Left Shoulder's namesake wound and the talismanic wolf skull I found pierced with an ox horn tip, it seems likely that such injuries must happen frequently.

Not long before I left Ellesmere, I traveled to a remote section of the island where scientists had discovered the remains of a grove of giant redwood trees dating back some 50 million years. Numerous carbonized stumps marked the spots where trees once towered. Though the climate had certainly grown colder over the millennia, Ellesmere's position relative to the equator has changed very little. What fascinated the scientists was the question of how such trees could have survived, since they stood enshrouded in darkness for nearly half the year. Life somehow finds a way.

So does death. Not far away from these stumps, the scientists were also disinterring fossilized mollusk shells, the jaw of a giant lemur and teeth from a crocodile. If one is dealing with a long enough time frame, it seems that extinction is more the rule than the exception. I found myself wondering how soon it will be before all that remains of the wolf is a smattering of skulls covered by sand.

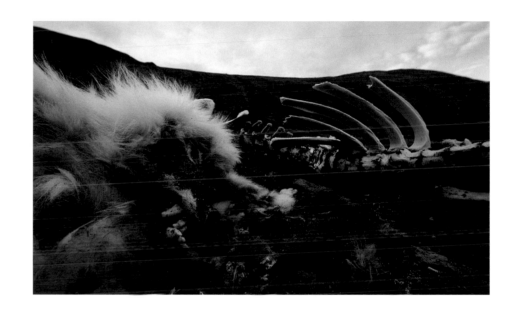

A wolf and his intended musk ox victim lie side-by-side in a frozen bond of death. After killing one wolf, the musk ox eventually fell before the surviving members of the pack.

The scarcity of decaying microbes in a cold dry climate allows the wolf's unconsumed body to remain relatively intact for years.

Ruddy turnstone eggs sit in a grass nest beside a snowbank. Purple saxifrage contribute a short-lived dash of color to the Arctic landscape. One of ten rock ptarmigan chicks peeks out momentarily from its mother's down comforter. (Opposite) From the distance, the chance for life seems remote on one of Elles- mere's many barren, multi-colored mountainsides.

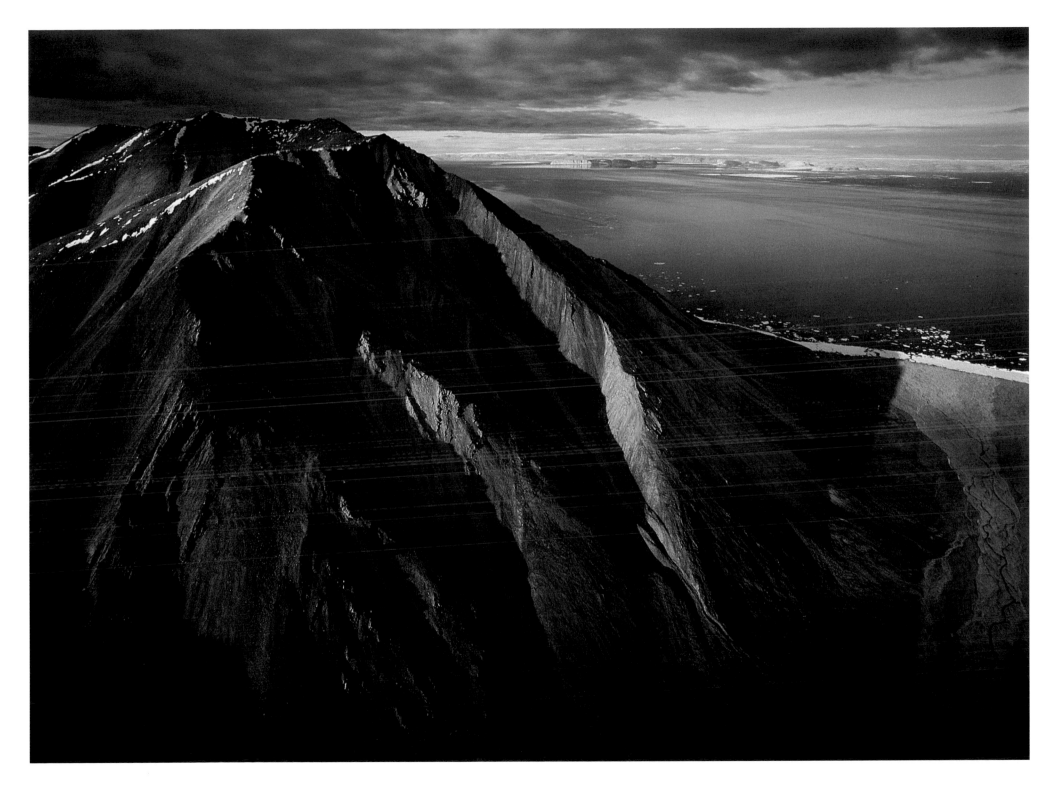

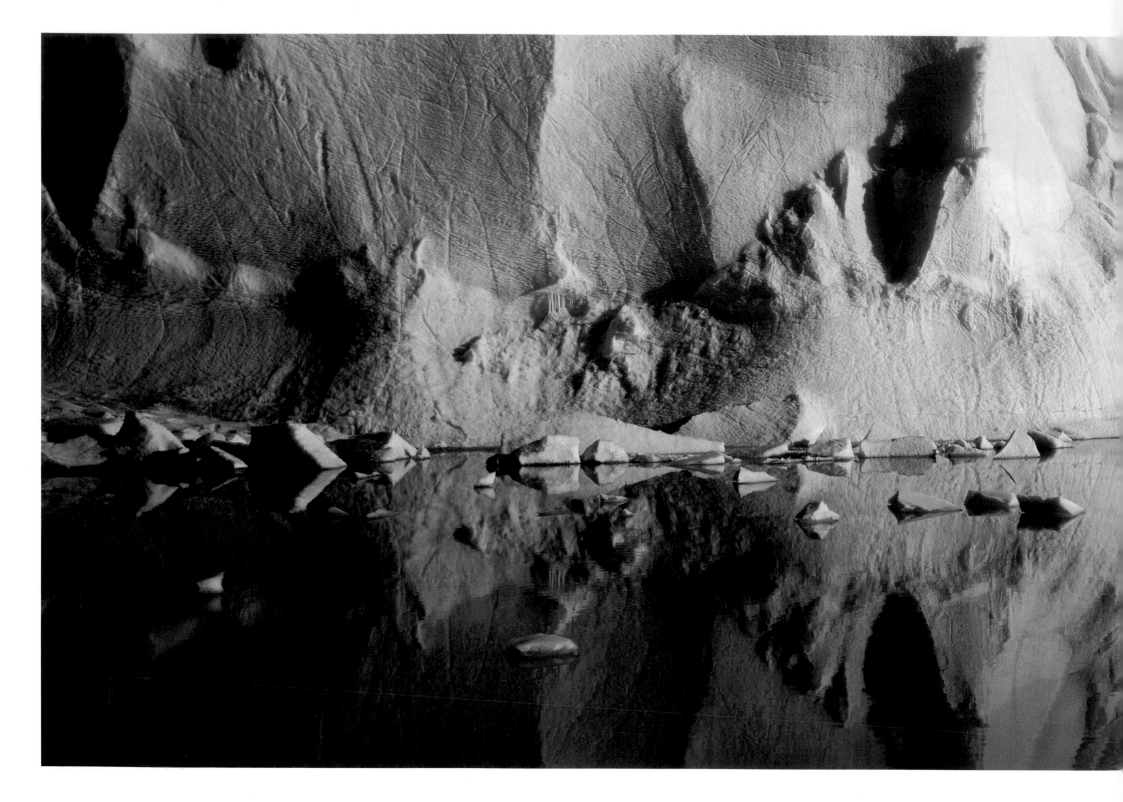

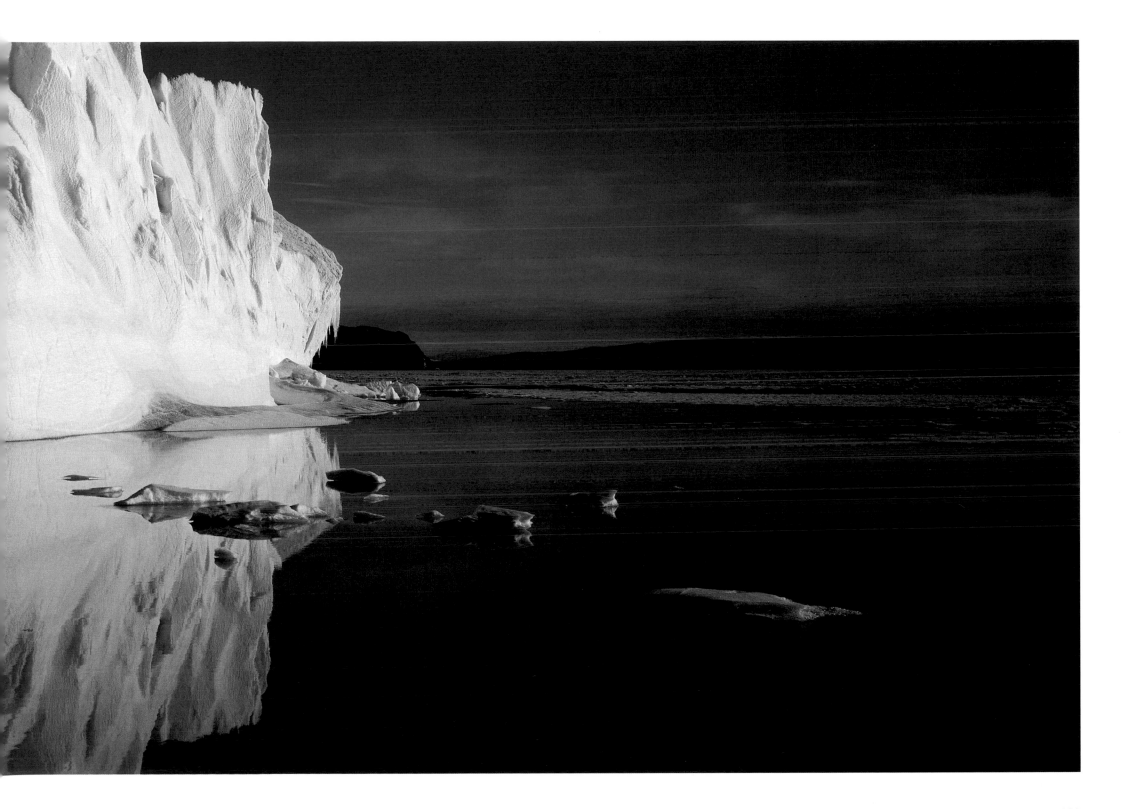

Lenticular or "lens-shaped" clouds are formed by cold, high-altitude winds. (Opposite) Despite the superb hunting equipment nature has given the wolves, nature has been equally kind to their prey. Musk oxen, the primary food of the pack, have perfected their characteristic defensive ring after eons of evolution in a treeless habitat.

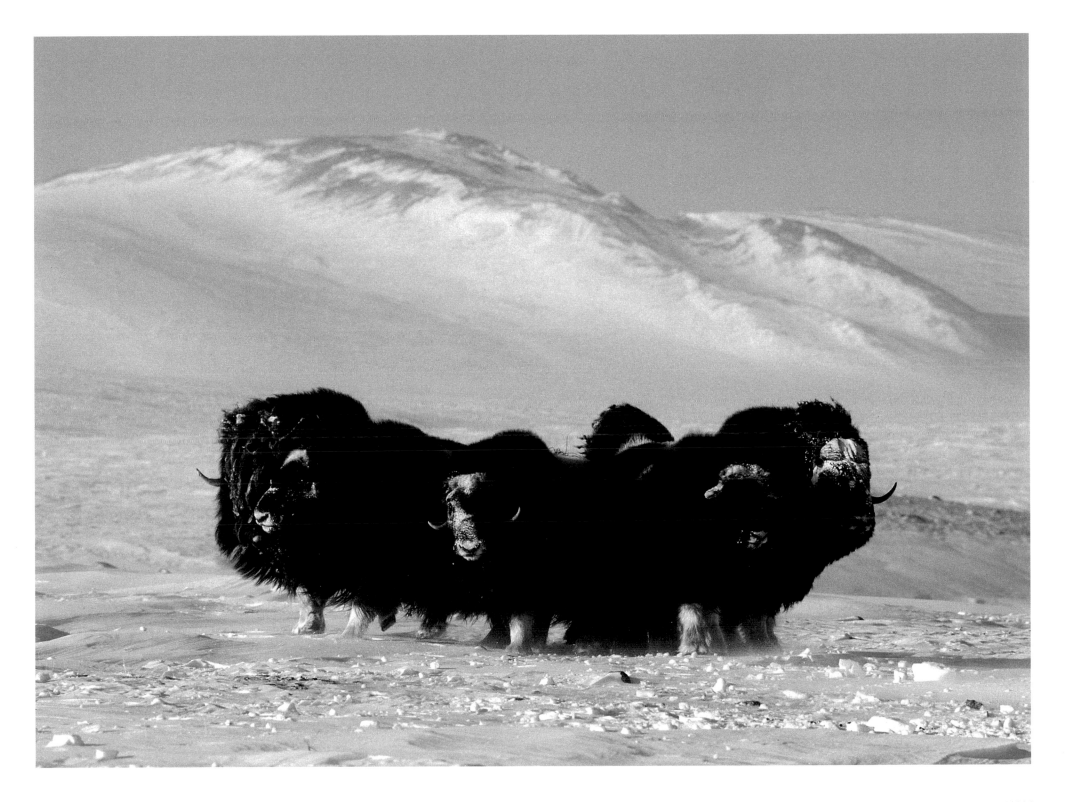

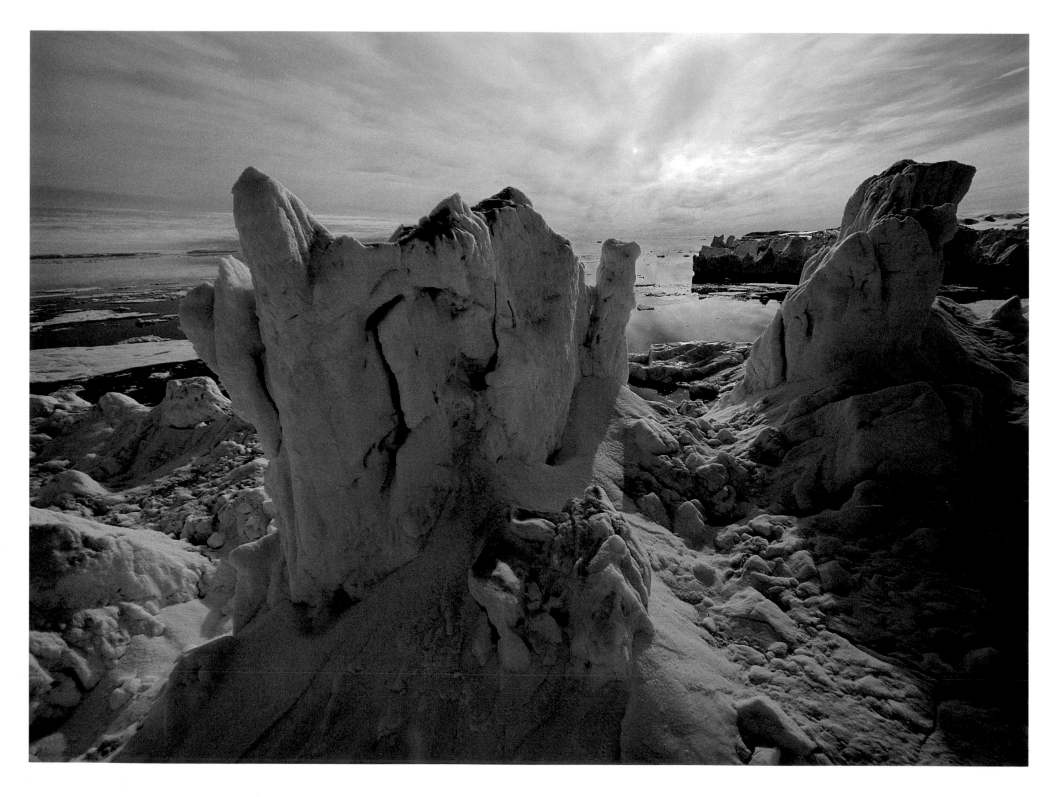

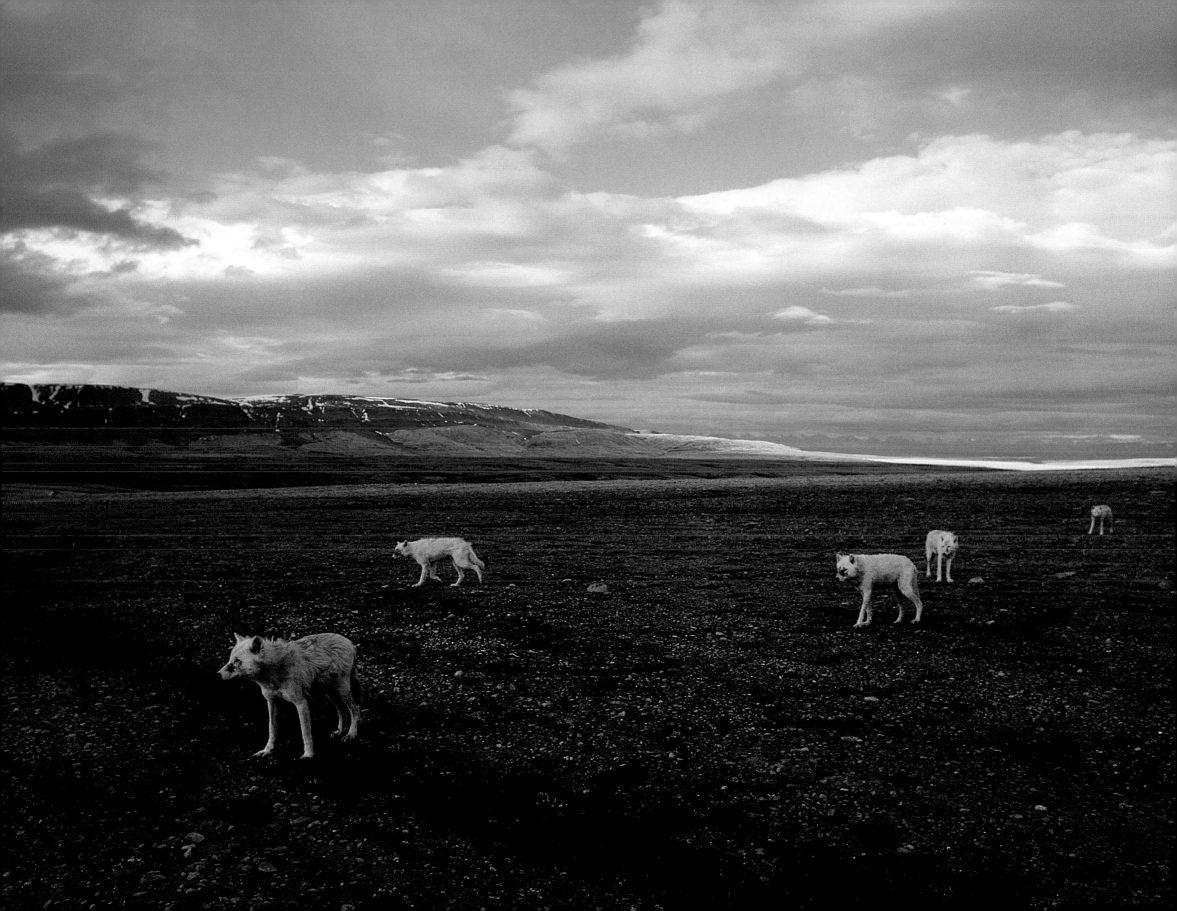

social species, the pups' behavior was a guileless, slightly rough copy of their adult role models. They cocked their puerile muzzles to the heavens and chirped out their contributions to the chorus. For ten minutes, this wake-up continued as sluggishness gradually gave way to great excitement. More and more, I could sense in the wolves a heightened focus and intensity. My own atavistic hackles, that is, puny goosebumps, rose on my skin in response.

Suddenly, Midback took off toward the east, quickly followed by a single-file parade of all the other adults in the pack. The pups watched and whined as their elders marched, at a deliberate trot, down the great valley that stretched out below the den. At the speed they were going, I knew they would quickly be out of sight.

I ran back to camp, shook Mech's tent, and began to gather together enough food and extra fuel to sustain what I expected to be a long trip. Since the wolves regularly disappeared for days at a time, I had no idea how long we'd be gone. I had always wondered where they went and what they did on these expeditions. Here, I knew, was a great chance to witness firsthand the way wild wolves make their living.

It took us less than ten minutes to load our ATVs and collect our gear, but even so the pack had disappeared from sight. We checked our odometers and headed in the direction they had taken, driving up to 30 miles per hour in an attempt to catch up. It took seven miles before we reached a high ridge that enabled us to spy the distant wolves through our binoculars. They were still moving fast and straight over rocky terrain that made travel on wheels very difficult. Once we caught up, we hung off to the side, like odd mechanical adjuncts to the pack. Even with the considerable advantages the vehicles lent us, it took all of our energy to keep up with the wolves. The steadiness of their gait over the uneven ground was amazing.

Throughout their march, the wolves ignored us. Occasionally they would close ranks around us, and we'd drive along side by side, as if for a few miles we had been granted card-carrying pack status. These moments were quite stirring, and the sense of acceptance they brought me was almost dreamlike. But just as I was beginning to get into a kind of hunting wolf mind-set, they would veer off again, and Mech and I would have to scramble like laughable sidekicks to try to keep them in range.

The first musk ox herd they encountered consisted of ten animals, all adults in apparently healthy condition. As the wolves approached them, their trot gave way to a slow, deliberate stalk. The musk oxen, upon noticing the wolves, quickly went into their defensive circle. The wolves charged around them once in an attempt to worry the prey. Then, much more quickly than I would have imagined, they gave up and resumed their trot into the hinterlands.

Somehow the wolves had sensed that this herd was too healthy, too impenetrable to waste energy on. It has been estimated that a high percentage of wolf attacks on musk oxen herds prove unsuccessful. Nevertheless, they test many herds regularly, sometimes on a daily basis, hoping that injury or infirmity might have weakened an individual since the last test. Clearly, there is a strong adaptive advantage in being able quickly to size up one's adversary—and to avoid biting off more than one can chew.

After a half-hour, the pack happened upon a herd that looked more promising. This time, there were only three musk oxen, all adults. Too few in number to assume a classic defensive ring, the beasts arranged themselves into a kind of triangle. The wolves worked the herd hard, circling tightly, darting in to nip at their flanks, barking, charging and feinting frontal attacks that stayed just outside the range of the horns. Though the wolves had been trotting for hours without showing any signs of fatigue, these short sprints quickly exhausted them. One by one, they lay down panting off to the side of the herd, but close enough to keep the pressure on. After resting, they would stand up and test the herd some more.

The wolves routinely test one or more herds in hopes of finding a vulnerable member.

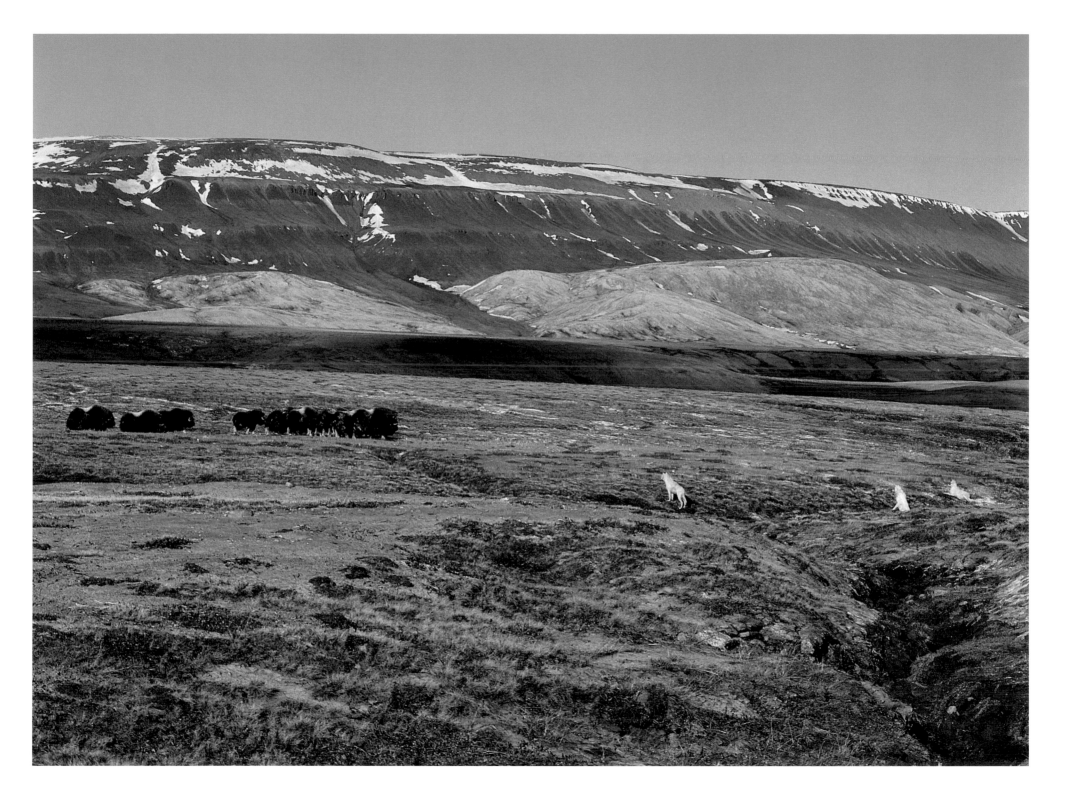

Finally, they gave up. We were, at this point, almost 20 miles from the den. It began to dawn on me just how many calories wolves must routinely expend. I had watched them go days without eating, becoming quite thin in the process. Though nature has provided the wolves with magnificent equipment for predation, nature has been equally kind to their prey. Even when game is plentiful, a successful hunting trip is by no means guaranteed. I began to wonder if the pack might eventually be forced to return to the pups without any meat for them, but the pack had no intention of giving up yet. After one more rest period, they were back on their feet and off again on their search for something vulnerable.

We had been on the move for another half-hour when the pack inadvertently scared up a weasel. This brownish little carnivore, about the size of a rat that's been fed through a pasta extruder, could not be much of a meal for an entire hungry pack, but the wolves seemed obsessed with catching the varmint. The weasel led the wolves on an incredible chase, zigzagging across the tundra with the frenetic pack at its heels. The straightaway sprints reminded me of greyhounds chasing an artificial rabbit around a racetrack. Then the weasel would change directions drastically, and the wolves would be scrambling, dust and gravel flying everywhere. After five minutes, the weasel was finally able to squirt into a rock pile and safety. The wolves took a short rest and were soon back on the trail again. I admired their tirelessness and persistence though the wisdom of their passion sometimes eluded me.

The pack moved into the outskirts of its considerable territory. If the den was at the center of their habitat, and this 35-mile radius was typical of the distances to which they would range, then the overall territory encompassed close to 4,000 square miles. No wonder they like to howl to one another and urinate on prominent spots. I found myself wishing for a Rand McNally of my own.

The wolves moved in a beeline up an inclined plain, their noses occasionally turned to the prevailing breeze. The

If the wolves can spook a musk ox herd into abandoning its defensive stance, the chances for successful predation greatly increase.

directness of their march made me think that one of them might have made a scouting trip earlier. In any event, they seemed to have a definite sense of destination. Realizing that an encounter might await us over the ridge, I decided to race ahead. I wanted to have my movie camera ready to go.

Sure enough, a half-mile ahead I saw a herd of nearly a dozen musk oxen grazing in a grassy valley. The herd, which included three vulnerable calves, was arrayed randomly across the broad valley. In the distance, several icebergs slowly drifted in a fjord. This was one of the most beautiful settings I'd yet seen in Ellesmere: a perfect backdrop for whatever drama might develop. Moments after I had set up my tripod, the wolves appeared on the top of the rise. Instantly they spotted the herd and froze. With Midback taking the lead, the pack crept forward, like cats stalking mice, each step delicate and deliberate. Closer and closer they approached, steadily increasing their pace, until suddenly they were charging full speed down the hillside in an attempt to catch the herd off guard.

The musk oxen were spread out some distance from one another in a very exposed position. This was prime grazing ground, low and boggy, but a lousy place for defense. Ideally, musk oxen under attack prefer a high, rocky ridge, where their defensive posture becomes as impenetrable as a fortress. When the wolves had made it halfway down the slope, the musk oxen finally saw them. They ran across the wet ground toward one another and gathered into a ring just as the wolves arrived. Slipping into the inner sanctum of the ring, the three calves all but disappeared from view.

The expression in the dull eyes of their parents and guardians was not, to my eye, one of panic. This visitation was probably just one of many disagreeable experiences they'd endured from wolves. After circling, the wolves charged a few times, but the musk oxen held their ground. With so many horned adults to deal with, the wolves' prospects for success looked slim to me. The wolves seemed to agree. Once more, they opted to give up before wasting much more energy. I was

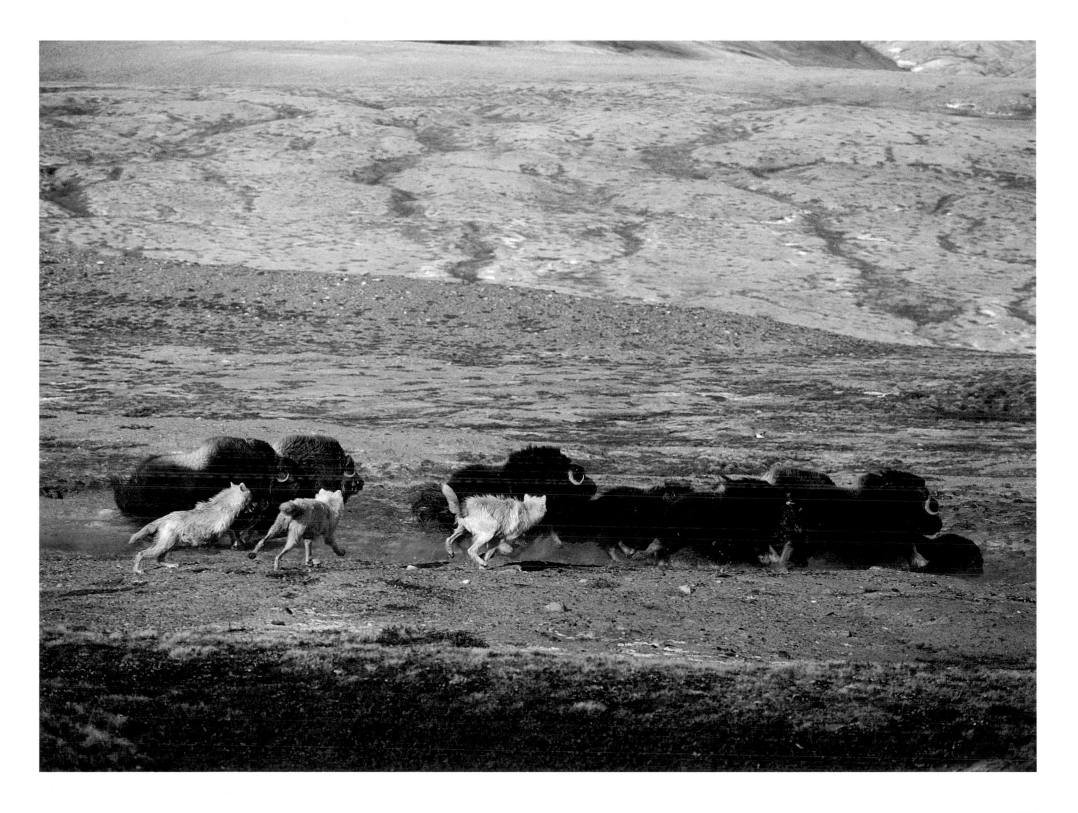

just starting to pack up my gear when the drama had a quick change of plot.

As the wolves were trotting away, the herd bolted for high ground. Evidently, their instinctive discomfort at being trapped in boggy terrain was too much for them. Instead of waiting for the wolves to disappear, they began to gallop uphill. This stampede had a predictable effect on the wolves, who turned around and began to pursue the herd at great speed. This exacerbated the frenzy of the stampede, which by pure luck was heading straight toward the spot where I had set up my movie camera. It all happened so fast that I had little time to react. All I could do was hunker down, shoot the film, and hope to avoid being trampled.

As the herd broke around me, thundering by on both sides, one of the wolves grabbed a calf by its flank, tore at it, and separated the calf from the herd. As the wolf held on with its jaws, the calf bucked and kicked fiercely, struggling to get loose. The two disappeared over a ridge far from the rest of the herd, which was being chased by the rest of the pack. Finally, the wolf let go of the calf and ran to catch up with his fellow wolves. Perhaps he knew they could come back and kill this calf later, or perhaps he was overcome with a sense of lupine fraternity and did not want to miss out on the group action.

The pack was in hot pursuit of a second calf and had just managed to separate it from its mother. Simultaneously, the herd reached high ground and closed ranks into a circle. Several pack members grabbed the second calf by the flank when suddenly the mother charged over from her position in the circle. Trying to hook the wolves, she began to wildly swing her horns. The wolves loosened their grip for a split second and the calf, which had been facing almost certain death, scrambled alongside its mother back to the ring.

The wolves quickly sized up the new situation. The circle was tight and inviolable; the traumatized calf was safe inside. The pack turned and ran across the ridge, catching up in seconds with the first calf that had been left behind. One

Hooves and horns are formidable weapons — the wolves must take extreme care to avoid mortal injury.

wolf grabbed the calf by the flank while another seized the nose. Momentarily, the calf broke loose. Almost immediately, the wolves caught up and resecured their death grips.

The calf remained standing for several minutes, bucking in a hopeless attempt to throw off the swarm of wolves, each of which was biting away at whatever flesh it could find. The whole process took about five minutes, longer than I would have imagined. Predators seldom wait until they've delivered a lethal wound before beginning to consume their prey. Instead, it's a continuous process of biting and eating as fast as possible, until finally the animal dies.

Very quickly, the alpha pair took control of the carcass, feasting while the rest of the pack waltzed around the edges, whining for a share. Buster and Midback ignored their solicitations, which seemed to me a virtual cartoon of obsequiousness. After the alphas finally showed signs of having had enough, the lower-ranking members, beginning with Mom, came closer and closer, cringing and begging in their hunger. As they crawled forward, their chests dragged along the ground and their tails curled tightly between their legs.

The alpha male, bristling with proprietary aloofness, stood erect above what remained of the carcass, snapping now and then at an intruder who came too close. His underlings were literally that: so low to the ground that they appeared to be crawling on their bellies. Time and again, they held out their front legs to him in a beseeching gesture; it was almost like prayer. Their heads tilted back, they pulled their lips into a nervous grin, and all the while they inched, fidgety and hesitant, closer to their leader and the prize he alone could choose to share with them. Inches away from him, they began to wave their paws back and forth. Then, ready at any moment to pull back from a snapping jaw, they began to lick the blood from his muzzle.

This gesture of appeasement went on for several minutes. Whenever an underling began to lick with too much confidence, Buster would snap, causing a tightening of their

The alpha pair, Buster and Midback, are usually the first to strike. Below, Mom awaits the stampeding herd. (Overleaf) Buster closes in on a calf.

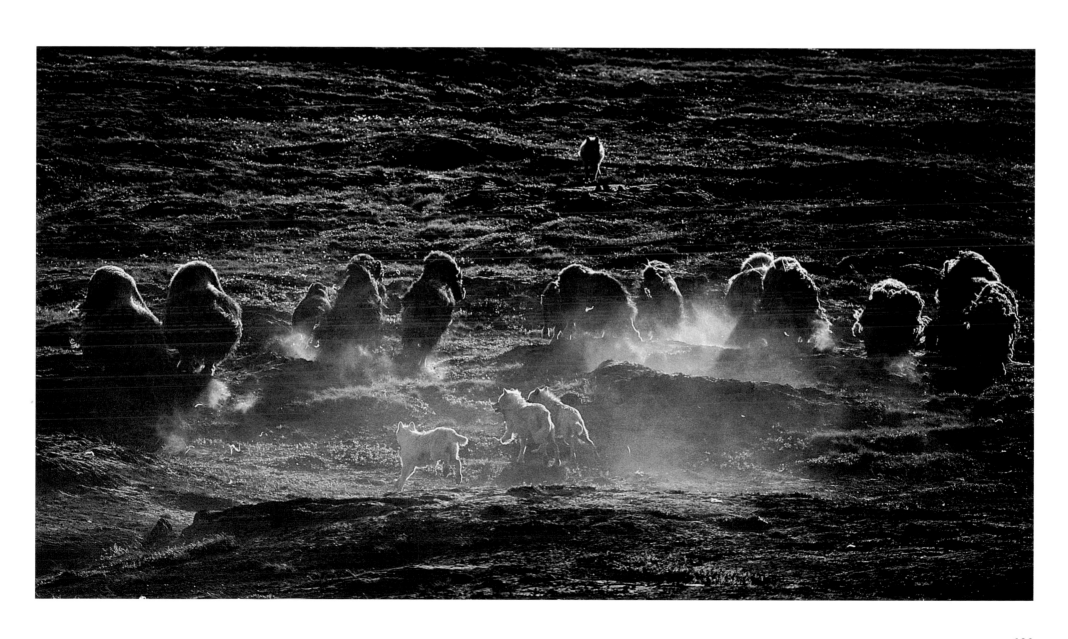

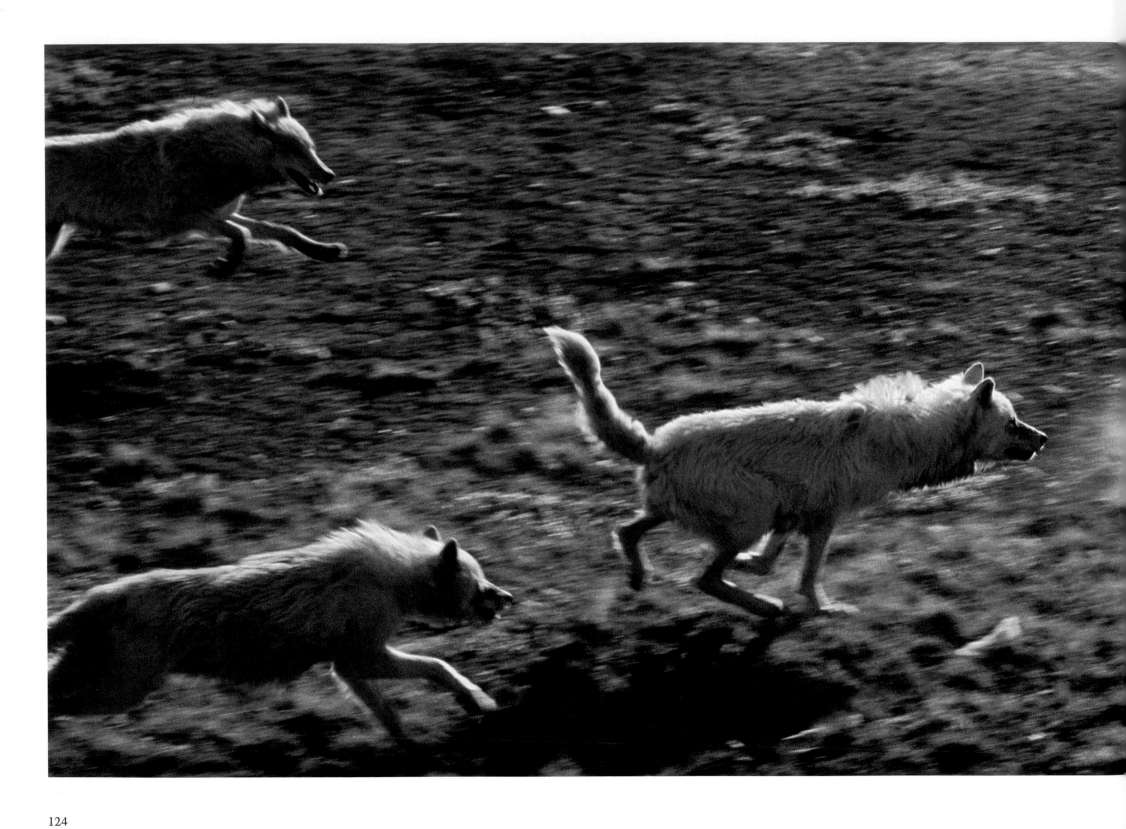

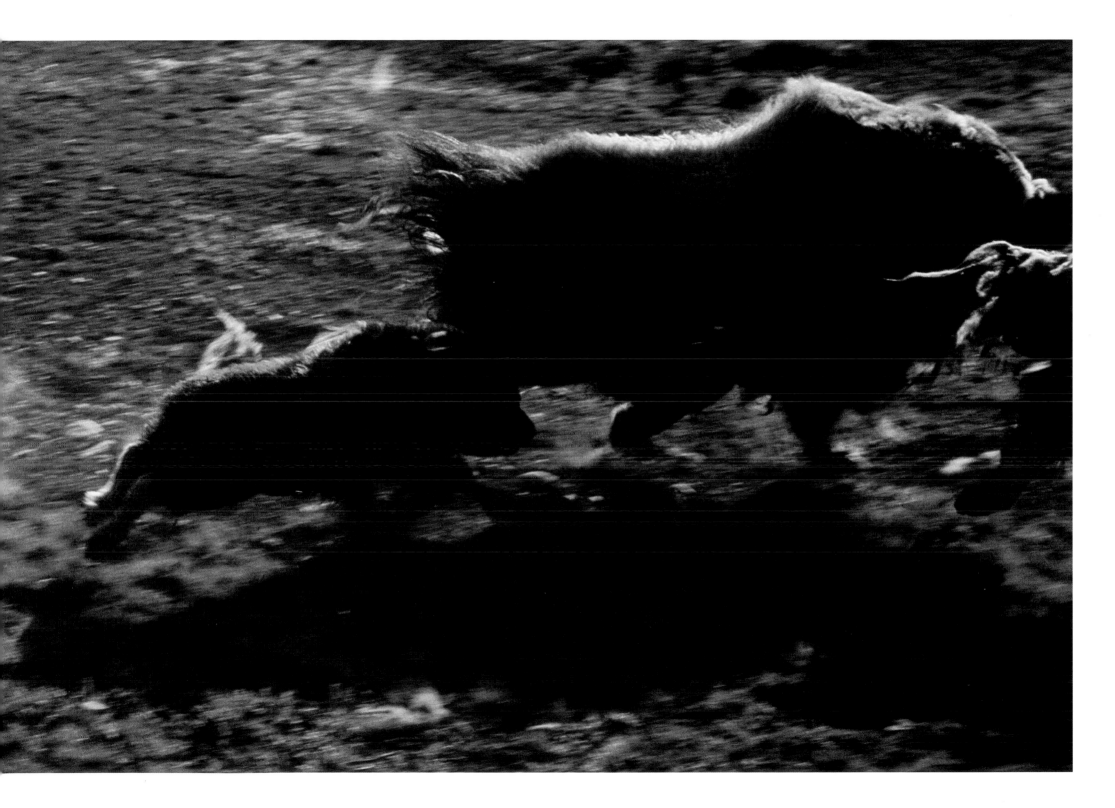

tails. At last, the underlings seemed to satisfy whatever demands for groveling the alphas required of them. As the alphas carried off large chunks of meat and the lower-ranking pack members began at last to eat their share, which came to nearly 20 pounds per wolf. It took the pack two hours to reduce the calf to hide and bone. After eating, the wolves trotted to a nearby pond to drink. They also splashed in the water, washing excess blood off their bodies, then wiped themselves by rolling on the adjacent field of grass. Despite these efforts at cleanliness, each wolf still sported a blood mask that would take several days to wear off.

After a short rest, they resumed their traveling. Six hungry puppies, after all, were waiting back at the den, and each adult now carried a bellyful of nourishment to share with them. The wolves trotted as fast as they could back to the den, rarely stopping to rest. As soon as I realized that this was their destination, I raced ahead to set up my cameras for the subsequent feeding.

The pups heard the older generation howling several miles away. Something in these howls communicated the pack's success. The moment of reunion was especially delightful to watch. Puppy tails wagged furiously while each glutted adult pranced about haughtily with its stomach stuffed to an almost comical degree.

The act of regurgitation, which was performed both to cache extra meat and feed the puppies, was always done in great secrecy. In the case of caching, this made sense; it was an obvious advantage to each individual to keep his or her private stash of food hidden from the other wolves. The pattern during caching was invariable. An adult would slink off at some distance from its packmates, check a few times to make sure no one was watching, and dig a shallow hole in the soil above the permafrost. With its back turned from both its fellow wolves and my camera, the wolf would arch its back and retch into the hole. Afterwards, the wolf would use its front paws to cover the regurgitation with dirt, tamping it all down with its

nose. The dryness, cold and scarcity of decaying microbes in this habitat functioned as an effective means of refrigeration, and the undigested meat could survive such burial indefinitely, providing a tremendous resource during hard times.

Of course, with the pups around, much of the meat never even made it into the ground. The puppies could tell, perhaps by reading subtle body language, whenever an adult had a full stomach. Tails wagging as fast as possible, whining and squeaking and leaping up to nip the adult's muzzle, they would instantly converge. Stimulated by such cues, the adult would wander off in a swarm of puppies to regurgitate. Again, this was done in great secrecy, almost as if a certain embarrassment attended the act. As soon as the cascade of shishkebob-sized chunks hit the grass, the pups gobbled it up with a voracity that suggested their lives depended on it. With only six weeks of summer in which to fatten enough to survive the winter, doubtless such a description was true.

Seventeen hours after Midback had awakened and howled the others to consciousness, every member of the pack was luxuriating in post-meal relaxation. To reach this state, they had traveled more than 100 kilometers, tested three herds, and had one successful, seemingly serendipitous kill of a musk ox calf. It would not last them long, but for the time being, they all seemed happy. Although I'd been up for nearly 48 hours, I was content as well. The dreams I'd missed could not possibly have measured up to the dream come true I'd just experienced. Around noon, the pack curled up to start a 12-hour sleep. Mech and I crawled into our sleeping bags and followed their example.

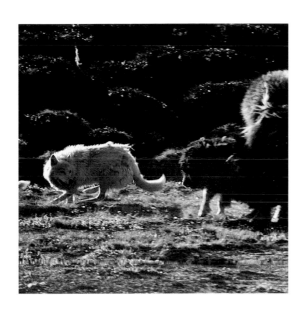 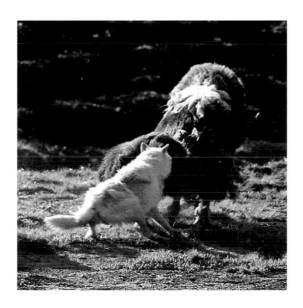 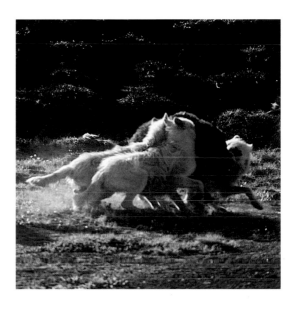

A doomed calf and its predator exchange a death stare. The alpha male latches onto the calf and is soon joined by his packmates. One wolf grabs the prey's nose, and the animal is soon pulled down to its death.

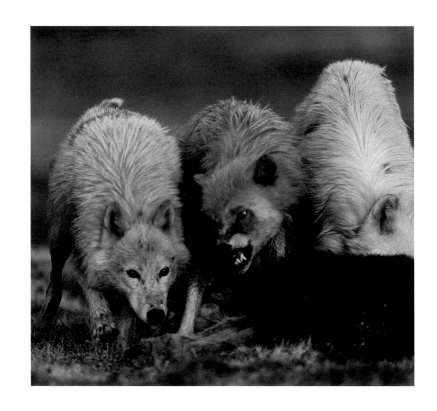

Once a kill is made, the alpha pair eats first. Here Midback, standing between Buster and Mom, keeps the subordinate Mom at bay till both alphas have had their fill. (Opposite) Mom is next to feed, followed by the others in the pack's descending order of hierarchy.

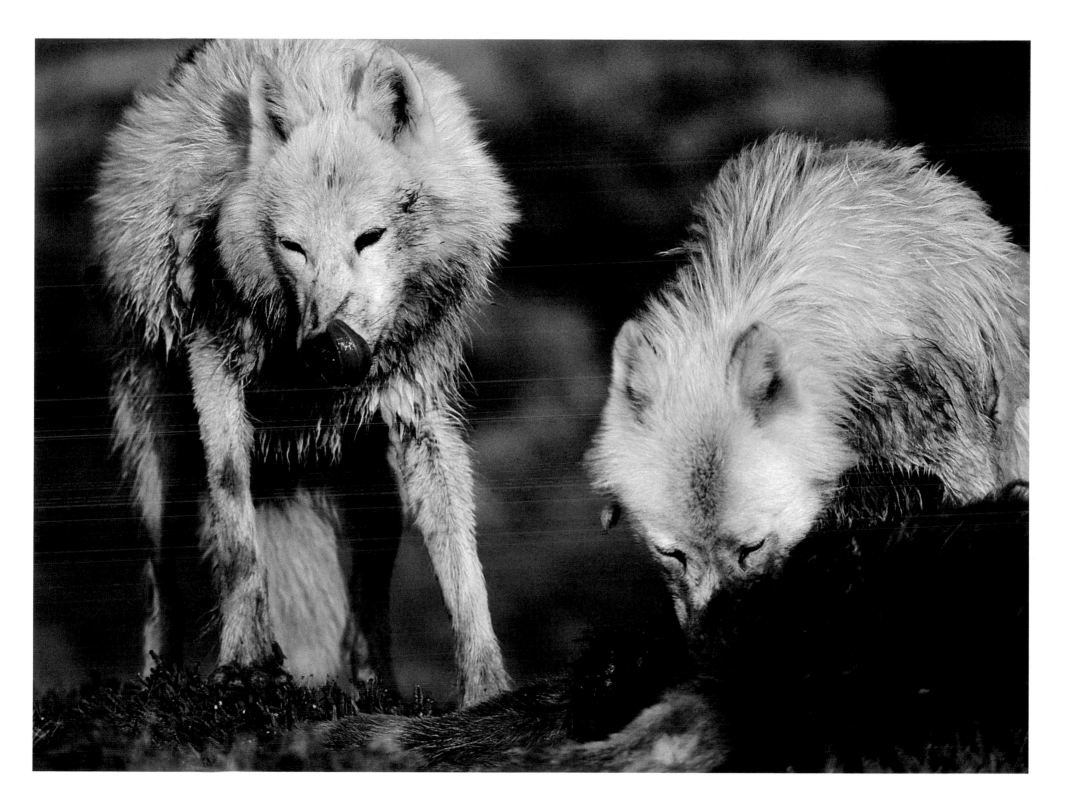

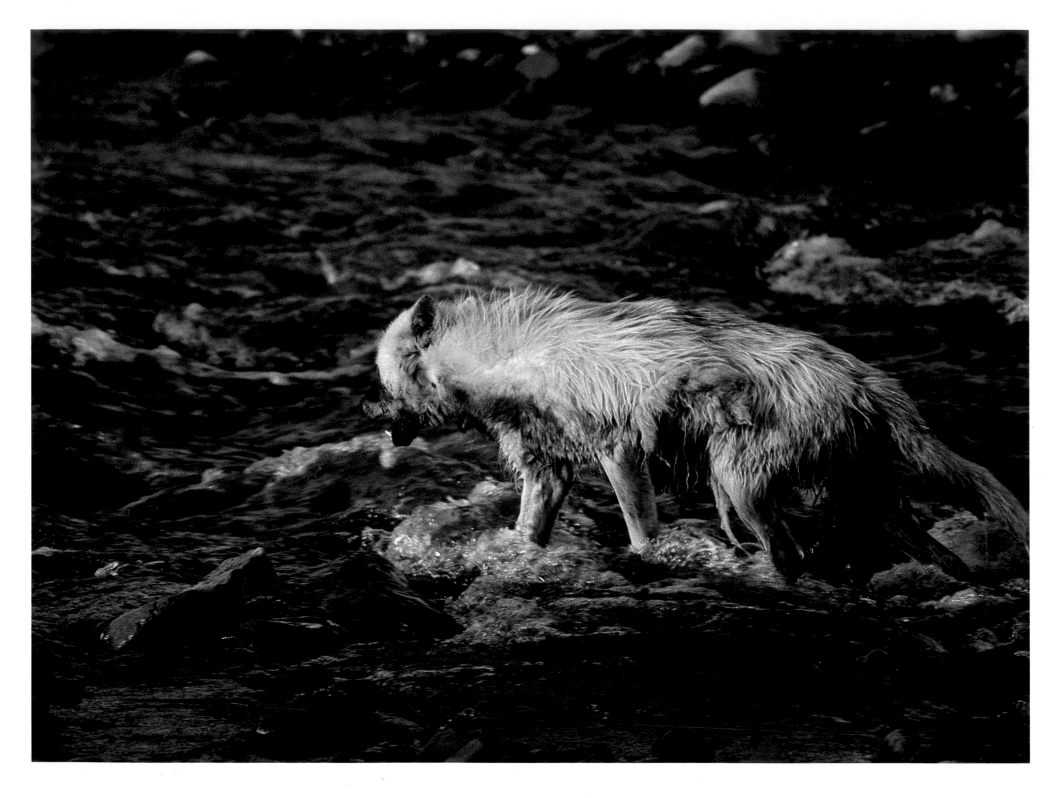

 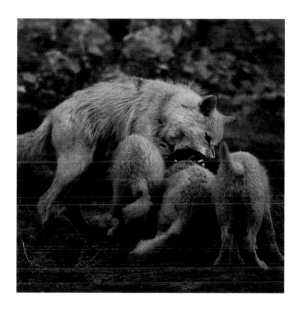 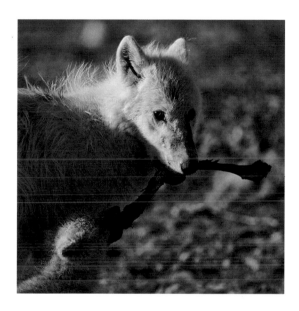

Throughout their engourgement, the wolves make trips to a nearby stream to drink water necessary to digest so much meat. They also wash the blood from their white coats before it has a chance to dry and harden. Later, the adults drag intact haunches as well as carry chunks of meat in their stomachs to regurgitate to the pups waiting hungrily back at the den.

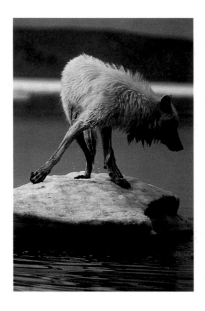

Wolves, persistent opportunists, explore every inch of their territory in search of morsels. Here, Buster scavenges for dead sea life revealed by the spring thaw.

J

he prospect of waking up to the sniffing of a wolf is not something the average person might look forward to. Indeed, the first question that I am invariably asked about my experiences with the pack is, *Weren't you scared?*

My mother was unflappable as I left to photograph rhinos in Nepal. She greeted my tale of detainment by Russian K.G.B. agents with something akin to amusement. She had never, in short, expressed the slightest fear at any assignment I had ever worked on anywhere in the world, but she greeted the wolf project with maternal anxieties. Every time I prepared to leave for Ellesmere, she would say something like: "You be careful now, living with that pack of wolves. Wolves are *dangerous.*"

Many of my closest friends had a similar reaction; they thought I'd become slightly daft, and could barely keep from suggesting a panoply of therapeutic options. If only they knew how joyful and relaxed the experience was for me. It was like a vacation, the ultimate wildlife experience, infinitely less stressful than driving in rush-hour traffic.

The reality of living with wolves is nothing like the Jack London fantasy. But a high percentage of North Americans, it seems, are convinced wolves *will* attack people, and believe that wolves consider the human jugular a delicacy. This notion of lupine savagery toward humans has its roots in Europe, where anecdotal evidence suggests that wolves may once have been more aggressive toward people. Whether attacks by non-rabid wolves did occur in Europe is

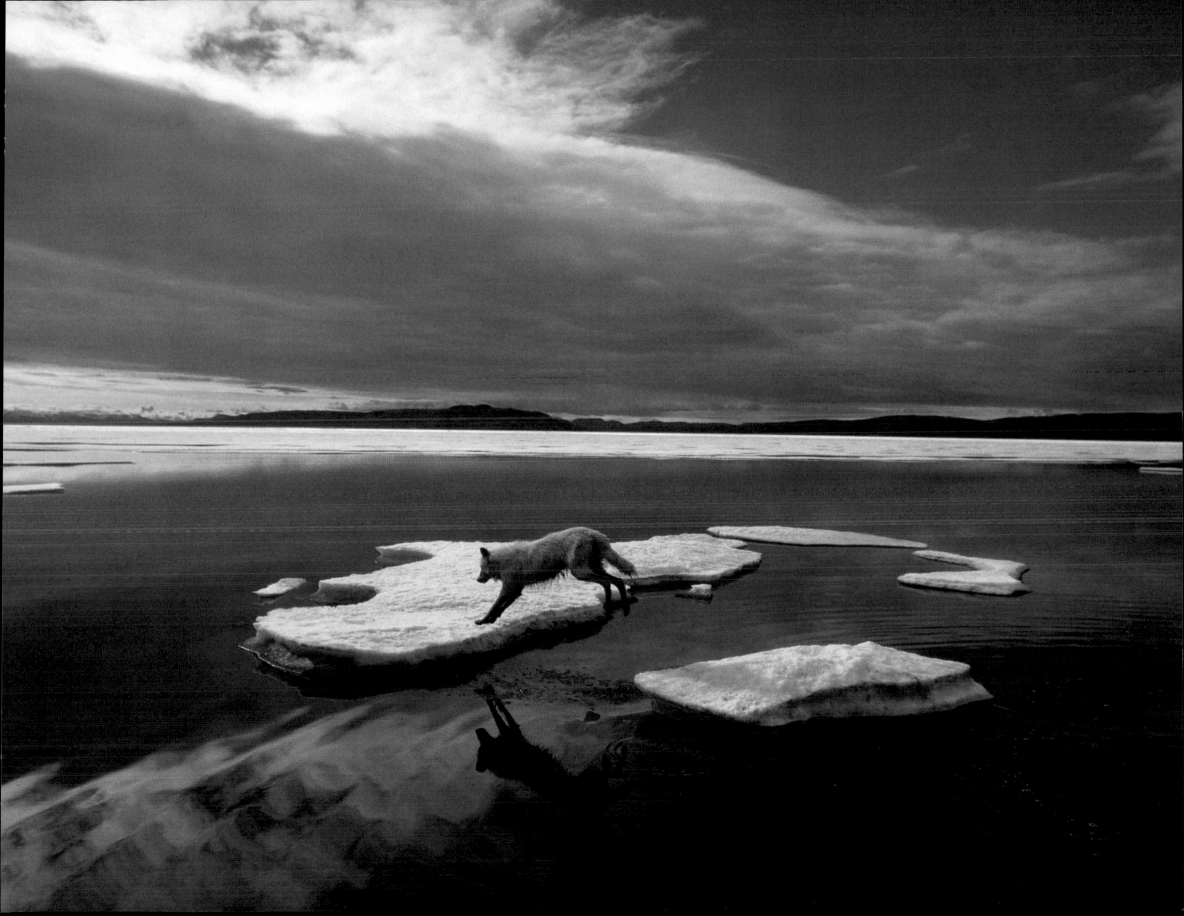

controversial; current evidence suggests that if they did, they were certainly infrequent.

Nevertheless, in North America, confirmed accounts of wolf attacks on humans are virtually unrecorded. Among the only documented examples on our continent involved a construction worker and a Native American woman. In the first case, workers on a particular stretch of the Alaska pipeline "befriended" a pack of wolves and would occasionally toss them scraps of sandwich meat from their lunch pails. One time, an impatient and hungry wolf darted in to snare his offering and bit one of the men in the process. The workers later reported that this wolf had been acting erratically before the attack, indicating the animal was probably sick.

The other recorded incident occurred in Canada, where the remains of an Indian woman were found in the forest. The woman had a history of epileptic seizures, and there was conjecture that the wolf pack may have found her body *after* she had died, or that somehow they were triggered into an attack by her behavior during a seizure. It has long been known that wolves will zero in on young, sick, injured, or old prey whose capacities for self-defense are reduced. There are theories that wolves can pick up on sickly energy, that their senses are fine-tuned to detect abnormalities. It is uncanny how quickly they will focus in on the one injured animal in a herd.

In any event, these two examples represent a few of the rare bona fide attacks recorded after countless wolf-human interactions.

Our chances of being attacked by a fellow human are vastly greater than any risk posed by a wolf. Every major predator in North America, from mountain lions to grizzly bears, will occasionally strike out against humans, but wolves just don't. While I have asked a number of biologists about this, I have never received a logical explanation.

Perhaps the answer lies in the peculiar similarities between our species. We are both, after all, social predators who have evolved over the eons in smallish bands designed to kill efficiently. Such a kinship of profession is inescapable. It is, no doubt, also the reason why transmogrified wolves—our domesticated dogs—are alone among mammals in their ability to stimulate feelings of camaraderie and reciprocal friendship. Truly, from the first time a hunter-gatherer pack of men "adopted" a litter of wolf pups and benefited from the experience, our two species have been bonded in a love-hate relationship.

Sadly, the hate has all too frequently overshadowed the love. The forces of wolf-hating have been stoked for centuries in our species' collective subconsciousness by tales like "Little Red Riding Hood," with its transvestite grandmother wolf, and "The Three Little Pigs," who are besieged by a wolf that is equal parts big and bad. For generations, parents have used wolves as a demonic metaphor to keep their kids in line.

In Norway, the language itself keeps this hatred alive. One word for wolf, *varg*, also means "wild one," "that which cannot be controlled," and "outlaw man." Another Norwegian term for wolf, *skrubb*, means "unpleasant and threatening creature." Little wonder that anti-wolf clubs and societies thrive in Norway, their members dedicated to tracking down and exterminating the few wolves that still exist there.

The psychological force of such defamation should not be underestimated, nor should the contemporary, parochial wolf criticisms of humans, from cattlemen to deer hunters, whose economic and recreational self-interests appear to clash with the interests of thriving wolves. Fear of wolves is not limited, of course, to those who have lived around wolves for generations and inherited their biases from their ancestors. One of my northern Minnesota neighbors, a highly educated transplant from the Twin Cities and an environmental sympathizer, regularly jogs the backwoods trails with a .44 Magnum revolver strapped to his side. He wants to have something to protect himself, he says, in case he runs into a hungry wolf.

Such rampant nonsense has long made the wolf's prospects less than rosy. Wolves are one of the most persecuted

*The ever-confident
Buster appears to take
great pleasure in finding
novel situations.*

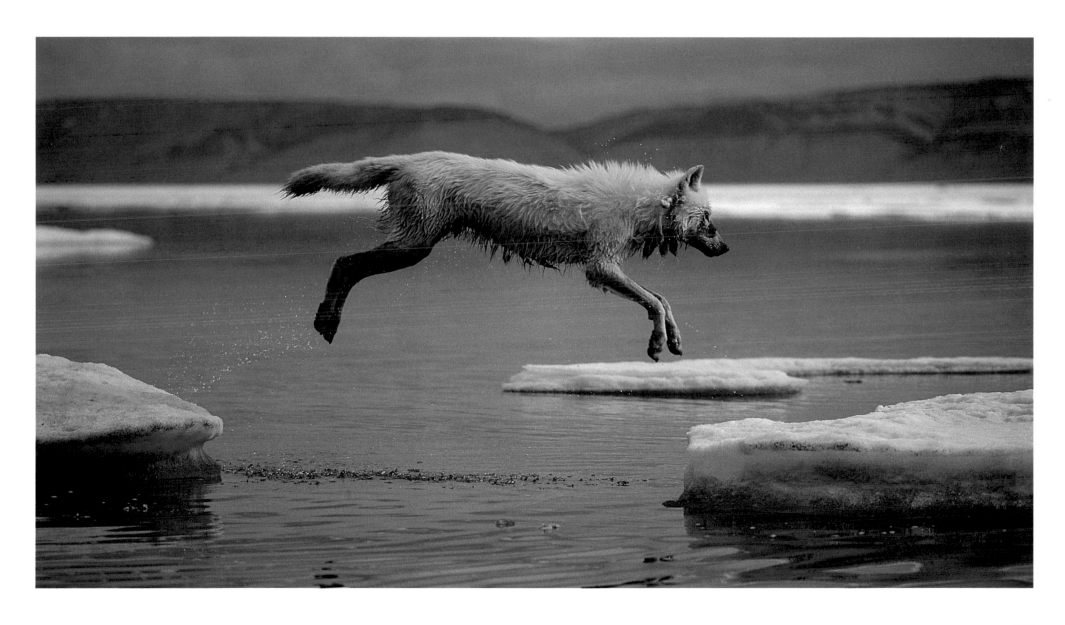

When it comes to aquatic hunting, wolves cannot match the prowess of polar bears. Here, a lone bear searches among the ice floes for seals.

animals on earth. In the Soviet Union and much of northern Europe, a comprehensive program of trapping, bounty hunting, aerial shooting and poison baiting is dedicated to wiping the wolf off the face of that continent. In the continental United States, wolves today occupy less than one percent of their former range. Ten years ago, a Minnesota zealot threw the corpse of a wolf on the doorstep of the Forest Service. He shot the wolf and spray-painted it with a hate slogan despite the threat of a $10,000 fine for killing an endangered species.

Fortunately, I've seen signs in recent years that the wolf's image is finally starting to turn around. The word is getting out that the wolf is not only an intriguing, but an ecologically crucial part of its habitat. Farley Mowat's entertaining (though partly fictional) account, *Never Cry Wolf*, has done much to sensitize the public to the wolf's plight. Publishers of wildlife art prints have found that pictures of wolves have emerged as top sellers in the past few years. Similarly, outfitters and guides in wolf country have begun to see increasing interest on the part of tourists hoping to have a wolf experience. An international wolf center has been proposed for northern Minnesota to attract tourist dollars. It has been my experience that people often "get religion" once money enters the picture. That wolf-haters might be converted to wolf-lovers by an appeal to the local economy is surely fine by me.

For eons, wolves have lived in sophisticated societies of mothers and fathers, aunts and uncles, pups and cousins, and in these groups they have struggled to eke out a living on earth. Time and again, I found myself overcome with respect for the Ellesmere wolf pack and its ways: how every adult pitched in to raise the pups, how they functioned as a hunting unit, and, perhaps most of all, how they seemed to constantly reassure one another with tail wagging, nose touching and howling. The wolf howl remains for me one of the great symbols of the natural world. Even if you never see a wolf but can hear one howling in the wilderness, your life will be enriched by a primal connection with our shared history.

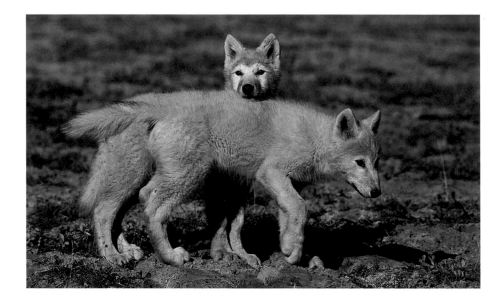

As the summer draws to a close, the fur of half-grown pups starts to blanch, beginning with their faces. Once they reach full maturity, their coats will remain white all year long. (Opposite) Wolves frequently return to former kill sites to chew on bones and glean whatever nourishment remains.

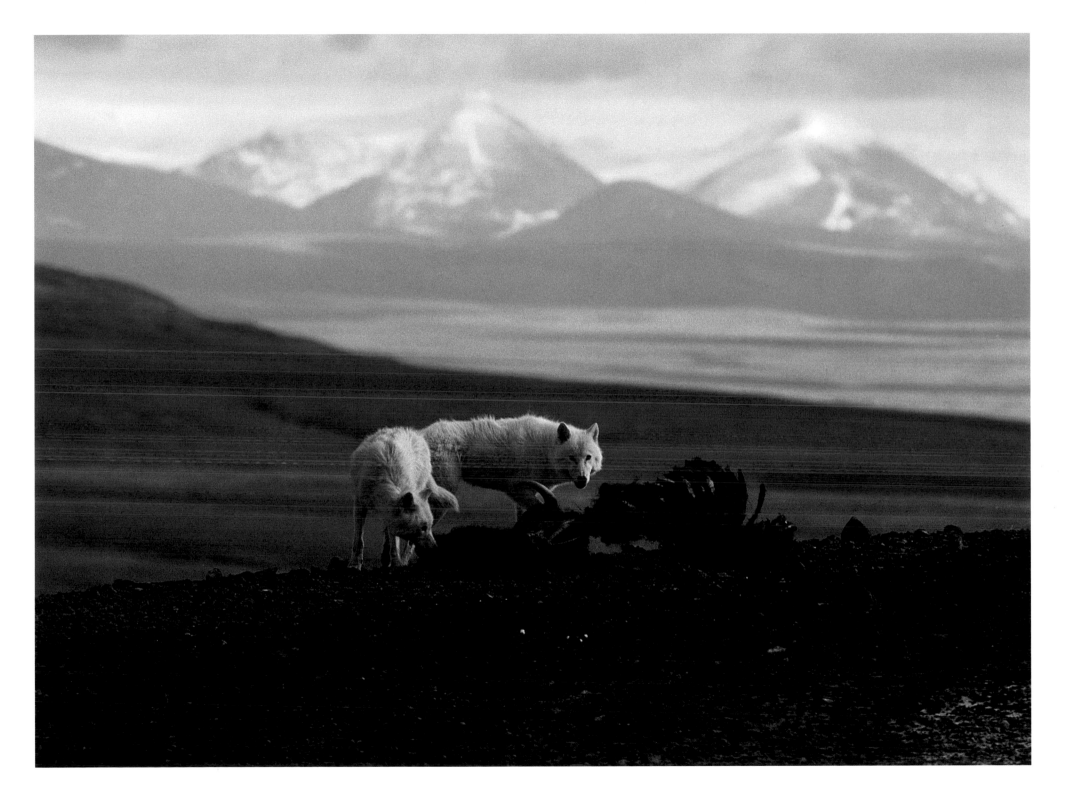

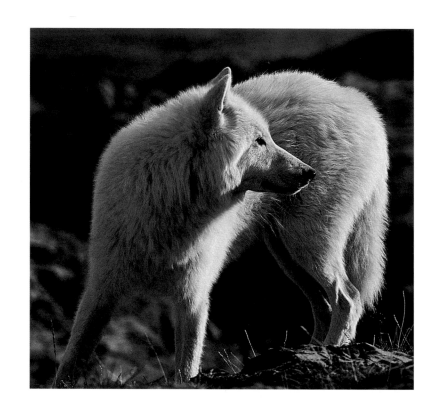

*Left Shoulder always
has the cleanest,
whitest coat of any
pack member.
(Opposite) Swirling
clouds and jagged
peaks convert the Arctic
sky into an ever-chang-
ing abstraction.*

GOODBYE

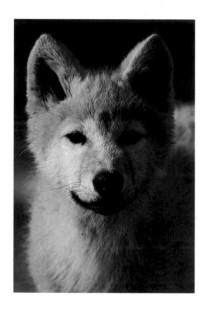

On the author's final afternoon with the pack, Left Shoulder relaxes in a field of Arctic cotton grass. The balmy atmosphere belies the inevitable advance of winter snows only a few weeks in the future.

reaking camp at the end of a two-month stay is never easy. A small mountain of tents, sleeping bags, radios, photographic equipment, maps, notes and ripe clothing had to be packed up and transported from our campsite to a landing strip six miles away. From there I'd arranged for a Twin Otter to pick us up and fly us home, a prospect tinged with excitement and regret.

After sleeping on the tundra for so long, it was hard not to fantasize about a comfortable bed, a hot shower and some home-cooked meals. Yet it was equally hard to deny a strong emotional attachment to the wolves, a feeling not unlike the bond I'd felt with favorite dogs over the years. I knew I would miss them greatly and I tried not to dwell too much on my imminent departure and the long season of darkness the wolves would soon be facing.

The wolves appeared to know something was up. They seemed fascinated by the logistics of the upcoming move and visited our camp to sit and watch us pack. Once they even brought their pups the quarter of mile from the den to see what we were up to. Why they showed such interest is anyone's guess. Perhaps the adults were remembering the time they raided our camp, strewing toilet paper and plastic butter pails across the valley. Perhaps they were trying to show the pups a possible source of food to keep in mind for the future. Or perhaps they were simply attracted to the activity. As evidence for this last theory, I remember the time a tire went flat on my ATV. As I started to change it, cussing a little under my

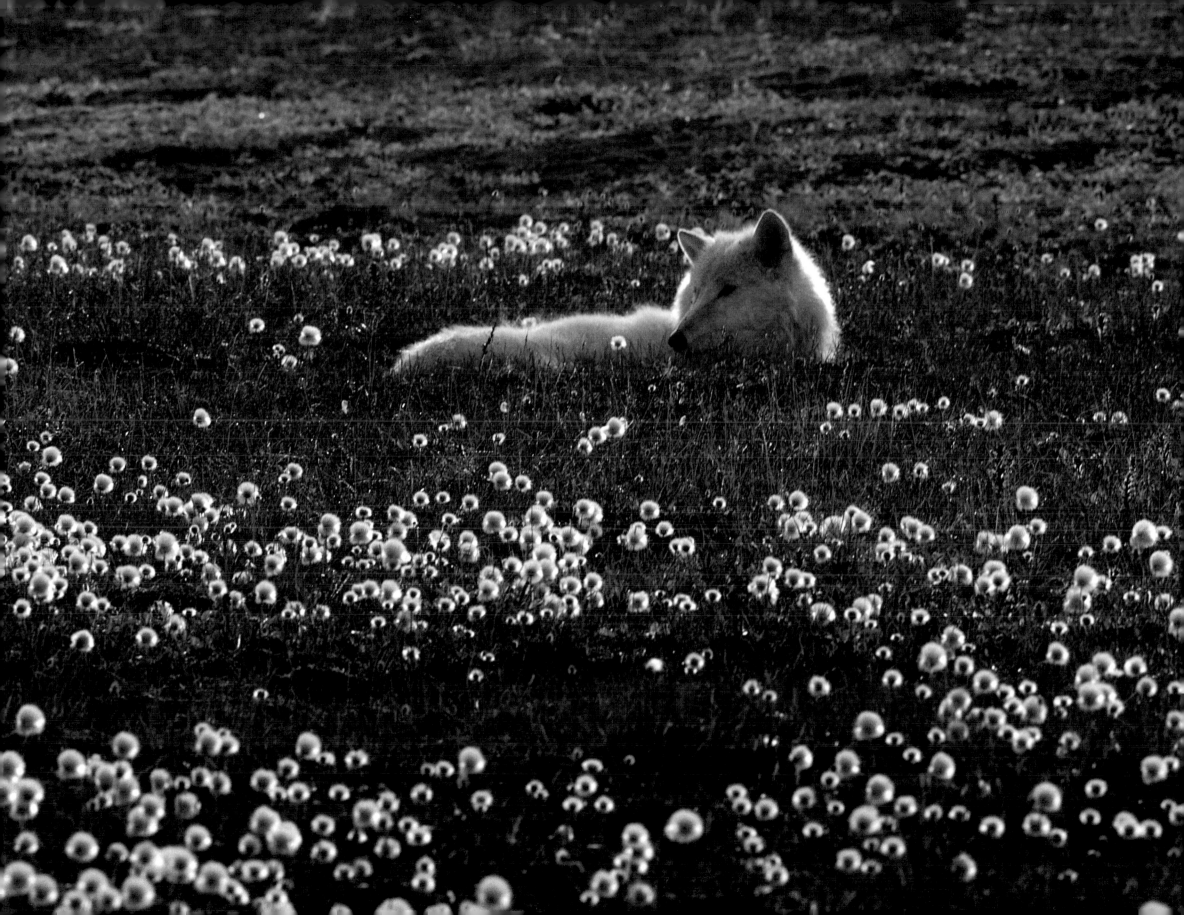

breath, the wolves trotted over to watch. They seemed to find the whole business fascinating.

It was now the end of August, and the first pre-winter snows were beginning to fall. The puppies had grown a lot, but they were still less than half the size of the adults and were incapable of catching any prey, even lemmings. They had much more to learn before they'd have even a marginal chance for survival on their own. Despite this imperative, the time frame for learning was minuscule.

The puppies' fur, which had been grayish at birth, reflected the inexorable changing of the seasons. Gray had given way to a buff orange color that provided perfect camouflage against the tawny fall colors of the vegetation. And from this buff orange, the pelage had already begun to whiten noticeably, especially around their faces. In the high Arctic, the seasons do not afford much time for puppies to stay puppies. Their education had begun early in life. As soon as they could walk with ease, their parents had started taking them to what is known as a rendezvous site, a kind of open-air den a quarter-mile from the actual den. Here the puppies spent their days, playing with each other, exploring their new world, and learning the lessons they would need to know as adults. The rendezvous site was evidently a traditional one, used by generation after generation of parents and pups. The ground was littered with years' worth of wolf hair tufts. To the side, a large bank of unmelted snow persisted throughout the summer, providing the pups with a cool refuge from mosquitoes.

By autumn, we had already seen the adults urging the puppies on short expeditions past the rendezvous site. Since the life of a wolf is necessarily peripatetic, it only makes sense that the puppies would be given early training in roaming. Even so, the greatest distance the puppies traveled on these sorties was half a mile. The morning we left to haul the last load of supplies the six miles to the airstrip, I looked over at the pack and said goodbye. A bittersweet moment, I was sure that I would never see them all together again.

"Only the mountain has lived long enough to listen objectively to the howl of a wolf."
Aldo Leopold, 1949.

Almost certainly, I knew, the pups would remain with the pack until the following spring. At that time, when the mating season began again, most of the puppies who survived the winter would be banished from the pack to make room for the new arrivals. Perhaps some of these survivors would form successful packs of their own in adjacent territories. More likely, though, given the severity of the habitat, they would perish.

It took several hours to load our equipment onto the Twin Otter. We were taking a short break before climbing aboard when I noticed some movement at the distant end of the runway. I couldn't believe my eyes: it was the wolves, and not just the adults. They had brought the puppies the entire six miles with them. As the adults sat watching us, the pups tugged at one another and played wolf tag. The sight of them all left me speechless. Was it coincidence that they had picked this day to take the pups on their first long-distance walk? Surely it couldn't be happenstance—but the other conclusion, that they had come in some inexplicable way to say goodbye, seemed preposterous. All I know is that I found this gesture, whatever its origins, deeply moving. I still have a hard time even talking about it.

As the plane ascended over Ellesmere Island, I looked out my porthole window at the iceberg, at the great valley below the den, which was now dusted with snow, and at the crooked inlets and fjords that would soon enough be frozen solid. All of these things, which had looked so monumental on the ground, looked small, almost fragile, from the air. My last glimpse of the wolves found them gazing up at the plane carrying us south. Who knows how they perceived our departure? I do not doubt there is a magic to wolves that we will never understand. I watched them watching me until they became too small to see anymore, and in my heart I wished them well.

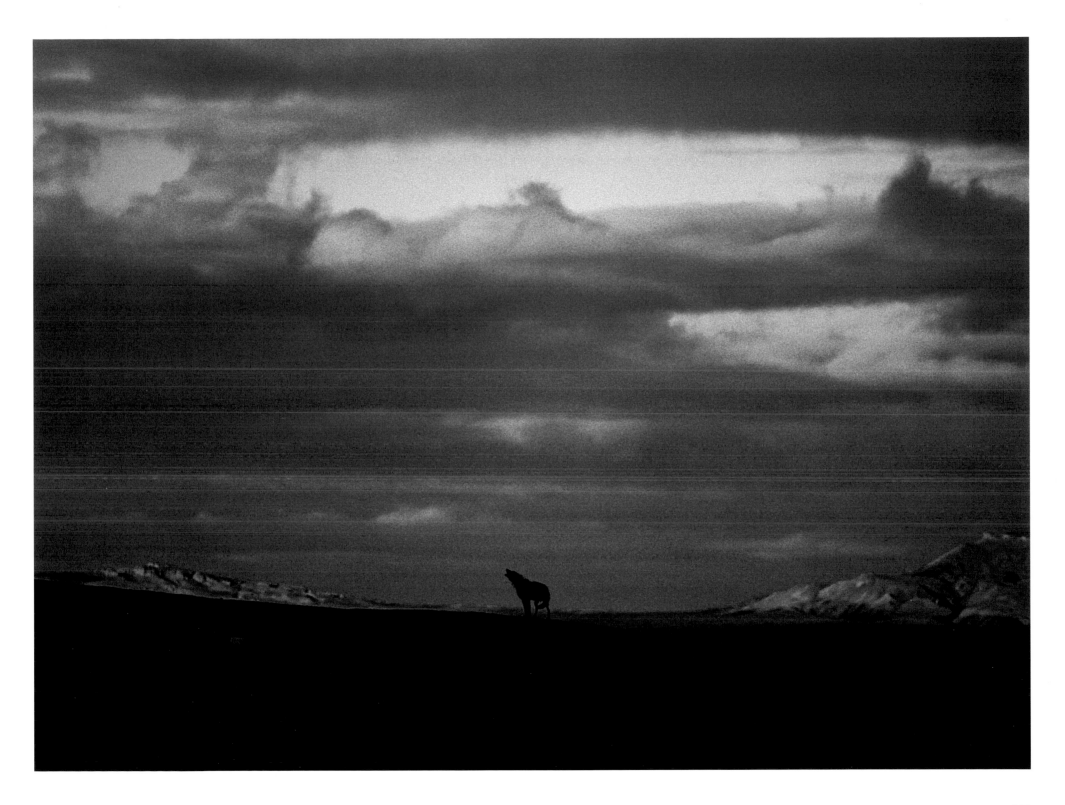

EPILOGUE

*A*t the end of May, 1988, I returned to Ellesmere Island to complete filming for an hour-long National Geographic/BBC television production on the natural history of the wolves. The trip north was an anxious time for me, with many questions rolling around in my mind. Had all the wolves survived the long winter? Had any fundamental changes occurred in the pack structure? Was there a new litter of pups this year?

At the Eureka Sound weather station, several meteorologists told me that the pack I had come to know so intimately had split into two groups. A pack of four wolves remained in the original territory; five others had disappeared.

The only clue to the latter pack's whereabouts came from a group of adventurers who had skied to Eureka Sound from the northern tip of Ellesmere. They told me that they had seen numerous tracks on what they described as a 30-mile "wolf highway" across the ice covering Greely Fjord. I could tell by their description of the geography that this so-called highway began very near where the musk ox kill had taken place the year before. Evidently, the splinter-group pack had decided it was time to find an entirely new range, one that lay well outside their old habitat. Or perhaps they had been forced away by the individuals that remained.

I could hardly contain my curiosity as I headed out to the den site. Surely the alphas, Buster and Midback, would remain, along with Mom and perhaps the baby-sitting Scruffy. When I arrived, I found four adult wolves, as the meteorologists had predicted. Spring had come early to

The social structure of a pack is always changing, as the author discovers on a return trip to Ellesmere. Astonishingly, Left Shoulder has become the pack's new alpha male and the father of this year's litter of pups. Here he stands with the assertiveness of Buster, who has disappeared along with Midback and other members of the original pack. Presumably, they have started a new pack in a distant territory.

Ellesmere, but the wolves still sported their winter pelage. Thus it took me a few days to determine their identities—a process complicated by the fact that what I discovered was so utterly unexpected.

The alpha male of the new pack was not Buster—it was Left Shoulder. The last time I had seen Left Shoulder, his subservience toward the smaller but more dominant Buster had bordered on the comical. But now he had assumed the mantle of leadership of the pack, and the other wolves were deferring to him. Despite his much improved status, though, Left Shoulder's personality had not been corrupted by power. He still seemed a very good-natured wolf, much more tolerant and peaceful than Buster had been. Buster was nowhere to be seen. Most likely, he was the alpha male of the splinter group.

The alpha female had also changed. Midback was gone and Mom had become the new female leader. Though she spent much of her time inside the den, Mom did occasionally emerge. I got a good look at her underside one morning and saw that her nipples were swollen. I had no idea how many pups this year's litter contained, but judging by the squeaks and squeals that came from the den, I assumed there was a good handful of them. Mom's equanimity was much the same as in the previous year, though her tolerance now bore a slight edge. Perhaps this was because of her new alpha status, or perhaps because her pups inside the den were still so young and vulnerable.

The rest of the pack consisted of Scruffy and a yearling pup I nicknamed Cloud because his coat was exceedingly white and fluffy. I have to say I greeted Scruffy's presence with pure delight. I should have known that Scruffy would somehow manage to figure out a way to stay in the home territory. His role in the pack still seemed to be one of very low status, but his goofy genius for ingratiating himself was remarkable. Day after day, I watched him hover in attendance to Mom—now and then sticking his nose inside the den, only to be greeted with growls and snarling.

Once I even saw him disappear completely inside the den for a few minutes, something I'd never witnessed an adult wolf other than a mother do before. What he was doing in there with Mom and the nursing pups remains a mystery to me. I found myself wondering if perhaps it is Scruffy's lot in life to be a permanent baby-sitter. Then again, judging by Left Shoulder's remarkable turnaround in status, perhaps even Scruffy will one day move up the ladder and have a season to hold his tail high.

As the days on Ellesmere passed, I spent much time trying to figure out why the original pack had split in two. Though I do not pretend to be sure of the answer, several possibilities suggest themselves. One theory is that perhaps Midback became pregnant along with Mom. Since the two females would be very unlikely to share a den, and since it would be equally unlikely that a single territory would have enough prey to support two growing litters, one of the mothers would have needed to find another den site and territory. One might reasonably expect that Midback, who was dominant over Mom, would banish her subordinate to the hinterlands. However, Mom had already used this den before and was accustomed to it. Perhaps in the case of den sites, as in food that an individual wolf has foraged on its own, possession is nine tenths of the law.

Another possibility is that Midback, with her dominant personality, was able to lure Buster to a new territory before mating season began. Of all the wolves, Midback had always been the most wary of humans. Perhaps, in her shyness and discomfort with our presence, she wanted to find a more remote hunting ground. Buster, in turn, may have respected Midback's considerable contributions as a co-hunter and opted to stay with her. Midback presumably would benefit by securing Buster as her own mate and would have no cause to fear romantic competition from Mom.

A final possibility is that the pack split as the result of a major fight. Such a fight might have occurred with an alien

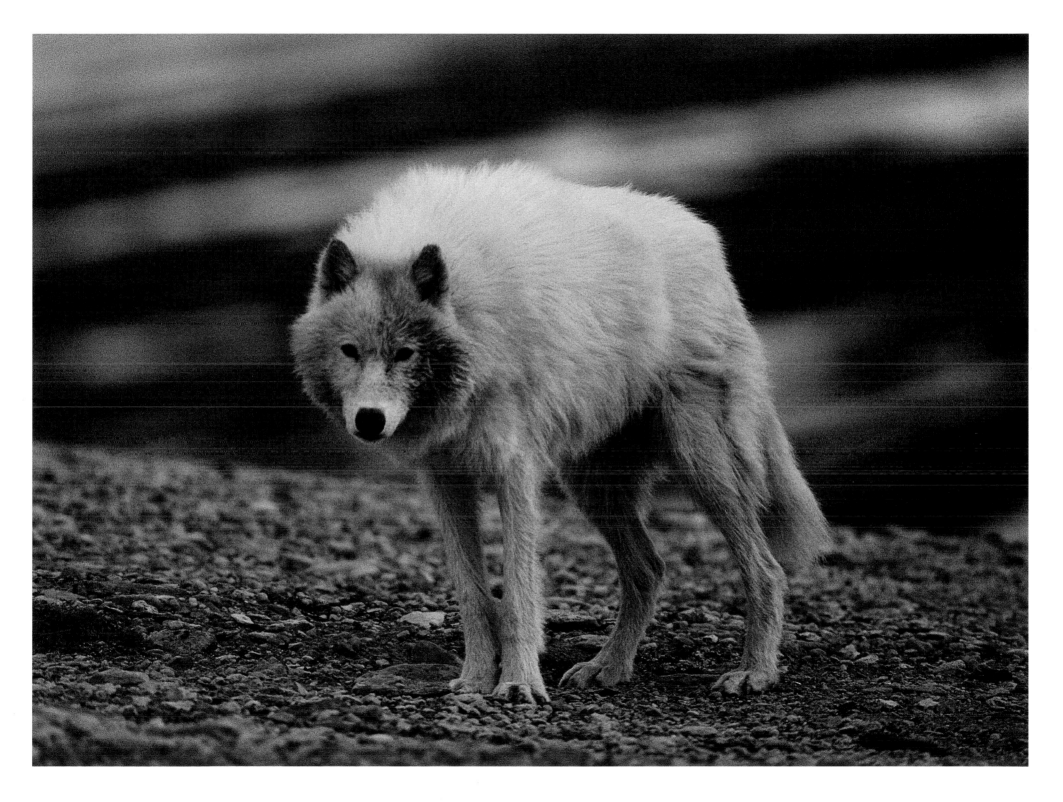

A melting snowbank gradually reveals the tragic harshness of life on Ellesmere. A yearling wolf lies dead of likely starvation near the den where it was born. A long-tailed jaeger circles overhead as the remaining pack members watch from the distance.

pack and resulted in the death of the original alphas. Or, more likely, perhaps it was an internal dispute, with the larger, more powerful Left Shoulder finally challenging Buster and winning.

One afternoon, while exploring a stretch of ice pack, I did find evidence of some kind of fight. The hair and skin of a wolf lay on the ice; no other parts of the body remained. Ordinarily, wolves will not eat a packmate that has been killed accidentally during a hunt, but wolves will reportedly eat other wolves that they have killed in battle. Whether this skin represented such an outcome, or whether it was all that remained after scavengers got through with it, is probably impossible to know. The same is true of the reasons for the split in the original pack. These questions will remain wrapped in the mystery of wolf society—a world that does not easily surrender its magic and inexplicability to science.

One of the reasons that wolf behavior can be so hard to explain, I found myself thinking, is that it is rarely repeatable and consistent. Every pack has a unique personality that tends to reflect the disposition of its leaders. This new pack, for instance, was much more peaceful and conciliatory than the group that had been dominated by Buster and Midback. The relationship between Mom and Left Shoulder seemed directly responsible for the collective goodwill. In fact, their union seemed to me almost preternaturally affectionate, as evidenced by an episode I saw early one cold, overcast afternoon.

Left Shoulder had been gone for almost a day on a solo hunt. Upon his return, he stood on the southern ridge that overlooked the den and surveyed his packmates. Scruffy, Cloud and Mom immediately ran to his side. Somehow they intuited that the hunt had been successful, and they greeted him with bowed heads, ears held back, tails tucked and wagging frenetically, signs of extreme submission. Soon they were all nipping and biting at the corners of his mouth.

It was precisely the same begging behavior that I had seen the puppies indulge in, time and again, when they hoped to trigger regurgitation in an adult. This time, though, it was adults that were behaving this way—an astonishing display that I could not imagine taking place in a pack led by the no-nonsense Buster and Midback. Never had I seen one adult wolf regurgitate food for another, and I didn't expect to see it now. I figured this display was a kind of regression stimulated by hunger. I felt certain that Left Shoulder would ignore the intercessions, and that would be that.

At first, my prediction seemed to be coming true. I watched through the 600-millimeter lens of my movie camera as Left Shoulder quickly trotted over to the den's entranceway, leaving the others behind. He appeared to listen to the squeaks and squeals inside, then turned back toward Mom. All of a sudden, he regurgitated at her feet. As she began to eat, Scruffy and Cloud bolted over to join in.

Left Shoulder would have none of this. For the two minutes or so that it took Mom to finish the meat, Left Shoulder chivalrously fended off the competition, allowing his mate to eat everything in peace. To me, it was a clear case of a mate taking care of the mother of his offspring. When Mom was finished, Left Shoulder spun around in a quick curl to the ground, closed his eyes and fell asleep. Within seconds, exhausted from his hunt, his body began to twitch in that telltale dog-dream way. Mom retired to the den, presumably to nurse the pups. And Scruffy and Cloud just looked around with the hungry, confused expressions that often crossed their faces.

Several days later, I noticed what I assumed at first to be a second example of Left Shoulder providing for Mom. About a hundred yards from the den, a tuft of white fur stuck out from a gradually melting snowbank. I thought it was an Arctic hare that Left Shoulder had cached for his mate. Because wolves tend to be very protective of their caches, I did not want to approach too close. But as the snow

continued to melt and more and more of the carcass emerged, I saw that I had made a mistake. It was not an Arctic hare but a yearling wolf, almost certainly a littermate of Cloud.

An inspection of the body, which had been largely preserved by the cold, revealed no sign of trauma. Most likely the cause of death had been starvation. The wolf was quite thin—its ribs protruded from beneath its hide. Clearly, each year many more pups come into the world than are likely to survive. Otherwise, the landscape would eventually be overrun by wolves, and nature's balance would be thrown out of whack. It is one thing to acknowledge the inexorabilities of population dynamics, however, and quite another thing to encounter a dead wolf with ribs protruding from beneath its hide. I could not help but think back to the year before, when this individual and his littermates had played wolf tag at the airstrip as I was leaving.

After the snowbank had melted completely, the wolves would often trot over to the slope where their dead relative lay. One by one they would sniff his body then curl up beside him for a nap. At such times, it was hard to tell from a distance that the pack did not still have five living adults.

The days passed, and my filming project was going well. This year's pups had still not emerged from the den, but I could hear their robust squeaks echoing inside, and I sensed that they must be doing fine. The pack continued to tolerate my presence with unusual good nature, showing little concern even on those occasions when I would walk right up to the entrance of the den. Going inside the den to photograph puppies had been a long-held dream of mine, but in past years the wariness of the alpha animals had kept me from attempting it.

This year, with only two days left before my final departure, I finally decided it was now or never. Still, I was determined to avoid upsetting the adults at all costs. All four of them were curled up a hundred yards away. Upon my approach, they stood up and eyed me with more curiosity

Four puppies less than a month old huddle together for warmth inside a centuries-old den that smelled sweetly of puppy fur.

than alarm. As I advanced closer and closer to the entrance with my cameras, tape recorder and flashlight, Left Shoulder emitted a short woofing bark; a sign of concern that, fortunately, passed quickly. Mom regarded me less with wariness than with a confused, highly quizzical look, as if to say, You've never done this before. For a moment I hovered at the entrance, my heart pounding. Then I got down on all fours and edged my body inside.

The narrow passageway issued down into a large, cool and damp chamber that smelled sweetly of puppy fur. A sliver of an opening along the back wall allowed fresh air to blow through the den, which glistened in spots from the frozen exhalations of the wolves. The beam of my flashlight quickly located a tight ball of four puppies, each of them shivering in the slight breeze and wiggling constantly to secure a better fit in the mass of sibling warmth. As I slid my microphone forward to record the squeaks and groans, one of the little fellows pointed his muzzle at me and growled. At three weeks old, he was already asserting dominance!

In less than five minutes, I was finished with my photographing and was out of the den. For a few minutes, Mom walked back and forth sniffing the spots near the entrance where my body had brushed against the rock. Inside, her offspring continued to squeak and groan. Finally she disappeared inside to make sure everything was all right.

The following day, June 9, my filming was almost complete. This was to be my final day on Ellesmere Island. After spending three consecutive summers with the wolves, I was quite emotional at the thought that these final hours would probably be the last I'd ever spend in the company of these wonderful creatures. At the airstrip, a DC-3 was scheduled to depart in the early afternoon. That morning, I packed up my gear and went over to the den to say goodbye.

The weather was fair for the first time in a week, the temperature hovering just above a comfortable 32-degrees Fahrenheit. I set my movie camera up about a hundred yards

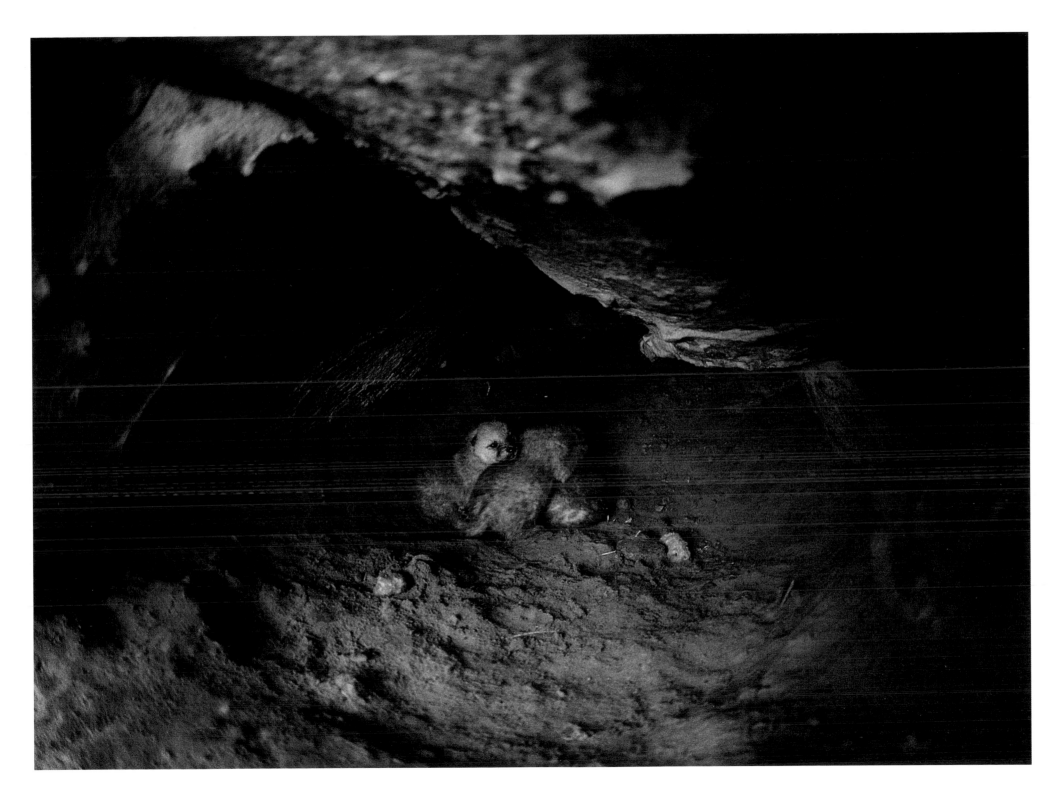

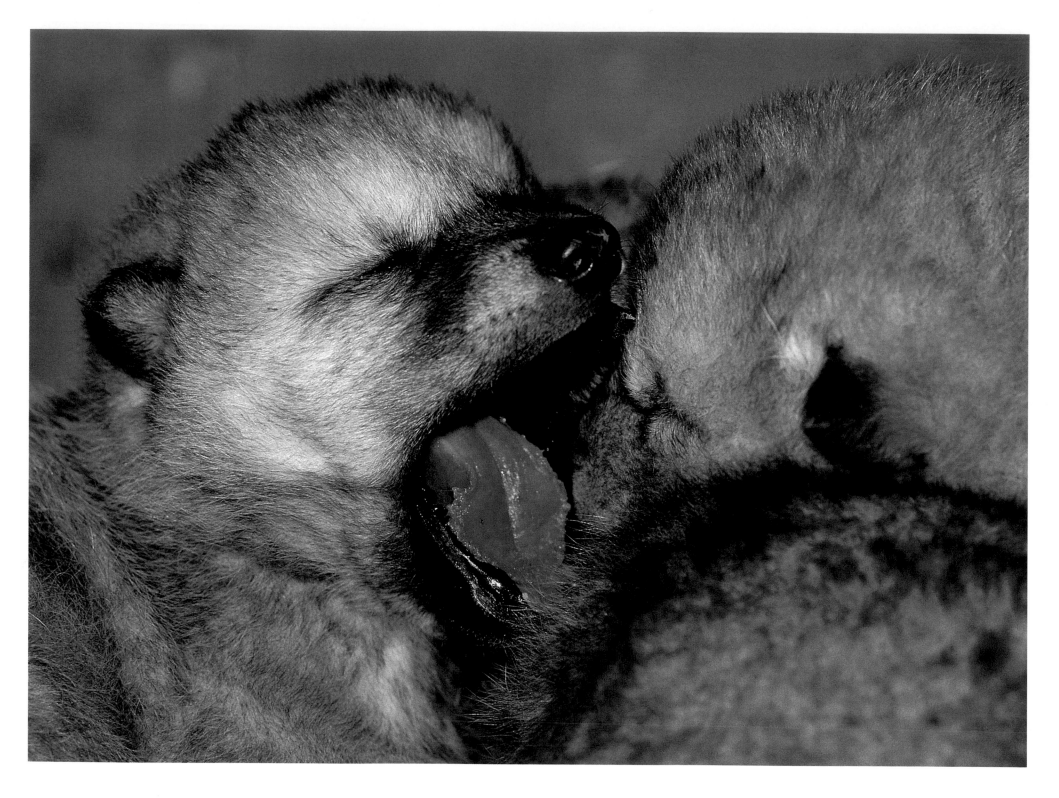

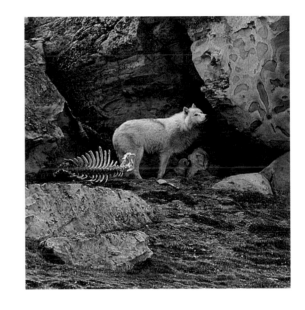

A couple of three-week-old puppies yawn nonchalantly at the author, who has crawled inside to briefly photograph their den. (Above) The pups narrow view of the world is seen from inside the den. Just outside, the mother of the pups patiently waits for the photo session to end. (Right) The next day, during the author's final hour with the pack, Mom proudly escorts her pups out of the den to show them off to the outside world for the first time.

downhill from the den, hoping to record a last bit of footage before departing. Overhead, a white sun burned through a thin layer of haze punctuated by lenticular clouds, lens-shaped puffs created by upper-level winds in cold climates. All in all, it was a beautiful example of high Arctic spring-time: purple saxifrage in bloom, bumblebees buzzing about despite the chill, and red knots and ruddy turnstones flying overhead in aerial courtship displays. On the rocky outcropping above the den, a male ptarmigan croaked out his stento-rian mating call.

One by one the wolves, cocked their snouts to the sky and howled. It was a splendid performance, discordant as always, and I could not help but imagine a mournful edge to it. I know from having raised wolves in Minnesota that they have an uncanny sense for how you are feeling, a sense that could be described as empathetic.

Mom alone chose not to join in the howling; she stood at the entranceway and watched the others. Perhaps her discretion could be explained by the four pups inside, who had still not emerged into the outside world.

I looked at my watch. The plane would be leaving soon—I knew I should begin the six-mile trek to the landing strip. I looked at the white wolves and the wide valley that stretched out to the snow-covered mountains in the distance. Just as I was getting ready to stand, I heard loud squeaking at the entrance to the den, and the four pups stumbled hesi-tantly into daylight for the first time in their lives. Mom stood above them, looking quite pleased with herself, a proud mother showing her offspring the world. I couldn't believe it—for two years in a row, the wolves had done something remarkable just as I was departing. Was it merely coinci-dence? The pups cavorted around, their faces filled with that "first time" look of wonder, their eyes reflecting equal parts bewilderment and curiosity.

I stayed much too late photographing this event—and got mildly chewed out by the pilot later. When I finally had to leave, Scruffy decided to trot along with me to the airstrip. After three miles, he froze, perked up his ears and gazed intently toward the south. Like a trained pointer, his body was aimed directly at a nearby herd of Peary caribou, a species I had been trying to film, without success, throughout this final trip. After I shot several minutes of film, Scruffy decided to make a charge. The herd had little trouble outdis-tancing him, and Scruffy was soon lying on the ground scratching. He looked at me, in that goofy, quizzical way of his, as if to say, What do you think of me now?

It was an easy question to answer. Scruffy and the other Arctic wolves changed my life. For over three years, I have been preoccupied with their story, which was the highlight of my career as a wildlife photographer. They gave me the chance to achieve a dream. I only hope that by sharing their lives with the world, and dispelling some of the misconcep-tions our species has formed about theirs, that I can begin to pay them back.

Quickly ascending an icy pass, a lone pack member searches his vast, cold land.

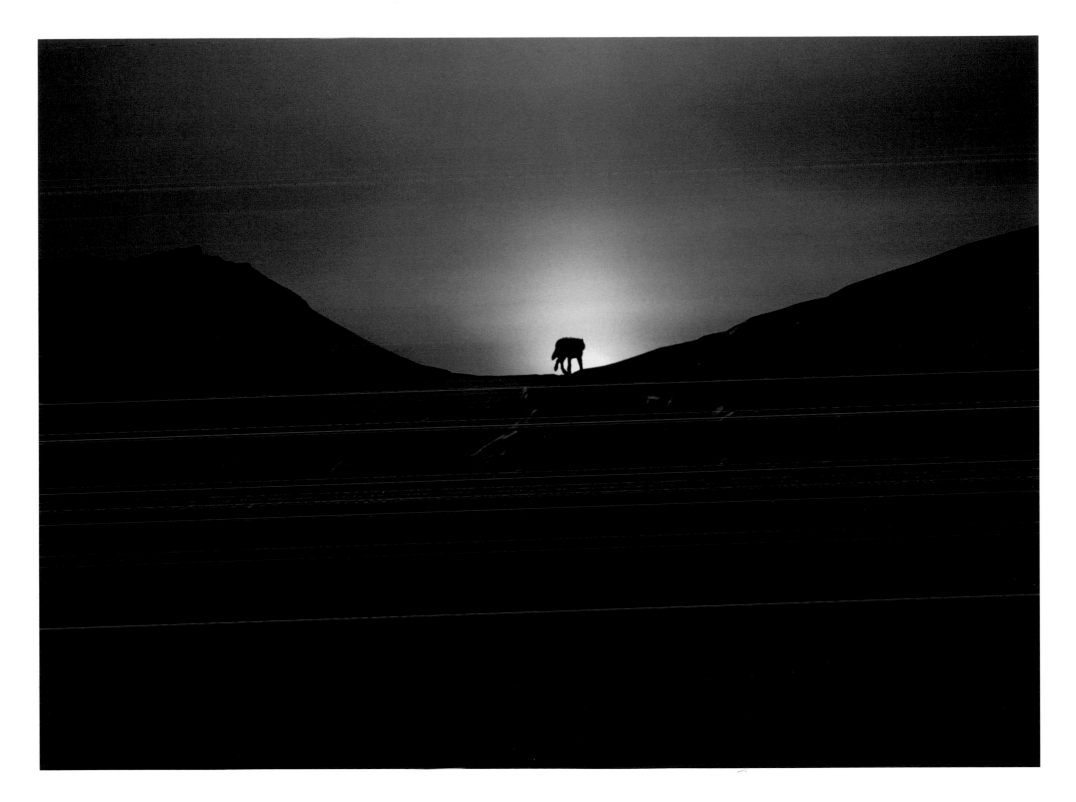

ELLESMERE ISLAND

Situated 500 miles from the North Pole, a cold and lonely Ellesmere is the earth's tenth largest island.

Roughly the size of Kansas, it has a population of 350 people. One hundred Inuit reside in Crise Fiord on the south coast. The remainder are government and military personnel working at Eureka's weather station and Alert, a military base on the north coast.

Some other Ellesmere facts:

The nearest tree grows 1,200 miles to the south.

A half mile of ice covers much of the island.

Less than 4 inches of annual precipitation, mostly in the form of snow, makes Ellesmere a true desert.

Temperatures range from 70°F (summer) to minus 70°F (winter).

Only seven species of land mammals are found here: Arctic wolf, Arctic fox, ermine, musk-oxen, Peary caribou, Arctic hare and collared lemming.

The Vikings visited the island in the 12th Century.

Moscow and Washington, D.C. are the same distance from Ellesmere.

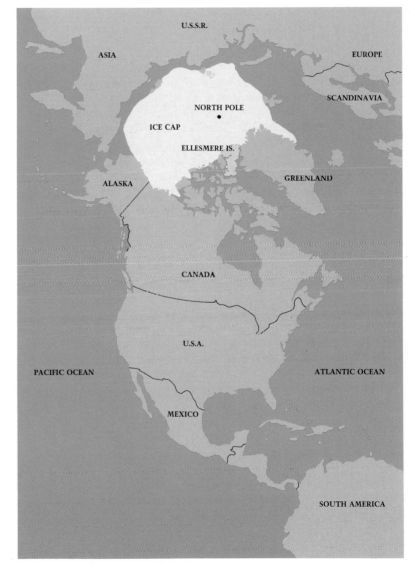